Computers & Art

Second Edition
edited by Stuart Mealing

intellect

Bristol, UK
Portland, OR, USA

Second edition published in Great Britain in 2002 by
Intellect, PO Box 862, Bristol BS99 1DE, UK

Second edition published in USA in 2002 by
Intellect, ISBS, 5824 N,E.Hassalo St, Portland, Oregon, 97213-3644, USA

First edition published in 1997

Consulting Editor: Masoud Yazdani
Copy Editors: Holly Spradling and Wendi Momen
Cover & book design: Toucan

Set in Quadraat

A catalogue record for this book is available from the British Library
ISBN 1-84150-062-3

Printed & bound in Great Britain by the Cromwell Press, Wiltshire

Contents

Stuart Mealing

Introduction

There is an undeniable frisson about juxtaposing the words 'art' and 'computers' since they stand at the gateways of seemingly opposite worlds, guardians of opposite values and standards. Their juxtaposition calls into dispute embedded notions about art, about creativity, about consciousness and thus about the human condition.

For over 30 years I have been either involved with art and excited by computers or involved with computers and excited by art. I should provide a prime audience for computer art, yet have often been left curiously cold by the products of the two disciplines coming together. I would not want to compile a book documenting computer art. 'Computers and art', however, is an altogether more expansive subject which can look at the practice and potential of computers as tools, enablers, creators and as sources of inspiration in the field of the visual arts.

The discipline is a new one; a medium perhaps still waiting for its time. As with the early years of photography, it once aped more established media and sought comfort from its own technology, but its very existence has also provoked some of the most stimulating questions of our time. Paul Davies, in the *Sunday Times*, quoted the scholar George Steiner on opening the Edinburgh Arts Festival, as remarking that science has now seized the high ground of human intellectual endeavour, leaving the arts floundering and looking irrelevantly self-indulgent – a tacit acknowledgement that scientists are now tackling many of the age-old questions of existence, topics that were formerly the exclusive preserve of religion and literature. If true, it might be that in those areas of the arts which embrace and overlap the sciences there is a heightened potential for such ground to be reclaimed.

It would be strange to criticise a painting because you could see that it had been made with a brush and paint, yet computer-generated images are often criticised for being "too computery" or because "you can tell they've been done by a computers". This implies either that there is merit in concealing the origin of the image – that the computer is not a worthy tool for the creation of images – or that the computer generates a particular (implicitly unsatisfactory) type of image. Perceived manifestations of computer generated imagery include – a lack of evidence of hand skills, absolute precision, a clear mathematical basis for the composition, palette limitations of tone or hue, a geometrical quality of line, a regularity of shapes and objects, limitations of an output device (e.g. scale, resolution), pixellation, and a clinical 'cleanness' of image.

Perhaps there is a tendency to criticise a medium for being recognisable when it is imitating something more usually (or better?) created in another medium. The artifice (or fraud) has been exposed. "You can tell it's a photograph" might be a legitimate criticism of an image which purports to be a painting but not of a piece of reportage, when the opposite criticism would be valid.

It is true that the art-generating computer has sometimes been used to do things which it is not good at or for which it lacks subtlety. Such attempts imply that global aesthetic judgements should be suspended in favour of local judgement of an immature art form. This is reminiscent of interpreting the performance of a two-year-old child playing *Chopsticks* on the piano as charming and talented whilst recognising that an adult duplicating the performance would merely prove embarrassing. Digital art must, of course, come to stand and be judged without concession alongside other art if it is to be taken seriously and after a few false starts it is now coming to do so.

Questions queue up to launch themselves at digital art and the most challenging are philosophical. Will the medium develop its own aesthetic? If a computer was to generate images at random and was able to evaluate its output in order to produce better work, what would be its criteria for judgement? Since an expert system would only reflect existing human values, what rules would allow a computer to bootstrap its way towards building its own value system? What sense would a machine's internal aesthetic make if its product is to be viewed by humans? And many more besides.

Within these chapters a number of viewpoints are expressed and perspectives illustrated in a range of styles. There has been a conscious editorial decision not to try to unify the styles in which the chapters are written since each proves expressive of the direction from which its author comes. Between them, however, the contributions are designed to cover a broad range of issues within the field of computer art, extended in this second edition by additional chapters.

Hopefully this discursive triangulation will help to pinpoint a worthwhile subject area. Contributors to the book are variously artists, scientists, critics, philosophers, educators or often several of those things. They come to the subject from a wide and often mixed range of backgrounds and their combined essays raise questions relevant to practitioners in as many different disciplines. In some cases those questions are answered but their having been posed is more useful to the debate than their resolution. My own interests currently come together in a research project connecting computers and life drawing. For some the meeting ground between computers and art is found in philosophical discourse. For others this same wedding is consumated in purely artistic output. Each reader will bring a unique personal perspective to the book and will hopefully be stimulated to share the excitement, concern and passion expressed within these pages.

Stuart Mealing is variously a writer, researcher, lecturer and consultant in visual applications of computing. Trained initially as a fine artist in the late 60s he exhibited widely and taught in art colleges for many years whilst maintaining a practical interest in the development of computing. Many years later he took a post-graduate degree in Computing in Design and is currently a Reader in Computers and Drawing at the University of Plymouth in Exeter and the research coordinator for Art & Design.

He was a founder member of their Centre for Visual Computing, a founding editor of *Digital Creativity* and has also been an Honorary Research Fellow in Computer Science at Exeter University. His research interests centre on computers, drawing, creativity and artificial intelligence (although an intermittent project on visual language keeps resurfacing). His publications include five books and his papers, articles and reviews have appeared in a range of journals.

Stuart Mealing

On drawing a circle

Emotions generated in the viewer by objective drawings which are made using traditional media are different from those elicited by digitally originated marks presented on a computer screen. This chapter explores the dichotomy of production and interpretation of the two forms of mark-making and considers the possibility that they may lead to different understandings of the world.

Prologue

The story is told by Vasari[2] of Pope Benedict IX sending a messenger to a number of artists with a view to commissioning one of them. In Florence he met with Giotto and requested of him a drawing to take to His Holiness. The painter took a brush, "then, resting his elbow on his side, with one turn of his hand he drew a circle so perfect and exact that it was a marvel to behold." The courtier thought he could not be serious to offer so little but took the drawing to the Pope who "instantly perceived that Giotto surpassed all other painters of his time."

The implicit equation of a circle (centred on j) is: $(x-xj)^2 + (y-yj)^2 - r^2 = 0$.

On drawing a circle

How do you, I or Giotto draw a circle? How its circularity stored in the mind – by its appearance, by its formula, by the algorithm used to construct it? A circle could be thought of either statically or dynamically, as a concatenation of all positions in one plane which are the same distance from a single point or as an arc sweeping before your eyes. In the first incarnation it is matched by a mathematical template, in the second by a turn of the wrist.

When fingers and wrist combine to take a line on a slow, looping journey there is constant feedback from eye to hand, correcting incrementally against a mental model. On a rapid circumscription it seems to be habit, burnt into the nerves and muscles, that drives the action. Of course in the context of objective drawing the mark not only has its own identity but also stands for something in the outside world. The significance is that a circle is more than its shape, it embodies a concept. It hints of containment, harbours dreams of perfection, reminds of heads, suns and apples. This reference to the world outside the drawing, whether tacit or explicit, ties the experience of the observer to that of the mark's creator and the mark may need to carry evidence of humanity to establish the link convincingly.

Making marks, externalising and looking are vital parts of an artist's process[3]. They are clearly linked to one another but also create a conduit through which ideas flow back and forth between artist, subject and image. It is through the process of making and refining marks to stand for the subject that the artist comes to a better understanding of the subject – its form, its weight, its articulation, its occupation of space, its place in the world, its circularity.

Poles apart

As I have commented in the introduction to this book, there is an undeniable frisson about juxtaposing the words 'art' and 'computer' since they stand at the gateways of seemingly opposite worlds, guardians of opposite values and standards. Their juxtaposition calls into dispute embedded notions about art, about creativity, about consciousness and thus about the human condition. Their union provokes questions about new aesthetics, new directions and new destinations.

Within the domain of art the immediacy and directness of objective drawing arguably renders it the subset of the discipline which has the narrowest gap between encounter and corresponding mark; the medium where artist, subject and image are closest. As such a knowing distinction between the stamp of man or machine could play an overbearing role in emotional response to an image. Negroponte[9] comments that

'computers and art can bring out the worst in each other when they first meet. One reason is that the signature of the machine can be too strong.' Neither is idiosyncrasy normally an intended feature of machines.

Local context can also be an issue, both in production and viewing, which separates traditional media from digital. The archetypal life drawing studio, stained by generations of use and redolent both of its own history and that of its subject, provides a very different working environment from that surrounding the average computer workstation. Similarly, viewing an image on the wall of an art gallery provides a very different physical and cultural experience to that of staring at a computer screen, even when the computer itself is displayed in a gallery.

Dislocations

Traditional coordinations are revised when drawing with a computer. Whilst the hand typically toils in a horizontal plane, the results of its efforts are output to a normally vertical screen and with a delay lasting from imperceptible to worrying according to the type of mark being made and the speed of the system.

The tools available in a computer paint system largely imitate those available for traditional mark-making. The value of this imitation is the apparent familiarity the user has with the new tools – there seems little to learn. The problem with this imitation is the apparent familiarity the user has with the new tools – the fundamental differences are overlooked. The computer provides a new set of relationships for the artist between tool and mark, relationships which modify, distort or destroy much of the feedback which drives traditional drawing.

The drawing tool is usually replaced in the current digital world with a universal proxy that stands for all available tools. Its feel does not change whether simulating the grate of a charcoal stick or the smooth slide of a sable brush nor whether it is making light, fine scratches or broad, wet sweeps. If it comes in the awkward form of a mouse the required grip is more like that on a bar of soap though a stylus is pencil-like and permits fingertip control reminiscent of 'real' media. Tool pressure can be set to modify variables such as size and opacity of marks but such relationships are pre-set rather than modified whilst in use. There is, however, none of the tactile feedback, none of the physicality of pen, chalk and paper. 'We draw a picture without making a mark, wield brushes that have no bristles, mix paints that do not pour'[1].

A new breed of haptic devices is slowly emerging which offers sensory feedback from the virtual texture of a surface and force-feedback from the virtual forces an object might embody but these are currently uncommon. Their functionality tends also to be limited and application specific.

The scale of marks is physically limited by the size of the graphics tablet (or mouse mat) available and may be psychologically inhibited by the cramped space often allocated to computer workstations. There is also the potential for the mapping of hand movement to screen mark being other than 1:1; a small hand movement can be scaled up to produce a larger mark for example, or the screen image may be enlarged so that the opposite is true. More disconcerting is that the relationship between tool and screen coordinates can be either absolute or relative, the former matching the real world but a mouse typically abandoning an absolute relationship when it is out of

contact with a surface. This means that if a mouse is raised from its mat and replaced at any new position the screen position of its cursor remains unchanged.

Digital mimicry

The term 'computer paint system' usually refers to a system using a pixel-based representation of marks in which all the information in an image is stored point by discrete point, row by discrete row. In such a system a straight line exists only as a number of contiguous pixel locations. The term 'computer drawing system' usually refers to a vector based system in which information is stored in terms of relative positions expressed mathematically. In this system a straight line is known by the coordinates of its endpoints. Systems increasingly combine these forms of representation but I use the two terms hereafter in their exclusive senses. The appearance of lines drawn with the two systems may appear similar on screen but they have very different identities which will be explored later.

The digital marks I describe are screen based (I resist the argument that they reside in the frame buffer – a specialised piece of computer memory reserved for image storage – and do not deal here with translations of the image that are output to devices such as printers) but the screen holds a canvas of marks made with light and not substance. This leads to a very different gamut from traditional media; the range, contrast and calibre of possible screen colours being poorly matched by paper and ink, whilst traditional media has a range of textures and qualities that pixels on a screen cannot match. And as Wright[14] puts it, an electronic image has a 'reproduced' quality to it – it seems to float behind the glass of the screen, seems to be unlocated at any unique point in space. .. Electronic images are limited by the screen but are not on the screen. There is some parallel here with the loss of substance in a traditional drawing locked behind glass. Petherbridge[10] has noted her regret that an exhibition cannot convey the pleasures that come from handling a drawing. That intimacy, that conversation with the work, cannot be replicated by drawings distanced behind glass and hung vertically on walls.

On a VDU screen the surface doesn't get dirty, the simulated water-colour does not soak in, the simulated lead does not tear the surface, there is no serendipitous smudging, the mark never becomes a physical part of the drawing and the tool itself is never eroded. In some way the image has become more cerebral because of this lack of physical integration with the surface. And while the hand moves in an analogue world the parameters of the digital mark it gives birth to – its position, width, colour, transparency – all change in pixel sized increments. Even attempts at a fine, clean mark are subverted by the demands of antialiasing (a counter-intuitive process by which the edges of a screen shape are blended into the background in order to give the appearance of a cleaner edge). Without antialiasing shapes have saw-toothed edges (unless resolutely vertical or horizontal) but by its very nature the process prohibits detail and will do so until improved display resolution renders its intervention unnecessary.

The struggle when using traditional media, making the material deny its own nature and become servant to an image, often drives the art process. It can provide much of the final image's excitement and is also a hook for the viewer's empathy. An image on a computer screen does not recount the same fight although a digital alternative may

have taken place. Making demands of stubborn software can be equally tiring and a successful outcome can be equally satisfying but the activity is more intellectual and less physical.

Drawing has traditionally been about hand skills with each drawing tool a fresh extension of the hand, its immediacy intuitively appropriate to investigation of the human condition. But can we, in cyberspace, recognise 'the primal nature of drawing, its universality and economy of means, its expressive intensity, its ability to reveal process and autograph'[10]; even the word 'drawing' has been appropriated by the world of computing to refer to mathematically defined marks which inhabit the same plane but retain discrete identities. The various discontinuities of physical and intellectual expectation in the digital process combine to incite a detachment between subject and image. There is an intuitive sense that the meaning a mark carries is not just a product of the viewer's ability to interpret it through experience, but a legacy of its creator's experience.

Passing time
The mark-making process in traditional drawing is both additive and subtractive. Marks are made, assessed and then either added to or removed (or the drawing is finished) yet the drawing as a whole is added to by both marks and erasures. The act of rubbing out a mark adds a positive intellectual statement to the drawing as well as adding a local change of texture to its surface. It breaks up the surface like a drawing tool and smudges marks that skirt its passage. It is also likely to leave behind some faint reminder of the mark erased and the developing drawing therefore reveals both its history and its current state. The drawing declares itself to have developed over time, to have had a life. An erasure becomes another type of mark.

On the other hand, in a typical computer paint system, erasure is usually absolute (though the Painter' software is a notable exception in which 'water-colour', for example, 'stains' the surface and is not erasable, whereas 'charcoal' etc. can be erased). The image 'surface' is returned to its virgin state with no trace of its recent history remaining. In this sense a computer generated image could be said to have no past, no provenance. If the system includes an 'undo' button then the drawing's past can be peeled back in discrete stages and the image returned to any previous state without record of time having past. It has effectively become a brain-washing button.

Two alternative strategies which allow a return to previous states are those of saving the image at regular stages (in which case a number of separate versions of an image coexist) and the use of layers (in which different elements of the image are stored discretely and superimposed on top of one another). The marks in a layered system, either individually or grouped in collections, are no longer welded together – stable and indivisible – they cooperate but are not bound to one another. Although both strategies offer an often welcome flexibility they both mitigate against commitment to a mark, one hallmark of its integrity.

The noble mark
At the time of the Renaissance one of the interpretations of the word drawing (disegno) was that of 'the creative idea made visible in the preliminary sketch'[5], a concept which embodies more than just the effectiveness of representation.

Drawing is also widely understood to provide a rich way of exploring and coming to understand the world about us with marks on a surface describing not only visual experience but attitudes to them. Perhaps notions such as these load hand-drawn marks with a spirituality and reverence that digital electronics lacks the gravitas to support.

The devotional aspects of viewing traditional drawing, of communing with the muses, seem to require evidence of a human hand which is disguised when in digital form. The affectionate hand has been equally present in screen-based marks but their lack of physical evidence is not easy to overlook. For generations introduced to drawing through digital means this may present little barrier and the computer's alternative strengths may outweigh any that are perceived. There are clearly cultural and generational perspectives on screen media which the prevalence of television and computer games has engendered.

New tools for old

Digital technology transforms the language of drawing. Although the physicality of 'real' media is removed in a computer paint system it clearly has its roots in traditional media. In a computer drawing system, however, a whole new grammar and syntax is born; the marks it gives rise to have a wholly different relationship to visual reality. The two systems are conceptually mapped to different worlds.

A straight line exists in a vector drawing as a rigid connection between end points, a mark-object which can be moved independent of the surface on which it sits. Or perhaps it would be more accurate to say the surface above which it floats; so unlike our own dear mortal mark. A vector drawing is a Meccano kit of customised parts which can be manipulated individually or bolted together in groups, all of which can be aligned automatically using a predefined screen grid. It lacks the benefits of ambiguity but asserts absolute confidence to the world.

Freehand marks may be permissible but the system exists to support geometry, that branch of mathematics concerned with the properties and relations of points, lines, surfaces, and solids and with the relative arrangement of objects or parts. Lines in this world are of constant, though re-definable width; they are 'dumb', not eloquent in the language of drawing[II]. They are, however, supremely accurate.

Curved lines may be defined by centre, radius and arc or as splines, in which user-specified control points provide the focus for a mathematically smooth curve. (Splines were originally flexible strips of wood held down by weights, their natural, internal tension and flexion being used in shipbuilding to create the smooth curves of a hull.) Interestingly, though a sphere can be defined with elegance and total accuracy by its radius and the XYZ location of its centre (i.e. four numbers), it is often generalised into a faceted, polygonal representation for display on screen (which requires the definition of much data). Closed shapes such as rectangles and ovoids can be created by interactively dragging to size and irregular polygons are constructed by 'clicking' on locations representing the required vertices. We are thus provided with a catalogue of precise, flat, customisable, mark templates singularly ill-fitted to the task of representing our perspectival view of the visible reality around us.

Not all drawings are derived, directly or indirectly, from views. Conceptual rather than visual understanding of form underpins a number of systems of representation both

in the drawings of children and engineers. The representation of what is there does not require it to be seen exclusively from a single viewing point at a single moment in time and the logical diagramming of, for instance, orthographic projection (which privileges real measurements over the foreshortening of vision) or oblique projection (which represents a measured compromise between object-centred and viewer-centred systems) could make easy use of computer drawing. Used in that way, however, a vector system fuels a different cognitive system to the one used in direct observation.

Traditional, western European, single viewpoint drawing is a special case of goal-directed mark-making in which a mental viewing-transform maps the three-dimensional space of the real world to the two dimensions of the drawing surface. It is also expressive. Mathematics has less to do with the process than has gesture. Vectorial geometry is for describing abstractions of the real world, diagrams of reality. It is for symbolic representation (though the competent artist can, of course, divert it to other ends). It does not pretend to provide an intuitive tool kit for dealing visually with the world around us simply because we don't comprehend that place in terms of mathematical relationships. Yet.

New landscapes for old

The appearance of the man-made world is being transformed by the use of computer tools at the design stage – as it has been by the evolution of successive generations of tools in the past. The number-crunching potential of the computer offers new accessibility within its drawing packages to geometries previously too complex to realise or manipulate on a viable time scale. Splines and meshes, for example, can be created, transformed and edited with an immediacy that has led to their widespread use and shows its effect in the creation of both two- and three-dimensional artefacts. It has now become easy to recognise their digital fingerprint on new vehicles, domestic artefacts and in architecture whilst their use in animation has lead to signature movements of disarmingly mathematical smoothness. The new freedoms offered to the users of such packages have extended the visionary space within which they can operate (though manufacturing processes might currently be inadequate to cope with some of the new demands made at the drawing/conception stage). This repackaged consumer world in turn reflects its new image back to its occupants and feeds a new aesthetic – a 'look' for the age.

The remarkable Guggenheim Museum in Bilbao by Frank Gehry, for example, uses forms that could come only from a computer and have extended the vocabulary and grammar of modern architecture. Digital technologies have allowed him to realise the gestural qualities he has long sought in his work. The repercussions of this extension of the visual vocabulary of a discipline that impacts on all our lives could be said (as Macluhan has claimed of extension of any of the senses) to be that, in some small way, it alters the way we think, act and perceive the world.

New visions for old

The conduct of the world is increasingly digital. Its communications, prognostications and disseminations are coded in binary notation. The spirit of the age flies down a wire. Negroponte sees a growing shift of emphasis from atoms to bits as vehicles of information[9] and it would be consistent with his thesis to recognise

a move from traditional to electronic media in the visual arts. Although the computer is digital, however, it 'is not to be characterised merely as "quantitative". Our brains, those electro-chemical, biological "computers" running on glucose, are, at rock bottom (quantum) levels, presumably quantitative. So what? We structure our mental models of the world (without which we could not act upon it) we perceive, process and communicate with qualities'.[12]

Whilst the reasons for drawing need not have changed there may be new rationales to add to the old and new methods more suitable to a current image's final home. It is more obviously appropriate to draw on a computer, for example, if a screen is to be an image's final resting place. New media can be interactive, new means of publication (such as the ubiquitous internet) invite collaboration, new relationships are implied between artist and viewer.

Drawing has often been claimed to provide a way of comprehending the world; Matisse, for instance, did not talk of learning to draw but of 'study by means of drawing'.[4] Might a new drawing methodology therefore, reveal a different world or provide a fresh viewing point from which to look at it? In defence of the mechanical mark Lansdown[6] comments that 'there is a special quality of drawings plotted in the very precise and regular way that computer output devices can often achieve. The output, untrammelled by the intuitive and subconscious modification that artists often add to manual drawing, invariably gains something simply by its mechanical perfection'.

Whilst I understand the world before me to be divisible into units capable of mathematical description I do not see it that way. I can understand descriptions of a table[3] given in terms of three-dimensional, volumetric primitives; of two-dimensional faces; of one-dimensional edges; or of zero-dimensional surface points. I can understand the building blocks of an image of a table in terms of marks, pixels or pictemes[8]. If I draw the circular top of the table at which I sit, however, my understanding of its obvious circularity plays only a small part in making the distorted perspectival ellipse, bent by my sweeping viewpoint, changing focus and binocular vision, that I 'see'. Whilst the rule of mathematical form implies a global understanding – a god's-eye view – I have a single, local viewpoint.

Given a drawing system of mathematical templates I might be given to greater acknowledgement of the table's inherent geometry and through that to an alternative representation. Such a system would force the assertion of different relationships between mark and reference and matching the world to such templates would either reveal new truths or lead to the reprioritisation of existing ones. It would refer to a different cognitive map. A world seen through vector spectacles might prove a world seen anew.

Postscript

A machine-drawn circle would be sure, accurate and reliable (that is if sureness, accuracy and reliability are really machine-like qualities), qualities which we implicitly seek in making a pure circle and never find. Qualities we might describe as devoid of emotion yet, as long as they are elusive, remain worth pursuing. The machine's circle, however, could not refer to anything outside of itself, could not be hinting at suns it had seen setting or balloons it had played with. Unless it had

experience – perhaps acquired via a robotic vision system[7], suitable programming and the technology of artificial intelligence. Then tempting questions loom about the evolution of a true machine aesthetic.

References

1 Binkley, Timothy. (1990) Digital dilemmas. *SIGGRAPH '90 Art show catalogue*. Leonardo (magazine). Pergamon Press, Oxford, p13.

2 Burroughs, Betty (Ed). (1962) *The essential Vasari*.. Unwin Books, London, p30.

3 Edmonds, Ernest. Cybernetic Serendipity revisited. In: Dartnall, T (Ed). (1994) *Artificial intelligence and creativity*. Kluwer Academic Publishers, Dordrecht/Boston/London, p339.

4 Elderfield, J. (1984) *The drawings of Henri Matisse*. ACGB, London, p22.

5 Lambert, Susan. (1984) *Drawing, technique & purpose*. Trefoil Books Ltd., London, p9.

6 Lansdown, J. Generative techniques in graphical computer art: some possibilities and practices. In: Lansdown, J & Earnshaw, R (Eds). (1989) *Computers in art, design and animation*. Springer Verlag, pp75/6.

7 Mealing, Stuart. (1998) KIKI – a computer drawing model. *Proceedings of Eurographics '98*. Eurographics, pp121/6.

8 Mealing, Stuart. Do you see what I'm saying? In: Yazdani, M & Barker, P (Eds). (2000) *Iconic communication*. Intellect Books, Bristol & Portland, p72.

9 Negroponte, Nicholas. (1995) *Being digital* . Hodder & Stoughton, London, p223.

10 Petherbridge, Deanna. (1991) *The primacy of drawing: an artist's view*. The South Bank Centre, p7.

11 ibid. p52.

12 Reffin-Smith, Brian. Post-modern art, or: Virtual reality as trojan donkey, or: Horsetail tartan literature groin art. In: Mealing, Stuart (Ed). (1997) *Computers & Art*. Intellect Books, Exeter, p109.

13 Willats, John. (1997) *Art and Representation*. Princeton University Press, Princeton, p8.

14 Wright, Richard. (1989) The image in art and 'computer art'. *SIGGRAPH '89 Art show catalogue*.Leonardo. Pergamon Press, Oxford, p50.

This chapter has been developed from a paper first published in Vol 6 of the journal *POINT*.

George Whale is an artist and software engineer with special interests in drawing, print and computer-mediated creative collaboration. Currently a Research Associate at Loughborough University School of Art & Design, UK, his work combines studies of drawing and cognition with computational modelling. He is co-author of *Digital Printmaking* (A & C Black, London). <g.whale@lboro.ac.uk>

George Whale

Why use computers to make drawings?

'... *even if the majority accepts new technology, only a minority truly adopts new practices.*' Malcolm McCullough [25].

With interactive software, even artistically untrained individuals can now create complex shapes with ease, make accurate perspective drawings or render real-world scenes in a range of painterly styles. If this seems unremarkable we should remind ourselves that, not so long ago, these kinds of tasks would have required years of specialist training. Yet some artists and designers remain sceptical, citing the dubious quality of many digital drawings to support their contention that the computer has little of value to offer them. Others are more accepting of the technology, but use it in entirely conventional ways.

It is certainly true that there are many drawing situations in which pencil and paper are still the technology of choice, with good reason: in life drawing, for example, or design conceptualization, the computer may confer few practical advantages. And it seems a safe bet that computer drawing systems will never be as compact and portable as pencil and paper. So we must ask the question: Why use computers to make drawings?

In the remainder of this chapter I will attempt to give some compelling reasons why – to show that computers not only facilitate a whole range of drawing tasks in art and design but are also spawning some genuinely new approaches to drawing, at the same time contributing to our understanding of this most central of human activities.

Precision, control and consistency
Most interactive drawing and painting packages facilitate the creation, transformation and editing of common shapes, curves and typographic forms, and some of the more specialized programs – for drafting, surface pattern design, chart and diagram production – allow for the production of more complex, composite structures, often through the application of spatial or combinatorial constraints.

Computers & Art Second Edition Why use computers to make drawings? George Whale

18

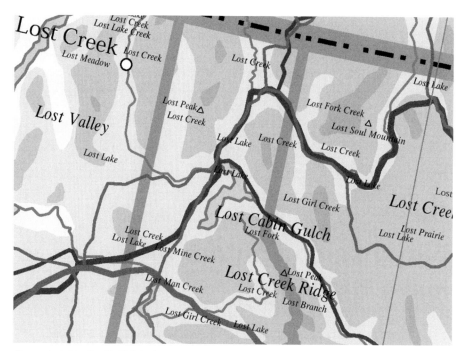

Figure 1 Lost Map (detail). Digital print on paper, 87.6 x 119 cm. Kathy Prendergast, 1999.

With some graphic design software (programs) it is also possible to apply stylistic 'rules' (relating to layouts, shapes, typefaces, colours and so on), which can help to ensure coherence and consistency in corporate design, for example, or in the design of graphical interfaces.

Elements of pictorial structure may be incorporated into software as data structures (representing classes of graphical objects, designs and styles), or as drawing procedures. In either case, retrieved, adapted and applied via the program interface they can help to compensate for shortcomings in the artist's domain knowledge, production technique or motor control.

Task automation

Fractal geometry predates the computer. Giusseppe Peano's eponymous space-filling curve was first published in 1890, Koch's curve was published in 1904, and in 1913 Jean Perrin, in *Les Atomes*, was one of the first to consider the 'anfractuosities' of many naturally occurring structures[23]. But it was only with the arrival of fast digital computers that it became practicable to visualize complex fractal structures such as the Mandelbrot Set and to apply fractal concepts to the representation of natural forms.

Even for computationally less intensive imaging tasks than this, the speed advantage of computers can be decisive. In 1997, I was invited to collaborate with UK artist Kathy Prendergast in a project to 'remap' regions of the world, by replacing the existing place names with names of settlements or geographical features normally considered too small, or too insignificant, to record. The artist conceived that the use of 'emotional' names – evocative of longing, loss and other kinds of personal experience – might facilitate rereading of the geography in more human terms.

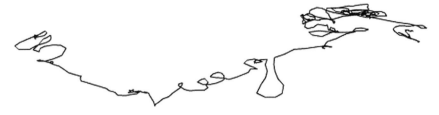

Figure 2a Boris. GPS drawing made at Summerfields School, Oxford. Boris the dog, 2001. (GPS Drawing: www.gpsdrawing.com).

Figure 2b Hackney football. GPS drawing of Hackney Marsh, London. Jeremy Wood, 2001.

Names and associated grid references were obtained from online databases, including the Geographic Names Information System (GNIS). Once categorized and sorted, they had to be placed on digital maps (kindly supplied by Bartholomew Ltd., Glasgow) in their correct geographic locations, taking account of the particular kind of (conic) projection employed. A program was created to automate this process, converting the longitude and latitude of each name in a list into a pair of horizontal and vertical coordinates specifying its (Cartesian) position on the map. Figure 1 shows part of the 'lost' map of the USA, produced with this method.

There are few drawing tasks that couldn't, in theory, be accomplished by conventional means, and in this case the tens of thousands of names could have been placed manually. In practice, however, it would have been hopeless, not least because each name had to be scaled according to feature type (town, valley, trail, etc.), and rotated to align it with the curving latitude lines of the map grid, or 'graticule'. When, as in this example, the computer is able to reduce the timescale for execution by orders of magnitude, and to automate the most error-prone operations, then projects which would otherwise be unthinkable become thinkable.

In another, very different kind of mapping project, Jeremy Wood and Hugh Pryor used a Global Positioning System (GPS) handset to record the paths of various journeys taken by land, sea and air in the UK and abroad. They wrote a computer program, *GPS-o-graph*, to draw the paths in $3D^{40}$. Two of the resulting drawings are shown in Figure 2.

Themes and variations – defining and exploring conceptual spaces

Many curves, some quite beautiful, are represented by mathematical formulae[18], and may be regarded as examples of mathematical visualization, or mathematical art (depending on the circumstances of production and presentation). Implemented as software routines, or procedures, formulae can be used to generate entire families of curves, by systematically changing certain of their numerical values, or parameters. We might say that, conceptually, the software defines an n-dimensional 'space' of graphic possibilities, where n is the number of parameters; and each set of parameter values defines a point in the space, corresponding to a particular curve.

At the level of source code (the sets of instructions which constitute a program, written in some programming language such as BASIC, C or Lisp) it is relatively easy to define not only parameterized forms, but also parameterized arrangements of forms, and it is not surprising that a number of artists interested in what we might loosely term 'systems-based' drawing have learned how to define their own 'conceptual spaces'[8] through programming. Bratislavan artist Robert Urbásek, for example, has developed software which is able to generate quite complex constructions by repeatedly drawing a line or simple shape, and with each iteration incrementing selected attributes such as size and orientation by specified amounts. A simple theme, with limitless variations; and, like much so-called 'algorithmic', or 'procedural', art, minimally connected with the real world of objects, emotions and experience.

There are many other ways of introducing (non-random) variability. Some programs, for example, employ 'lexicons' of elemental shapes, variously combining and modifying them according to sets of rules loosely analogous to the rules of syntax and morphology in natural language. Others can change an existing image by changing the underlying data values, or by reorganizing the data structure itself; the types of data structures used (lists, arrays, trees, etc.) largely determine the kinds of changes that can be made. In 'chaotic' systems such as cellular automata, small changes may be enough to produce markedly divergent forms, since it is a defining feature of chaotic systems that they are acutely sensitive to initial conditions – the so-called 'butterfly effect'.

Given the vastness of the space of potential images that may be defined by a generative program, effective search strategies are needed. One common strategy is to start from an arbitrarily chosen point in the space – i.e. a randomly generated image – and if it looks interesting, to explore the surrounding region – i.e. 'tweak' the image data. Other strategies may employ simple, evaluative criteria for 'filtering out' unlikely candidates, thereby significantly reducing the search space. The lack of reliable search strategies remains a significant barrier to the effective use of generative systems in art and design.

New tools, new paradigms

Traditionally, drawing is an activity in which tools transform movements of the hand and arm into marks on a surface. The relationships between marks and actions are sufficiently constrained that sometimes we feel that we can 'read' psychological states from a drawing almost as easily as we can read them from, say, the shrug of a shoulder, or the turn of a head. Digital drawing, however, is not so constrained, since the input from a mouse or stylus is infinitely transformable by software.

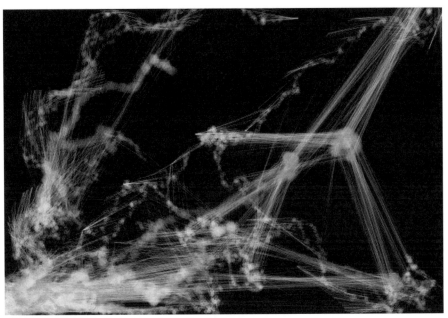

Figure 3 Image created with the interactive, online drawing program, re-move. Lia, 1999

> *Software tools introduce great power. It is the singular advantage of the software tool to give visible form and physical action to a logical operation otherwise lacking any physical correspondence, let alone any traditional counterparts*[26].

Scott Snibbe has written a series of experimental drawing programs[33] using particle systems: each program is intended to give 'an immediate sensation of touching an immaterial, but "natural" world with consistent and predictable reactions, but infinite variety'. *Myrmegraph* is based on the emergent group behavior of ants pursuing pheromone trails, whilst *Gravilux*, inspired by Hubble telescope images of galaxies colliding, models gravitational attraction and repulsion: as the cursor is moved through a mass of points, those in the vicinity are pulled towards it, or pushed away. Lia's *re-move* program[22] uses cursor position, speed and direction to control the generation of sequences of lines, dots or shapes which sweep and swirl across the picture surface, laying translucent clouds and veils of light on the black ground of the screen (Figure 3). Equally intriguing are the interactive screensavers commissioned by the ICA (Institute of Contemporary Arts) in London[14], wherein unskilled users can control a continually moving and changing drawing. Here, as in the previous examples, interaction is learnable and ultimately predictable but again, the tools themselves are quite unlike anything we might find in the traditional drawing studio.

Most interactive drawing media, like most traditional drawing media, are surface bound; and all thoughts and feelings are channelled through the single point of contact of the mouse or stylus. However, it is not a lack of suitable technology that prevents drawing developing into a truly spatial, synchronous, multi-channel activity, since all kinds of bodily movements can be accurately captured by video cameras and by 3D motion capture devices. Moreover, programs for translating movements into images, though mostly experimental, continue to be developed. The software at the

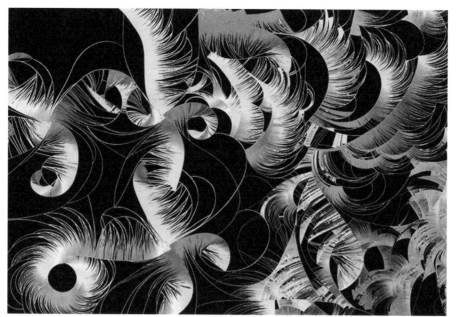

Figure 4 Volute. 'Artificial life' drawing. Mauro Annunziato and Piero Pierucci, 2000.

heart of Annunziato and Pierucci's 'artificial life' installation, *Relazioni Emergenti (Emerging Relations)*[5], enables observers to interact with a large, back-projected drawing (see Figure 4) made up of 'graphic filaments' which germinate, grow, interact and reproduce in response to signs of 'energy and life' picked up by a nearby video camera. *Relazioni* also has a musical component: a synthesizer converts the data underlying the continuously changing shapes and patterns into sound, which is to say that both image and sound derive from the same movement data.

This ease of translation between modalities – indeed, the ability to realize any kind of digitally encoded process, state or structure as a drawing – greatly extends the range of possible contexts for drawing. Golan Levin's *Aurora*, for example, permits a user 'to create and manipulate a shimmering, nebulous cloud of color and sound [which] rapidly evolves, dissolves and disperses as it follows and responds to the user's movements'[21]. Ben Fry, of MIT's Aesthetics and Computation Group[2], has experimented with 'organic' representations of dynamic data structures. His creation, *Anemone*, gives a plantlike visual representation of the interconnected structure of a website: it continually grows and branches in response to changes in site structure and usage. Andy Deck's *Icontext* is less ambitious, but nonetheless interesting, for it enables online users to explore relationships between text and image:

> Within Icontext, each letter typed appears also as a colored pixel in the emerging icon, while drawing a line leaves a parallel trail of letters. Not every image is an interesting text and vice versa, but the Icontext software lets people negotiate the balance (or imbalance) between image and text. The 'icontext' is the resulting document, which is simultaneously an icon and a text[9].

Specialized programs such as these enable exploration in relatively unfamiliar conceptual spaces, in some cases enabling us to create and manipulate a drawing

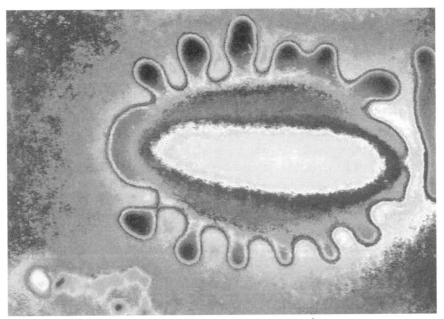

Figure 5 Photo Chemicals. An example of a 'lucky find'.Steve Whealton 1999.[36]

indirectly, e.g., through music or text. However, as with commercial software, the space of possibilities is entirely defined by the creator(s) of the software.

The issue of software adaptability is important for artist-programmers. Finding that an existing program does something similar to what they want, but unwilling to compromise, most would rather modify or augment existing code than spend days or weeks writing something from scratch. Object-oriented programming facilitates the use of 'DLLs' – dynamic link libraries – by which functionality can be added to a program without changing the program itself (extensions, or 'plug-ins', used with popular applications such as Adobe® Photoshop®, Illustrator® and 3D Studio Max® work in this way). This means that an artist wanting, for example, to generate and visualize new classes of 3D forms, can focus on the algorithms – the generative procedures – themselves and let the main application take care of interaction, rendering, printing and so on.

It is often supposed that computer-mediated drawing leaves no room for serendipity, but this is quite untrue. Every graphics programmer knows that the mistakes, or 'bugs', which invariably creep in during program development can be a source of inspiration. I once covered an entire wall with prints of accidental images generated by (my own) faulty software: unfortunately, I had absolutely no idea how most of them came about, or how to reproduce them! Happy accidents can also occur during interactive drawing, and 'lucky finds' arising from other media may lend themselves to digital processing (Figure 5).

Program output need not be confined to the plane. Bruce Shapiro, who has built (amongst other things) computer controlled devices for drawing onto eggs, and for etching into sand, lays down the challenge: 'Now ... instead of a pen, why not an engraving bit, router, cutting torch, laser, ...?'[32] To this list we can add stereography,

holography, various electronic 3D-display technologies under development, and some of the new, rapid prototyping technologies such as stereolithography, by which three-dimensional gestures can, in principle, be made fully concrete.

Applying ideas from other domains

Given the pace of contemporary scientific research and development, and the diffusion of scientific ideas into the public domain, it is not surprising that some of those ideas have been co-opted in the service of art. The natural sciences, in particular, provide inspiration for a growing number of visual artists. Phenomena of self-organization, for example, which are of interest to chemists studying the conformation of large molecules, and to biologists studying the flocking and schooling behaviours of animals, have been modelled computationally and applied in computer graphics.[30] Self-organizing systems suggest that hierarchical, 'top-down' planning may not be the only way of producing interesting or complex pictorial structure, since they rely only on simple, localized interactions of elements. Such a potentially novel approach to picture making gives artists food for thought:

> What are the aesthetic and experiential possibilities for dynamic compositions whose elements have an understanding of themselves and their relationship to the other elements? For example, what if the composition was homeostatic, constantly trying to maintain equilibrium regardless of external stimulus or if each element knew its visual properties and how to change them based on the current and previous data input into the system[?] [29].

Even if a drawing system is based on some natural system, there is no obligation to obey natural laws, as Stephen Wolfram (creator of the Mathematica program) has noted:

> A computer program, like a natural system, operates according to definite rules. And if we could capture those rules we should be able to make programs that do the kinds of things nature does. But in fact we can do vastly more. For nature must follow the laws of our particular universe. Yet programs can follow whatever laws we choose. So we can in effect make an infinite collection of possible universes, not just our particular universe [39].

Thus, for example, when evolutionary ideas are applied to the making of art, the picture data structures rarely bear any resemblance to real genes, mutation rates are unfeasibly fast, and 'aesthetic selection' replaces natural selection as the driving force. These are the principles underlying Ellie Baker and Margo Seltzer's[6] evolutionary drawing system, which 'mates or mutates drawings selected by the user to create a new generation of drawings' (see Figure 6). Such drawings are not planned or preconceived, in the usual sense; only the initial data, and the algorithms and rules by which they are made. As Karl Sims, creator of some of the most strikingly original evolutionary graphics software, has said: 'A Darwinian process can create mysterious things without needing anyone to understand them ...'[11].

This way of originating an image or structure (which is impracticable without the computer), raises an interesting question: if, simply by making repeated choices from sets of alternatives, a user is able to discover something quite new, perhaps surprising even to the designer(s) and programmer(s) of the system, can his/her actions be considered creative? After all, we might argue that all drawing is ultimately a matter of

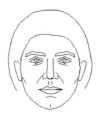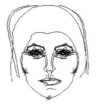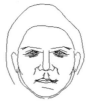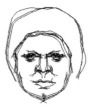

Figure 6 Evolving Line Drawings. The average face (left) and three of its descendants.
Ellie Baker and Margo Seltzer, 1994.

making choices from an array of possibilities. Perhaps the crucial difference is that in conventional modes of drawing we usually have greater freedom to *define* the space of possibilities, to decide for ourselves what kinds of knowledge and constraints to apply to the situation. (See Boden[7] for a fascinating discussion of these, and related, issues.)

Some of the most influential concepts in computer-based drawing have come from linguistics. Natural language has long provided a metaphor for talking about visual art, but it was only with the advent of computers that workable implementations of so-called 'shape grammars', comparable to natural language grammars in their ability to generate diverse, rule-governed structures, became possible. James Gips, one of the originators of shape grammars, identified four classes of programs: a shape grammar *interpreter* 'generates shapes in the language'; a *parsing* program 'determines if the shape is in the language generated by the grammar and, if so, gives the sequence of rules that produces the shape'; an *inference* program attempts to infer a grammar from a given set of shapes; and a computer-aided design program can 'help the user design shape grammars'[12]. Interpreters have been used for product design and architectural design, and for the generation of 'original' drawings in the styles of particular artists, using rules derived from detailed analyses of selected works [e.g. 17, 15]. Shape grammars may be highly productive, which is to say that they may be capable of generating huge numbers of configurations, and a significant problem in the design of interactive systems is how best to support the user's selection decisions. Essentially, this is the conceptual space navigation problem referred to earlier.

New depiction techniques

Non-photorealistic rendering (NPR) has been an area of active research and development for a number of years and is concerned with creating alternatives to photographic modes of depiction, which predominate in computer art and graphics. In its least interesting manifestations, NPR enables users of image-processing or painting programs to apply pseudo-painterly styles to photographs. It becomes more interesting when it attempts to isolate and process particular features of an image, as in some of the 'pen and ink' rendering software [e.g. 38] and more interesting still when lines, marks or shapes are applied directly to a 3D model, where they can be configured so as to convey information about depth, surface orientation and structure. For example, Peter Lee's interactive, linear contouring program depicts 3D models (some of them digitized from real objects) by means of surface contour lines which may be monochromatic or CMYK (cyan, magenta, yellow and black, facilitating four-colour output and printing) [19]. Lee's development cycle of drawing analysis, design, coding, testing and modification exemplifies the process by which drawing expertise is made

explicit and embodied in software, and those familiar with the artist's work are struck by the continuity between his earlier (handmade) paintings and screenprints, and the program's output.

NPR is not only of interest to artists. Medical illustrators, for example, know that the human eye is far better at extracting meaningful structure than any camera, and a good deal of research effort has been devoted to developing comparable capabilities in computers. Researchers in technical computer graphics are learning how to use line to improve the comprehensibility of digital representations [e.g. 31]. Hamel and Strothotte [13] have devised a way of capturing elements of individual drawing 'style' so that they can be automatically applied to the rendering of any 3D model.

Philip Rawson [28] showed that marks and combinations of marks may serve a multiplicity of functions within a picture, including representational, expressive and decorative functions. NPR researchers, in their efforts to understand the structures and functions of drawn marks – how to create and configure them so as to convey the information they need to convey – suffer no restrictions on the kinds of marks they can use, since marks and their attributes are individually modifiable and endlessly permutable. To the extent that NPR programs 'know' when and where to apply marks in particular kinds of drawing situations, they might be considered to embody particular 'mark-making strategies'; and strategy, of course, is an important component of drawing knowledge.

Remote collaboration

Tom Brinck described collaborative drawing as follows:

> Two or more people conversing with the use of drawings or working together to create a drawn artifact. Conversing and creating an artifact are very different types of tasks, though there exists a continuum between them, such that it's difficult to produce a successful collaborative drawing tool that doesn't support both to some extent [8].

Different kinds of collaborative drawing programs can be found on the web. Few of them support conversation, and in many cases, collaboration is strictly sequential, a matter of loading an existing drawing from an archive, modifying it, then saving it to the archive for other users to modify later. By contrast, Randy Moss's Shared Drawing website enables truly synchronous collaboration. Each partner is represented on the interface (Figure 7) by an animated iconic proxy that 'draws along with you' and successive drawings, created by any number of online artists in different locations, are saved to create what Moss describes as an 'ever evolving hand-drawn film' [27]. Vectorama [20], described by its originators as a 'multiuser playground', allows up to ten people at a time to create a picture together, but using predefined elements (vector graphics of people, objects, backgrounds, etc. selected from libraries) which may be individually scaled, rotated and coloured. Vectorama users may also communicate with one another via a text messaging system.

The experience of using these kinds of programs can be quite engaging (and may produce interesting artworks) though hardly comparable to real-world situations where two or more people use a whiteboard, or a single sheet of paper, on which to record and develop ideas together. In the real world, a shared drawing can promote a rich dialogue in which the activities of drawing and annotating are augmented by

Figure 7 Interface of the Shared Drawing website. Randy Moss, 2001.

speech, facial expression and body language. It is a way of working common in design conceptualization, but until recently it has required participants to be in the same room.

Clearboard, developed by Kobayashi and Ishii [34], comprises two networked terminals and a video connection supporting concurrent, 'face-to-face interaction' between two collaborators. The drawing surfaces are large, half-silvered displays, onto each of which real-time pictures transmitted from the other location are back projected. The effect is of a large pane of glass through which the other person can be seen drawing on the reverse side. The system supports 'gaze awareness' – 'collisions' are avoided, because each collaborator can see which part of the drawing the other is attending to. In addition, a videoconferencing function enables them to speak to each other.

As *Clearboard* and similar systems become more widely available, new drawing practices could emerge. The results are difficult to predict:

> *collaboration and communication produce surprising results. ... If a fundamental reciprocity can be maintained – a balance of getting and giving – what emerges is undoubtedly unforeseen and potentially exciting* [9].

Understanding real-world drawing

Harold Cohen's now legendary program (or rather, family of programs), called *Aaron*[24], has grown during the last three decades into probably the most knowledgeable of knowledge-based, fine art drawing programs. It operates according to a complex hierarchy of rules which enable it to decide what actions to take in a given drawing situation. At the highest level, overall organizational decisions are made; at the lowest level, decisions about the forms of individual lines and shapes. The first versions of *Aaron* drew abstract shapes, later versions drew figures: all were capable of generating innumerable, new compositions.

Aaron possesses two main types of stored knowledge, which interact with each other: specific knowledge about how to draw certain classes of objects (rocks, plants, human figures, etc.); and general knowledge of representation, e.g., how to depict solidity or occlusion. This knowledge derives from Cohen's long experience of drawing practice, and it is no surprise that the program possesses a distinctive 'style'. An unusual feature of the program's operation is feedback, which is to say that in making decisions it takes account of the current 'state' of the drawing. This, of course, is a crucial aspect of most human drawing activity. (A version of *Aaron* for desktop PC's has recently been developed in conjunction with Kurzweil CyberArt Technologies[16].)

One of Cohen's motivations was to arrive at a better understanding of drawing processes by 'teaching' a computer how to draw. Indeed, apart from an increase in productivity, it is difficult to see what other motivation there could have been, since Cohen could probably have made better drawings – and perhaps more varied and adventurous drawings – than *Aaron* ever has. To the extent that *Aaron* models thinking processes as well as motor processes, we might say that it embodies a 'cognitive model' of drawing, albeit one intimately bound up with Cohen's own ideas and restricted to drawing from memory (since there is no 'visual' input).

Computers and people have very different strengths and weaknesses. Unlike us, computers can perform masses of complicated, symbolic manipulations quickly and flawlessly. Computer vision systems can pick up (if not understand) every detail of a scene in an instant, whereas human vision appears to be highly selective: we scan the scene, fixating on salient parts and extracting from the retinal stimulus only the minimum information needed for the task at hand. In memory retrieval, we outperform computers, being able to retrieve salient information almost instantaneously from a practically unlimited-capacity long-term memory (LTM); this accounts in part for our astonishing powers of recognition, far superior to those of any computer. We are comparitively bad at making absolute judgements of shape, size, colour and so on, but good at making relative judgments. And although we take time to learn new motor skills, we are far better than any robot at adapting those skills to new situations.

Given these, and other, fundamental differences, it seems unlikely that algorithms designed for computer implementation are anything like our own 'algorithms' for doing the same things: far more likely that human drawing expertise develops in ways which exploit our inherent strengths. Any model of drawing, if it is to be plausible, must be consistent with current (scientific) understanding of human vision, cognition and action. Whilst we should not underestimate the difficulty of the

task, we can take encouragement from recent advances in the modelling of human performance. Byrne and Anderson's implementation of their ACT-R/PM theory, for example, demonstrates the feasibility of modelling real-world perceptual-motor tasks[3]. It uses production systems, which model the execution of hierarchical plans by means of rules, or 'productions', each of which triggers a particular action when a particular set of conditions is met. A production may be regarded as 'a basic step of cognition'[4]. Given a suitable set of them, complex sequences of actions can be performed.

As we have seen, one way of obtaining insights into the mental processes associated with drawing is by introspection, but it is not at all clear how reliable introspection is as a method of knowledge elicitation. Indeed, cognitive scientists agree that there are some aspects of cognition which are forever impenetrable to introspection. Future research in this field might well heed the experience of knowledge engineers: those whose job it is to elicit specialist knowledge from experts for incorporation into (mainly scientific or commercial) 'expert systems'.

Accumulating knowledge

If we consider graphical computing in terms of data and processes, then it is clear that much graphical interaction is concerned with selecting subsets of the image data and selecting processes to be applied to the data. For example, in a photo-manipulation program, any region of interest can be modified by using a shape selection tool to isolate it, then searching the menu hierarchy for a processing option, e.g., contrast enhancement or halftoning. Similarly, in a 3D modelling program, objects or object parts may be selected and operations applied to them: for example, Boolean operations such as intersection can be applied to pairs of objects. Data (hence objects and images) may be transformed, restructured, combined or abstracted in many other ways, and the kinds of operations possible will depend to a large extent on the kinds of data structures used (lists, arrays, trees, graphs, etc.).

First, there must be some data to work with, and in most cases this will be derived from body movements, usually via a mouse, stylus or similar input device. Streams of coordinates constituting movement 'paths' are turned into patterns of pixel-mapped 'marks', geometric shapes or virtual solids by some (pre-selected) process. Data can also be acquired from other sources, such as image files or other kinds of files (e.g., text or music, though the data may need to be restructured to make visual sense of it) or from some kind of generator within the program itself, e.g. a (parameterizable) procedure for producing spirals, or a shape grammar (whose lexicon and syntax may be user-definable).

In summary, the points at which the artist/user can exert control are: in the selection of data and the selection of processes to act on the data; in the creation of data and (to some extent) in the configuration of processes. The computer, in turn, runs the processes to produce new, or changed, images.

The term 'knowledge' is difficult to define, and even in computer science circles the precise relation between data, information and knowledge remains a source of confusion and disagreement, as Aamodt and Nygård [1] have noted. However, if we concur with them that knowledge is something 'incorporated in an agent's reasoning resources', something which 'is brought to bear *within the decision process* itself', then such attributes as expertise, experience and intuition all fall within its scope. In

Computers & Art Second Edition Why use computers to make drawings? George Whale

30

computer-mediated drawing, the user's knowledge (which must include some knowledge of the software and its functions as well as knowledge of drawing) is brought to bear during interaction. But it is clear that *algorithms* can also embody expert knowledge of drawing, including: knowledge of 'drawing systems'[37] such as perspective and orthogonal projection; knowledge of what might be termed 'mark-making systems', ways of configuring marks so as to convey representational, or other, information; and, as we saw in *Aaron*, knowledge of 'strategy', by which appropriate and timely decisions are made concerning the form and disposition of elements at each stage in the drawing's development. (As yet few, if any, drawing programs are capable of gathering or generating *their own* knowledge.)

The crucial question in relation to software-embedded knowledge is: Where does it come from? For it could be argued that a drawing is an artist's own only to the extent that he/she has applied his/her own knowledge in the making of it, whether through interaction or programming. James Elkins has argued that computer graphics tools incorporate a number of pictorial conventions:

> *Computer graphics is inextricably linked to the history of Western picture-making. The expressive meanings, artistic strategies and conventions of that genre continue to underwrite developments in computer graphics, especially when they are not acknowledged* [10].

To be fair, they often are acknowledged: in NPR research papers, for example, we find numerous references to Impressionist painting, Renaissance and Baroque engraving and the like. Nevertheless Elkins' point is a valid one, and these influences can be distracting. Clearly, the artist-programmer (or artist plus programmer) enjoys an advantage over the artist-user in being able to *create* the data structures and algorithms, to define and explore 'conceptual spaces' of his/her own. But an equally valuable consequence of this way of working is that aspects of drawing knowledge are made explicit:

> When you start working out a procedure for generating a new form you are forced to think in elementary ways about the very nature of the drawing process. … you learn a lot about how to draw by writing **drawing code** and you learn a lot about how to write **drawing code by drawing** [35].

In making the work, the artist also describes his/her method, and the description is in a form that can be studied and analyzed, adapted or developed by others.

The future

Why use computers to make drawings? In addressing this question it has not been my intention to persuade anybody that computers *should* be used to make drawings because, in the right hands, traditional drawing media remain as flexible and as eloquent as ever. But in showing some of the ways that computers *can* be used, both to extend the scope of drawing, and to help us understand the nature of drawing processes a little better, I hope to have dispelled some doubts.

The computer is useful only to the extent that it supports the drawing enterprise, and it must be acknowledged that there are situations in which its adoption may confer little, if any, practical benefit, though it may still be an invaluable research tool. One such situation is the life studio. However, in design fields at least, it seems likely that

computer-mediated drawing will become increasingly important. Today's passive 'drawing environments' could eventually be displaced by 'active drawing support systems' able to provide users with valuable, context-sensitive information; to indicate appropriate strategies, media and techniques; to identify errors and suggest alternatives; or perhaps even to evaluate drawings according to functional or aesthetic criteria. The key to such developments will be the embodiment of (generic and domain specific) knowledge in software, and we may one day see systems able not only to apply knowledge but also to learn, so that knowledge gleaned from previous drawing situations can be adapted and applied in new situations. Thus, the promotion of the computer from tool, to assistant, to fully-fledged collaborator would be complete.

At present, relatively few artists design or write programs, but as more intuitive, visually-oriented programming languages become available this could change, enabling more of them to contribute to the growing body of explicit drawing knowledge. This knowledge, in turn, could facilitate the development of more 'intelligent' support systems and, more importantly, might bring us closer to an understanding of what it is that makes one artist different from another.

We can be certain of one thing, however, which is that true originality in drawing – the 'X' factor that separates the very best artists from the rest of us, will remain the province of the human imagination – at least, for the time being.

References

1 Aamodt, A. & Nygård, M. (1995) Different roles and mutual dependencies of data, information, and knowledge: an AI perspective on their integration. *Data and Knowledge Engineering* 16, pp 191-222.

2 ACG (the Aesthetics and Computation Group). (2002) <http://acg.media.mit.edu> Accessed 22 Jan. 2002.

3 Anderson, J. R. & Lebiere, C. (1998) *The Atomic Components of Thought*. Mahwah, NJ: Lawrence Erlbaum Associates, pp 167-200

4 ibid p10

5 Annunziato, M., & Pierucci, P. (2002) *Relazioni Emergenti*. <http://www.plancton.com/entry.htm> Accessed 31 Jan. 2002.

6 Baker, E. & Seltzer, M. (1994) Evolving Line Drawings. *Proc. Graphics Interface '94*, Banff, Canada, May 1994, pp 91-100.

7 Boden, M. A. (1990) *The Creative Mind: Myths and Mechanisms*. London: Weidenfeld and Nicholson.

8 Brinck, T. (2002) *Usability Glossary: collaborative drawing*. <http://www.usabilityfirst.com/glossary/term_261.txl> Accessed 22 Jan. 2002.

9 Deck, A. (2002) *Icontext*. <http://www.artcontext.com/icontext/html/about.html> Accessed 22 Jan. 2002.

10 Elkins, J. (1994) Art History and the Criticism of Computer-Generated Images. *Leonardo*, 27, 4, pp 335-342.

11 Frauenfelder, M. (1998) Do-It-Yourself Darwin. *Wired*, 6, 10.

12 Gips, J. (1999) Computer Implementation of Shape Grammars. Invited paper, *Workshop on Shape Computation*, MIT.

13 Hamel, J. & Strothotte, T. (1999) Capturing and Re-Using Rendition Styles for Non-Photorealistic Rendering. Proc. *EuroGraphics '99*, Oxford, pp 173-182.

14 ICA New Media Centre. (2002) <http://www.newmediacentre.com> Accessed 22 Jan. 2002.

15 Kirsch, J. L. & Kirsch, R. A. (1988) The Anatomy of Painting Style: Description with Computer Rules. *Leonardo*, 21, 4, pp 437-444.

16 Kurzweil CyberArt Technologies. (2002) <www.kurzweilcyberart.com> Accessed 22 Jan. 2002.

17 Lauzzana, R. G. & Pocock-Williams, L. (1988) A Rule System for Analysis in the Visual Arts. *Leonardo*, 21, 4, pp 445-452.

18 Lawrence, J. D. (1972) *A Catalog of Special Plane Curves*. New York: Dover Publications.

19 Lee, P. (1997) Linear colour contouring for fine art printmaking. *Visual Proc. Siggraph*, Los Angeles, p 185.

Why use computers to make drawings? George Whale

31

Computers & Art Second Edition

20 Lehni, J., Lehni, U. & Koch, R. (2002) *Vectorama.org: A Multiuser Playground.* <www.vectorama.org> Accessed 22 Jan. 2002.

21 Levin, G. (2002) *An Audiovisual Environment Suite.*<http://acg.media.mit.edu/people/golan/aves> Accessed 22 Jan. 2002.

22 Lia. (2002) *re-move.* <http://www.re-move.org> Accessed 22 Jan. 2002.

23 Louvet, J-P. (2002) *The discovery of fractals.* <http://fractals.iuta.u-bordeaux.fr/jpl/history.html> Accessed 22 Jan. 2002.

24 McCorduck, P. (1991) *Aaron's Code: Meta-Art, Artificial Intelligence and the Work of Harold Cohen.* New York: W. H. Freeman & Company.

25 McCullough, M. (1996) *Abstracting Craft: The Practiced Digital Hand.* Cambridge, MA: MIT Press, p 78

26 ibid p 80

27 Moss, R. (2002) *Shared Drawing.* <http://www.shareddrawing.com/index.html> Accessed 22 Jan. 2002.

28 Rawson, P. (1969) *Drawing: The Appreciation of the arts.* London, New York: Oxford University Press.

29 Reas, C. (2002) *Relational Constructs.* <http://acg.media.mit.edu/people/creas/relationalconstructs> Accessed 22 Jan. 2002.

30 Reynolds, C. (2002) *Boids: Background and Update.* <http://www.red3d.com/cwr/boids> Accessed 31 Jan. 2002.

31 Saito, T. & Takahashi, T. (1990) Comprehensible Rendering of 3-D Shapes. *Computer Graphics* (Proc. Siggraph), 24, 4, pp 197-206.

32 Shapiro, B. (2002) *The Art of Motion Control: Process overview.* <http://www.taomc.com/process_overview.htm> Accessed 22 Jan. 2002.

33 Snibbe, S. (2002) *Dynamic Systems Series.* <http://www.snibbe.com/scott> Accessed 22 Jan. 2002.

34 Stocker, G. & Schöpf, C. (eds.) (2001) *Ars Electronica 2001. Takeover: who's doing the art of tomorrow.* Vienna, New York: Springer.

35 Verostko, R. (1994) *Algorithms and the Artist.* Helsinki: Fourth International Symposium on Electronic Art.

36 Whealton, S. (2002) *Steve Whealton: Algorithmic Visual Art.*<http://www.washingtonart.net/whealton/s.html> Accessed 31 Jan. 2002.

37 Willats, J. (1997) *Art and Representation: New Principles in the Analysis of Pictures.* Princeton, NJ: Princeton University Press.

38 Winkenbach, G. & Salesin, D. H. (1994) Computer-Generated Pen-and-Ink Illustration. *Computer Graphics* (Proc. Siggraph), 28, 4, pp 91-108.

39 Wolfram, S. (2002) *Graphica Defined.* <http://www.graphica.com/defined> Accessed 22 Jan. 2002.

40 Wood, J., & Pryor, H. (2002) *GPS Drawing: the Global Positioning System drawing project.*<http://www.gpsdrawing.com> Accessed 22 Jan. 2002.

Ed Burton (29) grew up playing with computer programming, with his first software title being published at the age of 17. Following a degree in Architecture at the University of Liverpool, Ed undertook the MA in Digital Arts at the Middlesex University Centre for Electronic Arts. His MA thesis on computer models of young childrens' drawing behaviour was subsequently developed into an ongoing PhD research project into artificial intelligence, dynamical systems and developmental psychology. After three years of research and teaching at the Centre for Electronic Arts, Ed joined Soda Creative Technologies Ltd (http://soda.co.uk) as Research and Development Director in 1998 and was the original author of the Java toy sodaconstructor (http://sodaplay.com), which subsequently received the BAFTA interactive entertainment award for Interactive Arts in 2001.

Ed Burton

Representing representation: artificial intelligence and drawing

1. Introduction

Any field of study requires a representational medium, a surface on which ideas can be recorded. This is not only vital for communication to others, the act of perceiving one's own ideas is essential to their evaluation and further development.

> 'Hence, one can learn by turning one's representations into stimuli - i.e. by externalizing them.'[1]

Academically this typically involves writing or drawing schematic diagrams to represent ideas. These methods involve passive recording media. Computer programming is different: it is an active medium, having the unique ability to dynamically execute the processes and decisions described by a theoretical model.

This chapter describes the creation of two computer programs, AARON[2] and my own work, Rose[3]). Both programs create images by representing ideas about certain aspects of human drawing behaviour. They use computer programming as an active medium to explore a region of common ground that existed between Artificial Intelligence (AI) and drawing theory. AI has since moved on to concentrate on adaptive dynamic systems and it is proposed that drawing theory could gain useful insights about the mechanisms of development in drawing by reestablishing links with this more contemporary AI.

2.1. AARON: background

AARON is a computer program written by Harold Cohen. Cohen started his career as a painter. Much of his painting was concerned with the way in which symbols could evoke significance or meaning in the viewer. In 1968 he left Britain and his career as a painter for California at a point when he had a 'reputation as a painter equal to that of any British artist of his generation', according to a former keeper of modern painting at the Tate Gallery.

It was in California that Cohen first encountered computer programing when a young graduate of music and computer science, Jeff Raskin (who later headed a team involved in designing the Macintosh home computer), taught him to program. Cohen immersed himself in this task as an intellectual challenge, at this stage not anticipating a link with his painting. It was not until six months later that he recognised a common denominator within his work as a painter and his hobby of computer programming. Both seemed to be concerned with attaching meaning to symbols. Cohen united the two fields by asking himself the question, 'what would a computer need to know in order to make images?'

In answer to this question Cohen has been developing AARON since 1972. 'Their' work has been exhibited at both science museums and art galleries across the world in the past two decades (and can be viewed at sites:

> http://www.scinetphotos.com/aaron.html
> http://crca-www.ucsd.edu/95_96/FACULTY/aaron.html

on the World Wide Web.) AARON's task is to create images. Not to copy pictures or transform a given input, but to continuously generate new images. AARON controls a robotic drawing machine, which until recently produced unsteady monochromatic line drawings which Cohen often chose to colour by hand. The latest incarnation of AARON also mixes colours and paints the drawings automatically.

Cohen considers not only that the pictures which AARON produces are art, but also that AARON itself is a work of art, saying that 'my behaviour in programming a machine to simulate human art-making behaviour is, in itself, primarily art-making behaviour,').[4] This level of indirection led Pamela McCorduck to christen Cohen as the first 'meta-artist' for 'this creation of a piece of art that itself makes art.'[5]

2.2. AARON: Evocation

An expedition during 1973 to see a group of ancient petroglyphs in the desert of northern California affected Cohen profoundly. He was struck by the fact that these rock pictures seemed evocative to him even though he had no knowledge of who created them or why. This led him to question '[w]hat are the minimum conditions under which a set of marks functions as an image?'.[6] AARON's first phase was an attempt to capture this evocative power.

Cohen was aware that drawing is not a simple process of copying what is in front of us. He saw it as a more complicated process of regenerating what we know about what is in front of us. Before approaching the problem of declarative (what) 'knowledge', Cohen had to instil in AARON procedural (how) 'knowledge'. In other words, Cohen was concerned with the question of how to draw without having an explicit intent of what to draw.

Cohen first publicly raised the possibility of a non-human autonomous art-maker in his provocative essay 'Parallel to Perception: Some Notes on the Problem of Machine-Generated Art'. About such a device he writes:

> '...that some of the machine's functions will need to parallel, at least in a primitive way, some aspects of the human perceptual process.' [7]

In AARON, Cohen forged the ability to construct what he called 'cognitive primitives', simple line patterns that he identified as being universal to human representation. The second main procedural strategy used by AARON affects the way that these forms are placed in the composition. This is controlled by what Cohen describes as 'behavioural functions' which he describes in the introduction to Parallel to Perception:

> 'Human art-making behaviour is characterised by the artist's awareness of the work in progress, and programs to model such behaviour will need to exhibit a similar awareness. Thus, 'behavioural functions' are defined here as functions which require feedback from the results of their actions as a determinant to their subsequent actions'. [8] [stress added]

Feedback from the picture being drawn was AARON's equivalent to human perception. Rather than simply taking an external input and transforming it to the output, AARON continuously sampled its output when making decisions.

> 'The drawing will be the real world for the computer, just as it is a part of the real world for the artist.' [9]

Cohen saw the level of feedback in a computer system as defining whether the computer was being used merely as a tool or as an autonomous art-maker. When the computer is used in such a way that feedback occurs only through the intervention of the operator in a manual process of review and modification then the computer is essentially no different from any other tool an artist might use, no matter how complex the operations it performs. If, however, the computer is made capable of modifying future actions on the grounds of its previous actions then Cohen describes the system as being autonomous.

By the end of the 70s AARON was using the 'behavioural functions' to create complex groupings of 'cognitive primitives'. AARON had preferences of pictorial composition and was developing the illusion of depth through occlusion. An exhibition at the San Francisco Museum of Modern art in 1979 inspired artist and writer Andrew Forge to write of AARON's drawings thus:

> 'What then can we do with this self contained world in front of us, a world charged, it seems, with life, with puffy clouds, beaming suns, wigwams, beetles, stones with eyes, flowers, a world irradiated with playfulness and chirpy good humour.' [Quoted in 1]

AARON was poised on the brink of the next phase when Cohen was ready to ask himself the question 'can it draw something I recognise?'

2.3. AARON: Representation

It was Cohen's interest in children's drawings that triggered AARON's development from abstract evocation towards explicit representation. He focused on the moment

when the child starts outlining his or her scribbles. The act of making an enclosing form seemed to be the point at which the child realises that the drawing can actually stand for something. Inspired by this act, Cohen modified AARON's drawing rules so that it created closed forms by drawing an outline around an 'imagined' core.

The outlining process gave AARON the flexibility needed for representation. However, in addition to this procedural knowledg, AARON would also need some kind of internal declarative knowledge about the world if it was going to draw recognisable things. Cohen describes the problem he faced:

> 'the human cognitive system not only develops an externalising mode, it also has to take stuff in. It has to know things about the world. We do, in fact, look at the outside world. We do, in fact, know about things in the outside world. And yet I think that when we make drawings we have a model in front of us and make representations of it - it's nevertheless the internal model we're representing, not the external world.' [11]

In people knowledge is acquired cumulatively. People's knowledge or internal models of the world must eventually refer back to their experience. AARON, not having a body with senses, has no direct experience. However, it is also possible to acquire knowledge indirectly through other people and this is how AARON receives information about the world. AARON is given knowledge by Cohen that refers to his experience.

AARON's knowledge of what to draw has to be encoded in an appropriate structure by Cohen. In the case of, for example, a human figure, it consists of several different types of information.

First AARON must know what parts the body consists of and what their relative sizes are. It has to know how these parts are put together and what their range of possible movement is. AARON must also have a quasi-physical sense of how to position the parts, based on rules of posture and balance. Lastly, AARON must know how people can relate to other things - they can for example stand on top of rocks but not usually on top of other people.

Making choices by a tree-like path through this body of knowledge, AARON still does not achieve a representation of the figure. All that is present at this stage is a kind of internal structural skeleton or 'concept' of what the person is like. It is not until this structural core is passed to AARON's procedural knowledge of how to draw that it is embodied. That is, it is translated into a representation consisting of closed forms outlined about the 'imaginary' core and taking into account factors such as visual depth and occlusion.

Initially the shapes with which AARON constructed its world of figures and foliage were two-dimensional. They where given the illusion of depth by their arrangement and the use of occlusion. By 1990 Cohen had extended AARON's knowledge to include three-dimensional figures and plants which can be drawn as if seen from any viewpoint.

AARON's latest stride forward has been the inclusion of colour. Whereas AARON once wielded only a black ink pen, it can now choose colours, mix paints and clean brushes in order to paint large canvases. AARON the painter made its public debut at the Boston Computer Museum in April 1995 where it executed a new painting for each day of the exhibition.

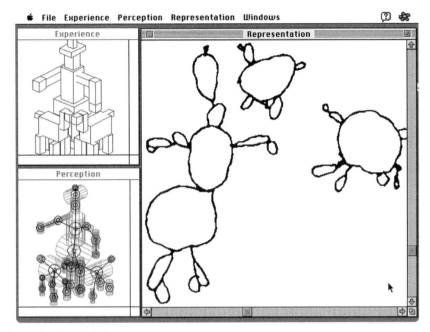

Figure 1 Rose's user interface

The rules that comprise AARON give us an objective and rigorous statement of Cohen's theory of art-making and thus an unprecedented degree of insight into its structure.[12] Cohen has approached image-making in the opposite direction to photo-realism (the most dominant approach to computer-graphic rendering). In human terms, photo-realism works from the outside world inwards to the image formed on the surface of the retina. AARON starts from behind the retina in the mind's internal world and works outwards to the image formed by the hands.

3.1. ROSE: Introduction

Rose (Representation Of Spatial Experience) is a representation of personal ideas about children's drawing. Rose was written in part out of a simple love of the innocence and verve of children's drawing and also a desire to understand some of the underlying cognitive processes. Rose is a computer application that takes three-dimensional computer models as its input and produces childlike two-dimensional drawings as its output. Rose is a metaphor for the human processes of experience perception and representation. As such, when psychological terms like perception are applied to Rose they are not used literally but metaphorically.

Rose has been designed as an interactive application. (See Fig 1) Thus the maximum scope for investigation and experimentation of Rose's characteristics is afforded.

3.2. How does ROSE draw?

It is usually assumed that drawing should consist of projecting the image of a scene viewed from a particular point in space. Children's drawings are often seen as distortions from this assumed goal. Rose does not subscribe to this assumption. Klee eloquently summarises the philosophy behind Rose's approach to drawing: 'Art does not reproduce the visible but makes visible'. [13]

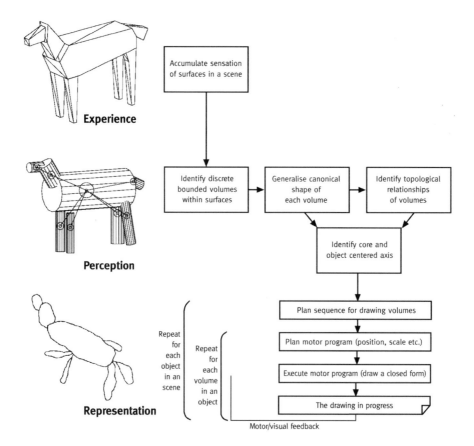

Figure 2 Schematic diagram of Rose's drawing process

Instead of projecting an image or shadow of a virtual world observed from a view point (the approach of the vast majority of computer graphic rendering), Rose actively constructs an equivalent self-contained world within the two-dimensional graphic medium from a vocabulary of forms that are translations of its 'perception' of a virtual world.

Rose uses primarily three different domains of spatial awareness (See Fig 2). Experience is Rose's equivalent to contact with the outside world. Perception is Rose's interpretation of the experience combining generalised shape and topological relationships of volumes. Representation is the drawing rendered from Rose's perception.

3.2.1. Experience

Our experience of a scene is multi-sensory and accumulated over time. For these reasons no single sense has been implemented. The senses most pertinent to representation are sight and touch. These experience only the surface properties of objects. Thus it is assumed that over time we can access the three-dimensional shape of all surfaces in a scene independently of a fixed view point. For this reason Rose's 'sensory' input is in the form of three-dimensional computer models of surfaces. These

models are not 'viewed' from a single point. Instead, Rose's experience process is more akin to 'feeling' all the surfaces of the model so that Rose senses its overall shape.

3.2.2. Perception

Rose's perception of the experience results in an output similar to that of Marr's and Nishihara's [14] final 3-D stage in their computational model of vision. Marr and Nishihara describe vision as 'a process that produces from images of the external world a description that is useful to the viewer and not cluttered by irrelevant information'.

Rose's perceptual process identifies the discreet bounded volumes within a scene from the surfaces of the experience. The detailed shape of each volume is generalised, recording simply the cylinder that matches its shape most closely. Finally the generalised volumes are placed within a structural skeleton that records the topological relationship of proximity or separation between volumes.

3.2.3. Representation

The drawing is created dynamically using a virtual pen. Rose endeavours to construct in the drawing two-dimensional equivalents to the perceived 3-D model by translating the perception into a simple graphic vocabulary. This vocabulary equates each volume with a single closed form whose size and approximate shape (round, elliptical or linear) correspond to the volume's perceived generalised shape. The form is placed freely in empty space or accreted to an already existing form according to its perceived topological relationships with other already rendered volumes. Rose receives continuous feedback from the drawing in progress. Thus a form is distorted if the pen strays too close to another form or the edge of the page. A form is completed when Rose detects that it has created a line crossing.

As there is no viewpoint, objects are placed arbitrarily on the page; furthermore the pen is disturbed to simulate poor motor control. These random influences make every drawing unique.

3.3. Looking at ROSE

Rose's output has been prolific. Figure3 shows a sequence of drawings produced during Rose's development. They chart a progression from uncontrolled scribbling, through abstract pattern-making to representation. In this way Rose's development parallels that of a child between the ages of 18 months and five years (Rose, however, was developed in five months not five years). Unlike a child, Rose did not learn how to draw; Rose was programmed. This does not mean that Rose's drawings have not been surprising and unpredictable. The complexity and undeterministic nature of the processes modelled means that it is impossible fully to anticipate their results. This is one reason why implementation in an active medium is so instructive. There follows three examples of how Rose has reproduced some commonly observed characteristics peculiar to children's drawing:

Figures 4 and 5 show Rose's input experience and output drawing of a human figure. This is compared with figure 6, a drawing by a child aged two years and eleven months. Notice that in both drawings limbs are drawn attached perpendicularly to the centre of the torsos. Arnheim[15] observes that projective child psychologists have erroneously identified the frequent gesture of such outstretched arms as an indication of despair. Rose, like the young child, will render limbs in this fashion

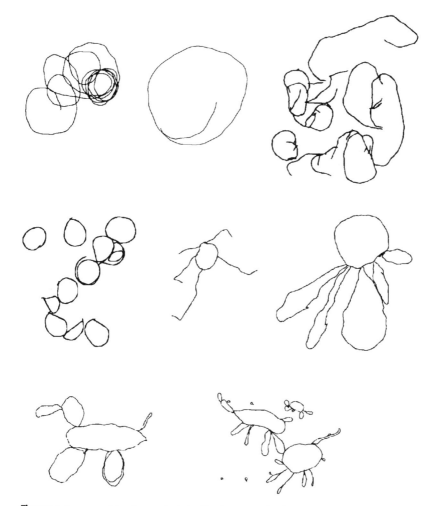

Figure 3 Sequence of drawings made during Rose's program development

regardless of their orientation in the experience model. This is a consequence of the output process as Rose certainly has no algorithm for emotional abandonment. At this stage the process of translation generalises all possible orientations of limbs as being equivalent. The angles are undifferentiated, being represented by the simplest angle offering the greatest contrast between elements, the right angle. Thus Rose illustrates the plausibility of Arnheim's assertion that this is the process that operates in children's drawing.

Figures 7 and 8 show Rose's experience and representation of a scene containing a cow and a man holding a bucket. Notice that the man has been drawn as if seen from the front and the cow as if from the side, despite the fact that they face in different directions in the experience model. This demonstrates a preference that Rose shares with young children - always to portray the canonical structure of an object. Rather than choosing an external view point, Rose identifies the axis of each object that

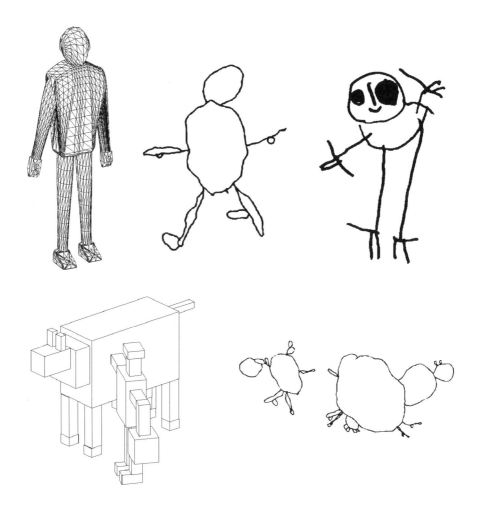

Figure 4 (top left) Rose's experience of a person
Figure 5 (top centre) Rose's representation
Figure 6 (top right) A child's representation
Figure 7 (bottom left) Rose's experience of a cow and a man holding a bucket
Figure 8 (bottom right) Rose's representation

differentiates its components most informatively. Thus Rose demonstrates that an external view point is not necessary to construct recognisable representations.

Figure 9 shows a drawing of a person inside a house with 'food' in the body. Such drawings are frequently produced by children and are often described as 'X-Ray' or 'section' drawings. Rose is not producing an 'X-Ray' or a 'section'. The drawing is a two-dimensional equivalent of the three-dimensional experience. The containment of one form within another on the page is the simplest and most obvious two-dimensional equivalent to three-dimensional enclosure. Rose is illustrative of an interpretation of children's drawing that is simpler than the descriptions of transparency and multiple viewpoints offered by some theorists.

Figure 9 Figure in a house with a tree and chimney

Rose's drawings share many qualities with those of children but they lack many more. This dissatisfaction will drive the further development of the theoretical model. Rose attempts to isolate the salient features of an experience and represent just those generalised qualities. The drawings produced can prove more evocative than projective views of the experience because they are general enough to allow the viewer to invest meaning in them. They are also more directly communicative of the overall structure of an experience because they are uncluttered by the details of the experience model's three-dimensional surfaces.

Rose as a young artist has created drawings that are lively, endearing and faltering like a child's. Rose as a model of representation implies that children's drawing is of an active, interpretive and constructive nature.

4.1. AARON, ROSE, Artificial intelligence and drawing

AARON and Rose are both personal investigations into image-making. However, they exist within a context, that being primarily the study of drawing and Artificial Intelligence (AI). These two fields are briefly described below and their relationship to each other is illustrated by AARON and Rose.

During the latter half of this century there has been a sea change in theories concerning the psychology of drawing and in particular children's drawing. In the first half of this century drawings were studied as static artifacts that were believed to reflect the child's mental images or concepts. It was supposed that the symbolic or linguistic nature of such representational thought caused children's drawings to deviate from visual realism towards 'intellectual realism'.[16] Research of this period focuses on what Freeman[17] calls the 'surface structure' of drawing and largely ignores the complex process of creating a drawing.

During the middle of the century several researchers turned to interpretive perceptual processes to account for the distinctive forms that appear in children's drawings[18]. More recent work has concentrated on the production of drawing, seeing it as an active process involving many decisions affecting the final outcome).[19] Thus the dominant model of drawing has moved from a passive output of images to an active process of interpretation and generation.

In parallel to the changes in ideas about children's drawing, the latter half of this century saw the emergence of the field of AI which uses computer models to represent the ways in which people represent and process information. This is to advance two goals: to make computers more useful and also to understand the principles that make intelligence possible.

AI followed two distinct strands: The 'connectionist' approach was based on some of what was known about the parallel distributed structure of the brain and was used principally to model perceptual processes).[20] The connectionist approach declined with the rise of the 'symbolic' approach which concentrated on logical operations on symbolic representations of knowledge.[21]

Both AI (particularly symbolic AI) and drawing theory came to model human behaviour as information processing. This view of human behaviour is characteristic of the 'cognitive revolution'[22] in psychology brought about by computer metaphors of mental processes such as those made by Miller, Garlanter and Pribram[23] and Newell and Simon.[24]

Information processing models were seen to address the weaknesses of the dominant 'Gestalt' and 'behaviourist' psychologies which Newell and Simon[25], among others, criticised as being insufficient to account for intelligent action, lacking an empirical basis and as being simply too vague. AI and psychology attempted to banish this vagueness by working in collaboration to generate detailed models of behaviour both by analysing people solving problems and by constructing computer programmes to solve similar problems.

There was a useful interaction between AI and drawing theory. For example, two figures that played a central role in the development of symbolic AI, Minsky and Papert[26], were interested in the drawings of young children. They treated the 'diagrammatic' quality of such drawings as evidence that intelligent systems represent information internally in terms of symbolic descriptions of parts and how these parts are put together. Some of the resulting links between AI and drawing theory are illustrated by AARON and Rose as follows:

AARON's use of a structured information owes much to the symbolic AI techniques of expert systems.[27] An Expert System is a body of knowledge in the form of rules covering a particular task domain. For example an expert system might contain a group of doctors' knowledge about diagnosing heart disease. Typically the systems are textural: the computer may interrogate the user about blood pressure or medication and then offer a suitable diagnosis. AARON is an expert about the pictures it creates. It 'interrogates' the picture in progress, makes decisions based on the composition of shapes already present and responds by creating new shapes. Indeed Cohen has described AARON as 'an Expert's System' in its role as a representation of his knowledge about image-making.

AARON's reliance on a body of structured knowledge is also similar in intent to Luquet's description of 'intellectual realism' that is so dominant in theories of drawing. AARON doesn't create picture's that look like photographs because AARON is embodying a very selective amount of knowledge about a pictures chosen subject. Both Expert Systems and Intellectual Realism take a similarly symbolic view of the nature of knowledge.

Rose does not have a knowledge base of things that it can draw. Instead Rose relies on its 'perception' of a virtual world. This leads to drawn artefacts peculiar to that perceptual process. This relates to those theorists such as Arnheim who saw drawing as a process of creating perceptual equivalents.[28]

The study of perception has had a long and rich relationship with AI: indeed some the first connectionist models were known as 'Perceptrons'.[29] Rose's model of perception has much in common with Marr and Nishihara's[30] computational model of the final stages of visual perception. Marr and Nishihara used computer programming as an integral part of the development of their theory and these models have been widely referenced by those studying drawing development.

Rose's method of translating from percept to drawing uses a simple graphic vocabulary in which each closed region in the drawing stands for a solid volume in the experience model. The idea that different sets of words should be used for the picture elements and the real world elements that they stand for can be attributed to Symbolic AI and in particular the work of Guzman[31], Clowes[32] and Huffman[33], who described such sets of relations as denotation systems. This was soon picked up by psychologists studying drawing such as Kennedy[34] and in particular Willats[35] who says that denotation systems…' "say what the marks in the picture stand for". To put this more precisely, denotation systems map features of the real world, or Scene primitives, onto corresponding elements in the picture, or picture primitives.'

AARON and Rose have exploited a useful commonality of ideas between research in AI and drawing theory. It is the passage of ideas between AI, which has always used computer programming as a central research tool, and drawing theory that has made computer programing a productive medium to hypothesise about the nature of drawing.

4.2. Modern AI and drawing development

As we have seen, research on drawing has had a fruitful relationship with AI, being influenced by the insights into perception and behaviour given by the early connectionist and symbolic AI paradigms. These early techniques were characterised by a fixed information processing architecture designed by the computer programmer. Without further intervention the programmes performance is completely determined by the authored computer programme. As Garnham [36] describes: 'They assumed that the nature of intelligence did not depend on its genesis - the fact that people learned most of their skills was irrelevant to how those skills should be described.'

AI researchers' concern with developing logical information processing solutions to tasks contributed to the poor performance of early AI when applied to the changeable nature of real world tasks. The influence of this incompatibility on drawing theory can be seen to some extent in the dominant approach to describing drawing development.

In response to the information processing metaphor, most drawing experiments consist of repeated experimental observation of children copying an object under controlled conditions. e.g. [37, 38] However, Costall[39] points out that children in their spontaneous drawing behaviour almost never reproduce the common experimental task of copying from a model. This experimental approach is an attempt to make the drawing task a constant reproducible act amenable to cross-sectional empirical

analysis. Left to their own devices, children's drawing is prolific, esoteric and varied. Most cross-sectional studies quash such variety, dismissing it as 'noise'.

Thus the gradual, fluid way in which children develop their drawing is not well described by the information processing metaphor. The result is that most explanations of drawing development are in the form of stage theories. e.g.[40, 41] They compartmentalise children's continuous behaviour into a series of discreet stages. The final stage of these models almost always culminates in an 'end-state' of visually realistic perspective drawing. These discreet stages can then be analysed and described in detail within the context of the information processing metaphor.

Both AARON and Rose, having been influenced by this context, have inherited a similarly fixed information processing structure. Although they both use feedback within the drawing process they are essentially linear in structure, taking an input and transforming it to the output (AARON's input is embedded within the program in the form of structured descriptions of possible objects; Rose's input is external to the program in the form of three-dimensional computer models). The way in which this transformation occurs has random elements but remains otherwise constant in any one incarnation of the program. Any change in ability requires the intervention of the computer programming.

Modern AI has realised that it may be unreasonable or impossible to programme interactively all the subtle demands of complex tasks. In response to this the late 1980s saw the reemergence of connectionist AI along with techniques such as genetic algorithms and classifier systems. Spurred by the failure of symbolic AI to perform well in environments that are as ambiguous and capricious as the real world, these more recent approaches concentrate on systems that have the ability to develop or evolve emergent behaviours and thus adapt to a task with some degree of autonomy. In other words, these systems have the ability to learn. These systems do not have a linear structure; they use feedback in such a way that their future performance is modified by each new experience.

Modern AI has continued to have a productive two-way relationship with much of psychology and in particular neuropsychology. The previous AI techniques can be described as 'dynamic systems' as they are nonlinear, can behave chaotically and result in the emergence of order and complexity. These principles are being applied by Thelen and Smith[42], among other,s within developmental psychology to account for all levels of intelligent behaviour. They see development as emerging from a continuous self-organising stream of action and perception. Edelman's[43] theory of Neural Darwinism, for example, sees behaviour as developing via a process akin to evolution within the brain. The construction of connectionist AI computer artifacts that exhibit this evolutionary learning is central to the development of his theory.

Conversely, most recent drawing research has become more isolated from modern AI, concentrating solely on the use of specific techniques such as occlusion or foreshortening at different developmental stages. e.g.[44] While this has a firm empirical basis of controlled drawing exercises, it neglects children's free drawing, mostly ignores the drawing of very young children and does not ask how it is that children reach any particular stage in the first place. Hence the attempt to define individual stages of development more exactly has left a vacuum between the stages.

As we have seen there has been a general movement in drawing theory spanning this century. At first, researchers considered only the 'surface structure' of drawings. In more recent decades the emphasis has shifted to the study of 'the process that generates the surface structure'. Now there is a potential to follow the lead suggested by the developments in modern AI and dynamic systems to progress further. The emphasis could shift again to consider 'the process that generates the process that generates the surface structure', in other words, the development of drawing.

4.3. Drawing as a dynamic system

The Dynamic Systems approach addresses the origin of new forms during development. It refutes the notion that these forms originate from a pre-existing code within either the organism or the environment. Dynamic Systems attempts to describe how behaviour develops continuously over time rather than simply describing series of discreet pre-defined stages. The central tenant of dynamic systems is self-organisation. Stable behaviours are viewed as resulting from attractors forming within the state space of many interacting parts within both the organism and the environment. This is described by Thelen[45] such that: '...pattern and order can emerge from the process of interactions of the components of a complex system without the need for explicit instructions.'

Research into drawing has remained isolated from Dynamic Systems. However, children's drawing is a vivid example of a system that progresses from a state of disorder in the first scribbles to states of order and complexity in image- making. With this in mind, the following areas of drawing theory are seen as being compatible with the approach and could benefit from a Dynamic Systems interpretation.

Drawing research has often attempted to describe the development of general transferable skills such as occlusion and perspective, e.g.[46, 47], for translating three-dimensional objects into two-dimensional drawings. However, there is an increasing amount of evidence to show that the child's drawing process is extremely sensitive to its environmental context.[48] Also Phillips, Inall and Lauder[49] have shown that young children do not, in fact, acquire general transferable drawing skills. Instead they accumulate a population of individual graphic descriptions relating to each subject that they can draw. Graphic descriptions are held in long term memory and form the basis of the characteristically repetitive nature of children's drawing. Van Sommers[50] calls this tendency to repeat stereotyped drawings 'conservatism'. Van Sommers goes on to show that new drawing types exhibit more variability than older, more established ones.

These findings fit well within the Dynamical System approach in which behaviour is formed by attractors emerging within the state space of its components. The emphasis on context sensitive situated action, which cannot be separated from its environment, is an inevitable result of this approach. The stability of an attractor is measured by its lack of variability.[51] Thus Phillips et al and van Sommers may be observing the formation and selection of stable attractors within the domain of drawing.

Computer models are being developed within the dynamic systems approach that develop abilities in task domains such as navigation, object grasping and recognition (for example see Edelman's 'Darwin' artifacts.[52] It is proposed that drawing may be a particularly appropriate domain to be investigated and represented by a Dynamic Systems computer model for the following reasons:

First, drawing requires both action and perception; however, there are many simple tasks that require these two cornerstones of behaviour. Second, drawing is to some extent self-documenting. Each drawing is a visual (and sometimes beautiful) record of the action that created it; thus a model may be the source of original computer-generated imagery. However, the most important factor that sets drawing apart from most other modelled domains is that drawing has no obvious end point. While it is easy to anticipate the nature of a successful action in a domain such as grasping, to which a system should converge, it is not at all obvious what a successful drawing action should be. Without a priori knowledge of an end state, how can drawing develop?

In answer to the question of how drawing can develop, a younger sibling for Rose, called Eor, is being implemented. Eor stands for Emergence Of Representation. Unlike Rose, it will have no initial ability to make images - it will have to learn to draw. As this is a far more formidable task, it is not anticipated that Eor will progress towards the explicitly representational drawings of Rose. Instead it will be closer to the child's progression from scribbling to simple patterns that occurs typically between the ages of 18 and 36 months. This is a formative period of development that has been neglected by the majority of drawing research. It is not essential that Eor follows the same path or even results in similar drawings, it is intended to represent only the general concept of graphic development.

Eor will endeavour to acquire the ability to identify qualities in its environment and transfer them to the domain of drawing. Thelen and Smith[53] state that 'cognition emerges in development through repeated cycles of perception-action-perception'. Thus feedback is the key feature of Eor's architecture. Eor will produce varied drawing actions in response to its environment. Each finished drawing will then be perceived by Eor. Perception will form categories linking groups of similar drawings with the actions that created them ('similar' meaning that they share some invariant qualities). Eor will then attempt to generalise the emergent relationships between actions and their resulting drawings. Given time to develop, this may allow Eor to produce intentionally representational actions in response to novel experiences. It is hoped that feedback and competitive economy within the system will lead to the emergence of novelty, complexity and order as it develops the ability to transfer an expanding vocabulary of qualities into its drawings.

5. Conclusion
AARON and Rose were spawned in part from a useful exchange of ideas between AI and the study of drawing. Computer programming is uniquely situated as a representational medium for embodying the drawing process as it has the property of being active. The chosen medium inspired their creation but the dominant techniques of the period also limited them. Thus they neglected the process by which drawing develops.

Drawing theory is currently distanced from AI, which now concentrates on adaptive systems with emergent properties that can learn from experience. This provides the potential for a new view of drawing to be gained from contemporary dynamic metaphors of human behaviour being implemented by AI researchers. Thus computer programming may further raise our level of self-knowledge by continuing the process of representing representation.

References

1 Reisberg, Daniel (1987) 'External Representations and the Advantages of Externalising One's Thoughts'. *Proc. of the 9th Annual Cognitive Science Society.* pp. 281-293.

2 Cohen, Harold (1995) The further exploits of AARON, Painter. SEHR, *Constructions of the Mind.* Vol 4, No 2. Website: http://shr.stanford.edu/shreview/4-2/text/cohen.html

3 Burton, Ed (1995) Thoughtful drawings: A computational model of the cognitive nature of children's drawing. *Eurographics '95.* Cambridge University Press.

4 Cohen, Harold (1973) 'Parallel to perception: Some notes on the problem of machine-generated art.' *Computer Studies.* 4. p. 125.

5 McCorduck, Pamela (1990) *AARON's Code, Meta-Art, Artificial Intelligence, and the Work of Harold Cohen.* New York: W. H. Freeman and Company. p46.

6 See ref 2.

7 See ref 4, p 124.

8 bid, p125.

9 ibid 4, p 124.

10 See ref 5, p 82.

11 bid, p 86.

12 Kurzweil, Raymond. *The Age of Intelligent Machines.* Massachusetts: The M.I.T. Press, 1990. p 368.

13 Spiller & Jürg eds. Paul Klee Notebooks Volume 1, *The Thinking Eye.* London: Lund Humphries Publishers Limited, 1961.

14 Marr, D. & Nishihara, H. Representation and Recognition of the Spatial Organisation of Three-dimensional Shapes. *Proceedings of the Royal Society of London..* 1978. Vol. B. 200. pp. 269-294.

15 Arnheim, Rudolf. *Art and Visual Perception, a psychology of the creative eye.* London: Faber and Faber, 1956.

16 Luquet, G H. *Les dessins d'un enfant.* Paris: Alcan, 1913.

17 Freeman, N H. *Strategies of representation in young children.* London: Academic Press, 1980.

18 See ref 15.

19 Freeman, N H. Process and product in children's drawings. *Perception* 1. 1972. pp. 123-140.

20 Rosenblatt, F. *Principles of Neurodynamics: Perceptrons and the Theory of Brain Mechanisms.* . New York: Spartan Books, 1962.

21 Feigenbaum, E.A. & Feldman, J. *Computers and Thought.* Malabar: Robert E. Krieger, 1963.

22 Strommen, Erik. *A century of children drawing: The evolution of theory and reasearch concerning the drawings of children..* University of Illinois: Visual Arts Research, 1988.

23 Miller,G. A. Galenter, E. & Pribram, K. *Plans and the structure of action.* New York: Rinhart & Winston, 1960.

24 Newell, A. & Simon, H. A. *Computer simulation of human thinking.* Science, 134. 1961. pp. 97-109.

25 ibid.

26 Minsky, Marvin & Papert, Seymour. Artificial Intelligence Progress Report, Memo 252. M.I.T. Artificial Intelligence Laboratory. Cambridge Massachusetts. 1972.

27 See ref 2.

28 See ref 15.

29 See ref 20.

30 See ref 14.

31 Guzman, A. (1968) Decomposition of a visual scene into three-dimensional bodies. *Proceedings of Fall Joint Computer Conference.* Washington D.C.: Thomson Book Co.. pp. 291-306.

32 Clowes, M. B. (1971) On seeing things. *Artificial Intelligence.* 2. 1. pp. 79-116.

33 Huffman, D.A. (1971) Impossible objects as nonsense sentences. *Machine Intelligence.* Meltzer & Mitchie (eds.). Endinburgh: University Press. Vol. 6.

34 Kennedy, John (1975) Drawing was discovered not invented. *New Scientist.* 67. pp. 523-525.

35 Willats, John (1985) Denotation systems revisited: the role of denotation systems in children's figure drawings. *Visual Order: the Nature and Development of Pictorial Representation.* Freeman & Cox (Eds.). Cambridge: Cambridge University Press. pp. 78-100.

36 Garnham, Alan (1988) *Artificial Intelligence, an introduction.*. London: Routledge & Kegan Paul.

37 Light, P. H. & Humphreys, J. (1981) Internal spatial relationships in young children's drawings. *Journal of Experimental Child Psychology*. 31. pp. 521-530.

38 Arrowsmith, J, Cox, M & Eames, K. (1994) Eliciting partial occlusions in the drawings of 4- and 5-year-olds. *British Journal of Developmental Psychology*. 12. pp. 577-584.

39 Costall, Alan (1995) The myth of the sensory core: the traditional verses the ecological approaches to children's drawings. *Drawing and Looking*. Lange-Küttner & Thomas (Eds.). London: Harvester Wheatsheaf.

40 Piaget, Jean & Inhelder, Bärbel (1971) *The Child's Conception of Space*. London: Routledge & Kegan Paul.

41 See ref 35.

42 Thelen, Esther & Smith, Linda (1994) *A Dynamic Systems Approach to the Development of Cognition and Action*. London: The MIT Press.

43 Edelman, Gerald (1992) Bright Air, Brilliant Fire. *On the matter of the mind*. Middlesex: Penguin Books.

44 See ref 38.

45 Thelen, Esther (1989) Self-organisation in developmental processes: Can systems approaches work? Systems and development. *The Minnesota Symposia in Child Psychology*. Gunnar & Thelen Eds.). New York: Erlbaum.

46 See ref 40.

47 Willats, John (1977) How children learn to draw realistic pictures. *Quarterly Journal of Experimental Psychology*. 29. pp. 367-382.

48 Goodnow, Jacqueline (1977) *Children's Drawing*, London: Fontana/ Open Books Publishing.

49 Phillips, W. A. Inall, M. and Lauder, E. (1985) On the discovery, storage and use of graphic descriptions. *Visual Order: the Nature and Development of Pictorial Representation*. Freeman & Cox (Eds.). Cambridge: Cambridge University Press.

50 van Sommers, Peter (1985) The conservatism of children's drawing strategies: At what level does stability persist? *Aquisition of Symbolic Skills*. Rogers & Sloboda (Eds.).

51 See ref 42.

52 See ref 43.

53 See ref 50.

John Lansdown was Emeritus Professor of Computer Aided Art
and Design until his death in 1999 and was formerly Head of the Centre
for Electronic Arts (CEA), Middlesex University from 1988 to1995. In 1968
he founded, with others, the Computer Arts Society and was its Honorary
Secretary for more than twenty years. He used computers in creative
activities such as art, architecture, music and choreography since1960
and was the author of more than 300 papers on the use of computers in
the creative arts.

John Lansdown

Some trends in computer graphic art

Early computer art graphics

Computers have been used in creative activities almost since they first became
generally available in the early 1960s. In that tentative dawn, computer-based
graphical images were usually confined to plotter drawings, although some striking
interactive screen-based images were created – even before Sutherland's 1963
Sketchpad[1] – using refresh tube technology and lightpens. This early work can be seen
as largely exploratory although certain themes were well in evidence by the early 1970s
and Franke[2] is perhaps the most accessible source of illustrations of this pioneering
work. The themes included:

- the use of Lissajous figures of varying degrees of complexity – work that often
reproduced in a new way the late nineteenth century Victorian preoccupation
with harmonograph drawings;

- the use of alphanumeric characters as marks from which a drawing could be
built up – much of this work was of a trivial 'Snoopy' picture variety but some –
like the images composed by the American, Ken Knowlton and by the Brazilian,
Waldemar Cordeiro – was masterly and already illustrated the promising
possibilities of computer art;

- the use of modular elements which might be arranged in a matrix and modified
by rotation, black-and-white reversal, or superimposition: Lomax[3] gives some
tutorial examples but the undoubted master of this theme at that time was
Manfred Mohr;

- linear drawings subjected to various transformations and distortions, a theme characterised by some of the work of Leslie Mezei and Charles Csuri – the contemporary ideas of 'morphing'[4, 5, 6] grew partially out of this sort of work;

- linear drawings, sometimes in perspective, and used as animated images from which films were made.

In addition there was a growing use of computers to control interactive 'sculptures' or 'installations'. The most novel examples of this approach were Nicholas Negroponte's ill-fated gerbil environment, the Computer Art Society's 'Ecogame', and arguably the only true masterpiece of computer art, Edward Ihnatowicz's 'Senster' (for a description of the last two of these see Lansdown[7]).

Photorealism

It is only since the beginning of the 1980s that computer graphics as we currently know it has come fully on the scene. Prior to about 1983 – with some notable and pioneering exceptions – creating images of 3-D objects on a computer was usually confined to depicting 'wire-frame' representations in monochrome. Then even quite simple animated scenes took hours, or perhaps days, of computing time to produce. By using modern computer graphics, however, it is now possible quickly to synthesise images that almost resemble photographs of real objects and scenes – and much research and production effort goes towards making this type of image. The research covers such things as developing new means of modelling objects, see, for instance[8, 9]; depicting convincing movements[10, 11]; accurately rendering colour, texture and surface features[12, 13, 14, 15, 16]; as well as improving speed of production[17, 18]. Whilst many artists, animators and designers contribute to these developments, the major thrust and direction of progress of this work has been largely in the hands of computer scientists trying to push back the boundaries of representation mainly for scientific, advertising and commercial purposes (for example, film-making and flight simulation).

In parallel with these remarkable advances, though, there has been a steady growth in the use of computing for purely artistic reasons. This work has built on the pioneering efforts of the 1960s and 70s. Here, the aim has been not just to use photorealistic techniques to illustrate real or imagined scenes, although some interesting artistic work has arisen in this area too. Among many artists, however, there has been something of a revolt against photorealism – which they see either as misguided or as far too restricting to their creativity. The revolt takes two forms: one, by those who react to existing developments and wish to investigate computer graphic means of depicting scenes in non-realistic ways; and two, by those who ignore depiction of visual 'reality' altogether and are concerned mainly with abstractions and interactions. Smith[19, 20] summarises some of the new views with refreshingly ironic comments on the state of computer graphics. Wright[21] also has some perceptive comments.

That photorealism is not the main current concern of artists should come as no surprise to us. Only comparatively rarely in history has artistic preoccupation been with depicting the visual world in a 'realistic' way as if seen by an eyewitness or recorded by a snapshot camera[22]. For most of history, artists have struggled to represent a view of the world filtered through their imaginations and it is rare, for

example, to find paintings that, despite superficial appearances, present even a perspective view from a single fixed viewpoint. The works of, say, Duccio or Degas, Rivera or Rouault, Matisse or Mantegna look unlike photographs of scenes not because of some basic inability these artists had to copy what appears 'out there' but from artistic choice.

The current trends

We can recognise three main artistic trends and developments that have been happening via the medium of computing over the last few years. These are:

- algorithmic and mathematical art;
- new forms of representation;
- interactivity.

(On the horizon, though, is a fourth development of great promise: that is, the use of networking – the Internet and World Wide Web (WWW) – to produce multiply-authored artworks. It is, perhaps, too early to make a judgement on these although it is already clear, as we approach the 21st century, that this form of working will take on more and more significance).

Each of the three trends (which, to a certain extent, overlap and coalesce) has some counterpart in the computer art of the 1960s and 70s but advances work into new and perhaps more appropriate areas. Indeed it is this concept of 'appropriateness' that might need more exploration. Early in the development of any new medium there is a tendency for it to be used to imitate older media. It is not until a medium reaches a sort of maturity that it begins to take on a life of its own and displays characteristics which belong to it and no other. The first photographers, for example, saw themselves as portrait or landscape painters who 'painted with light' rather than with water colours or oils. Their visual preoccupations were with the same sort of effects that many of their contemporary portrait or landscape artists sought – and their photographs looked like it. Later, when purely photographic ideas began to dominate, painting itself came to be changed by photography. This curious reversal of influences shows how profoundly an art medium can alter the way we perceive the world.

Maturity, then, brings with it ideas that suit a medium in a unique way. These ideas seem right; others – though quite possible – seem to be just inappropriate simulations. This is not to suggest, however, that important work cannot be done by what might appear to be inappropriate means. Paint systems, for example, attempt to simulate artists' conventional tools – pencils, water colour brushes, airbrushes and so on – but have helped to produce some striking work particularly when coupled with the system's assistance in making 'collages'. Note though that the film-maker Peter Greenaway[23] is right when he says that the image manipulation which a paint system makes possible 'cannot be satisfactorily contained in the word collage' and that 'its possibilities could radically affect cinema, television, photography, painting and printing (and maybe much else), allowing them to reach degrees of sophistication not before considered'. The way in which Greenaway used the Quantel Graphical PaintBox to create new imagery for his film Prospero's Books points up the extraordinary potential of this medium.

Although practising artists are developing many of the new trends, it is in the activities of students, particularly postgraduate and research students studying

computer aided art and design that we begin to see some of the most imaginative ideas beginning to take root. Many of the concepts I discuss here arise out of student work and I am grateful to the many students I have worked with for the unselfish way they have shared their ideas with me.

Algorithmic and mathematical art

At the heart of any computer process lies an algorithm – a step-by-step series of instructions for producing some end result. Art, on the other hand, is not normally produced by algorithmic methods. We do not teach people to make a great artwork by saying 'First you do this thing, then this thing, then this... – indeed we don't often know what the 'things' to be done should be. We expect artworks to arise from human intuition and imagination normally underpinned by manual skills. In conventional art, ideas and skills go together to produce a work, the processes of thinking and doing being highly interactive. The ideas influence what is to be done and what is being done influences the ideas. Thus those who use computers to help them make art tend to develop algorithms to help them achieve an outcome that they have more or less firmly in mind. But it is possible to work in an entirely different way: rather than having an artwork in mind and creating an algorithm to help realise it, we can devise an algorithm and see what sort of artwork it produces.

Strange as this approach appears, it has its origins in conventional art – particularly in the so-called 'systems art' of the 1960s, but also in things like Schoenberg's serial twelve-tone music ideas of the 1920s. Indeed, the history of music abounds with related concepts. Younger artists, like the Canadian Janet Bartz and the Brazilian Heloise Siffert -building on earlier work of those such as Roger Saunders[24], are beginning to explore the possibilities of algorithmic art. Starting with a non – art concept, such as the dynamics of mixing two fluids, or the way in which force fields work, they devise an algorithm to simulate the physics of the situation and then explore the visual outcome of this. Their aim is not scientific nor technological. It is artistic. The physics and mathematics of the real situation are the catalysts for the exploration and, in the process of exploring, the artists sometimes leave the original idea behind. The effects, though, are often remarkable and open up new and exciting prospects.

Mathematical art, much of it based on the ideas of chaos theory, also abounds. The earliest manifestation of the visual interest in chaos theory images dates back to 1974 with the publication of a paper by two scientists working at CERN, Gumowski and Mira[25]. Since that date, many artists have begun to examine the visual possibilities of these types of image: ones where, though the mathematics are simple, the outcome is complex and unpredictably related to starting conditions. Barry Martin[26] has shown us some beautiful images which illuminate this sort of work. Field and Golubitsky[27] illustrate some of the endless possibilities that the exploration opens up, whilst the 3-D chaos work of Jones and Campa[28] takes the idea into new realms of investigation.

Some will argue that this is not art at all but 'mere pattern-making'. This West centred view, however, is far too parochial: in some cultures 'pattern' is the only form of visual art. Mathematical and algorithmic art does not narrow our view of what art should be; it broadens it to embrace new and challenging visual experiences.

New forms of representation

As a reaction against the prevailing trend of photorealism in computer graphics, artists such as Brian Reffin Smith and Simon Schofield look to new forms of representation; in Smith's case by using low resolution equipment and non-realistic rendering of photographic imagery; in Schofield's case by trying to emulate the sort of 'marks' that painters make. Smith has shown works based on photographs but where different tones have been rendered as short lines at different angles and densities – the computer deciding the required angle and density by algorithm. Schofield began his explorations by trying to make computer graphics output look like painting. His early, 1990, system could take a computer model and automatically render it to resemble different painters' styles using painterly marks – brush strokes, pencil lines and so on. His most recent work, still based on an underlying 3D-model and automatic rendering, makes use of much more general marks. These lead to images having the qualities normally associated with hand-rendered drawings. A somewhat similar approach to painterly imagery, but requiring physical interaction by a user, has been taken by Haeberli[29]. The development of this new approach to computer graphics imagery is in its early stages but already shows great promise and wIll undoubtedly give rise to new ways of making art. Lansdown and Schofield [30] review some of the possibilities and practices here.

An interesting variation on the theme of 'realism' – and one which owes its conception entirely to the existence of the computer – occurs when all the computations necessary to display a photorealistic image are made, but the computations are used to show the results in an unusual form. As an example of this idea two French students, Beatrice Selleron and Remi Bichet, contrived what they called the 'Imaginary City' to illustrate what they knew about computer-based lighting and rendering. This city is constructed by program according to certain rules. For example, the amount of light falling on an object (which is invisible) causes certain forms of building to grow: a spherical one if the light is at a maximum, a rectilinear one if the light is at a minimum, a conical one for lighting of average intensity. Other rules determine transparency, height, colour and so on. Thus, rather than choosing to show lighting techniques by simply creating a particular object photorealistically rendered, they have done so by inventing a new world in which the techniques have more fundamental aesthetic purposes.

Another trend which is having a growing influence is the use of non-geometrical ways of representing objects in computers. Normally, complex objects must be represented as a collection of primitive solids such as cones, cylinders, spheres and so on. Alternatively, they can be represented by triangular or rectangular meshes that delineate their surfaces. Representations such as these are appropriate for manufactured objects of clearly defined forms made from solid materials. They are not particularly useful for amorphous or soft objects which are often best described by representations based on 'equipotential' surfaces in force fields[31]. Developments in this area are already having an influence on the work of some computer artists. The work of Heloise Siffert referred to above, for example, uses a 2-D version of this approach[32].

Interactivity

From the artist's point of view, one of the advantages of computer-based graphics over those produced by conventional means is the opportunity computers afford for interactivity. Interaction can be effected in a number of ways. For example:

- simply by physical presence;
- by gesture or similar physical activity (including dance);
- by sound;
- by drawing-like activities.

By means of this interaction, individuals or groups can choose the order of display of images; modify their contents, colour or form; or otherwise change what is to be seen – and a growing number of artists are beginning to exploit the possibilities that this facility allows.

In many ways, the fuller exploitation of interactivity presents computer artists with their greatest challenge: that of passing aesthetic control of their work out of their own hands into those of their audience. This is not to suggest, however, that the appreciation of conventional work is entirely under an artist's control. On the contrary, in order to interpret any art work we have to actively participate in our viewing of it: we have to bring to it much of our own experience – and this experience, and hence the extent of our engagement with the work, is not directly within the artist's influence.

Interactive art, however, demands a different form of participation. Our engagement is not just required in the interpretation of the work; it is needed in its 'creation' too. Depending on the degree of openness of the work, the participation can comprise anything from the equivalent of assembling from a kit of parts, to an exploration of uncharted routes. In order to assist in our engagement, though, interactivity has sometimes tended towards gimmickry and this has inevitably led critics – many of whose minds are set in the 'artist as auteur' mould – to doubt the seriousness of the work and to compare it unfavourably with 'conventional' art. We can, however, just begin to see the possibilities that interactive art offers.

Jeffrey Shaw's 'The Legible City' is a case in point. In order to interact with this work a viewer has to sit on a fixed bicycle and notionally steer and pedal through a city of words projected on a large screen in front of her. The three- dimensionally arranged words form texts taken from statements by various New York personalities, such as Donald Trump, Mayor Koch, taxi-drivers and so on. The text comprise storylines related to different parts of Manhattan identified by different colours. By cycling through this virtual environment one can either follow each storyline separately or pass from one to another in a seamless way, making new texts as one goes. In addition to the main screen is a smaller one fixed to the bicycle which locates the participant on a map of Manhattan. Thus one has experience of both the real and the virtual city but, in each case, in ways which are not like reality.

This form of art work would not be possible without computing. More significantly, though, it would not even be thought of if the medium of computing did not exist.

This absolute dependence on computing for both physical and theoretical existence is a principle which is fundamental to new many ideas in interactive art. The principle applies to Brian Reffin Smith's 'Co-operative drawing' works where two users have to

create a drawing by jointly moving joysticks. If they do not interact together co-operatively, they cannot make a drawing. It applies to Toni Chan's 'Fish Bowl' work where one drops bits of latex-foam 'food' into a water-filled glass bowl which stands in front of a computer monitor. When the food hits the water, sensors calculate its position and computer graphic fish appear on the monitor to nibble the food. It applies to the 'environments' of Tessa Elliott and Jonathan Jones-Morris in which images and sounds not only depend on the actions of current participants but also on those of previous ones.

These are not works where the computer is used simply as a tool to assist in doing things faster or more accurately than is possible by conventional means. Computing is the bedrock of their existence. It determines what they do and what they are. They represent, too, what computer art graphics might become: open, interactive, and participative in new and exciting ways.

Concluding remarks

Although, clearly, much of this new work will be carried out by artists and will be seen, either immediately or in the future, as part of the conventional art scene, it is interesting to speculate what might have happened 30-odd years ago if we had decided not to see these developments as art at all. We wondered then and I wonder now whether we should call it 'art' at all. In treating it as art we have tended to weigh it down with the burden of conventional art history and art criticism. Even now – and knowing that the use of computing will give rise to developments that are as far from conventional art as computers are from the abacus – is it not too late for us to think of 'computer art' as something different from 'art'? As something that perhaps carries with it parallel aesthetic and emotional charges but having different and more appropriate aims, purposes and cultural baggage?

References

1 Sutherland E (1963) 'Sketchpad: A man-machine graphical communication system', SJCC, Spartan Books, Baltimore pp 329.

2 Franke HW (1971) *Computer Graphics – Computer Art*, Phaidon, London.

3 Lomax JD (ed) (1973) *Computers in the Creative Arts*, NCC Publications, Manchester.

4 Sederberg TW and Greenwood E (1992) 'A physically-based approach to 2-D shape blending', *ACM Computer Graphics*, (26) 2 pp 25-34.

5 Beier T and Neely S (1992) 'Feature-based image metamorphosis', *ACM Computer Graphics*, (26) 2 pp 35-42.

6 Chen DT, State A and Banks D (1995) 'Interactive shape metamorphosis', *Proceedings ACM Symposium on Interactive 3D Graphics*, Hanrahan P, Winget J and Zyda M (eds), ACM, New York pp 43-44, 205.

7 Lansdown J (1980) 'Is the computer a tool?- The question in an art context', In Sundin B (ed) *Is the Computer a Tool?*, Almqvist and Wiksell, Stockholm pp 25-35.

8 Snyder JM (1992) *Generative Modelling for Computer Graphics and CAD*, Academic Press, San Diego.

9 Welch W and Witkin A (1994) 'Free-form shape design using triangulated surfaces', *Computer Graphics Proceedings*, Annual Conference Series 1994, ACM SIGGRAPH, New York pp 247-256.

10 Wejchert J and Haumann D (1991) 'Animation aerodynamics', *ACM Computer Graphics*, (25) 4, pp 19-22.

11 Granieri JP, Becket W, Reich BD, Crabtree J and Badler NI (1995) 'Behavioural control for real-time simulated human agents, *Proceedings ACM Symposium on Interactive 3D Graphics*, Hanrahan P, Winget J and Zyda M (eds), ACM, New York pp 173-180.

12 Chen H and Wu E-H (1991) 'Radiosity for furry surfaces', *Eurographics 91*, Post FH and Barth W (eds), North-Holland,

Amsterdam pp 447-457.

13 Anjyo K, Usami Y and Tsuneya K (1992) 'A simple method for extracting the natural beauty of hair', *ACM Computer Graphics*, (26) 2 pp lll-120.

14 Carignan M, Yang Y, Magnenat Thalmann N and Thalmann D (1992) 'Dressing animated synthetic actors with complex deformable clothes', *ACM Computer Graphics*, (26) 2 pp 99-104.

15 Schoeneman C, Dorsey J, Smits B, Arvo J and Greenberg D (1993) 'Painting with light', *Computer Graphics Proceedings, Annual Conference Series 1993*, ACM SIGGRAPH, New York pp l43-146.

16 Cazals F, Drettakis G and Puech C (1995) 'Filtering, clustering and hierarchy construction: a new solution for ray-tracing complex scenes', *Computer Graphics Forum* (14) 3 pp 371-382.

17 Gröller E and Purgathofer W (1991) 'Using temporal and spatial coherence for accelerating the calculation of animation sequences', *Eurographics 91*, Post FH and Barth W (eds), North-Holland, Amsterdam pp 103-113.

18 Enger W (1992) 'Interval ray tracing – a divide and conquer strategy for realistic computer graphics', *The Visual Computer* (9) 2 pp 91-104.

19 Smith BR (1986) 'Computers and art', in Berkum A and Bleckkenhorst T, *Science * Art*, Fentener van Vlissingen Fund, Utrecht pp ll3-122.

20 Smith BR (1989) 'Beyond computer art', in Resch M (ed), *'Computer Art in Context'*, Leonardo Supplemental Issue, pp 39-41.

21 Wright R (1989) 'The image in art and 'Computer Art' ', in Resch M (ed), *Computer Art in Context'*, Leonardo Supplemental Issue, pp 49-53.

22 Gombrich EH (1980) 'Standards of truth', in *The Language of Images*, Mitchell WJT (ed), University of Chicago Press, Chicago pp l8l-218.

23 Greenaway P (1991) *Prospero's Books*, Chatto and Windus, London and a film of the same name (an Allarts – Cine/Camera One – Penta co-production).

24 Saunders R (1972) 'A description and analysis of character maps', *Computer Journal* (15) 3 pp l60-169.

25 Gumowski J and Mira C (1974) 'Point sequences generated by two-dimensional occurrences', in *Information Processing 74*, North-Holland, Amsterdam pp 851-855.

26 Martin B (1989) 'Graphic potential of recursive functions', in Lansdown J and Earnshaw RA, *Computers in Art, Design and Animation*, Springer, New York pp lo9-129.

27 Field M and Golubitsky M (1992) *Symmetry in Chaos: A Search for Pattern in Mathematics, Art and Nature*, OUP, Oxford.

28 Jones H and Campa A (1993) 'Abstract and natural forms from iterated function systems', in Thalmann D and Thalmann NM (eds) *Communicating with Virtual Worlds*, Springer, Tokyo pp 332-344.

29 Haeberli P (1990) 'Paint by numbers: Abstract image representation', *ACM Computer Graphics*, (24) 4 pp 207-214.

30 Lansdown J and Schofield S (1995) 'Expressive rendering: an assessment and review of non-photorealistic techniques', *IEEE Computer Graphics and Applications*, (15) 3 pp 29-37.

31 Wyvill B and Wyvill G (1989) 'Using soft objects in computer-generated character animation', in Lansdown J and Earnshaw RA, *Computers in Art, Design and Animation*, Springer, New York pp 283-297.

32 Jones H and Siffert H (1995) 'Animation control using scalar fields: a case study', in *Proceedings Eurographics UK Conference*, Eurographics UK, pp 207-214.

Jim Noble now lives and works in London. His background was as a practising fine artist and he was awarded a Henry Moore Foundation Scholarship to attend the Royal College of Art, graduating from the MA printmaking course in 1992. From there, he served for two years as the Stanley Picker Demonstrator in Advanced Printmaking at Kingston University and has been a Research Assistant in Fine Art at the University of Wales Institute, Cardiff where he worked on a practice-based PhD project entitled: 'Print and computing in the context of Fine Art: An investigation into relationships and strategies'.

Jim Noble

Fatal attraction: print meets computer

Introduction

What is the computer to the fine artist? The computer art press is divided on this question. For one artist the computer is only a tool, for another it is a completely new medium. Neither position alone is tenable, however, since both identities are present to at least some degree in all computer artworks. My concern here is with the identity and potential of the 'computer print', though the coining of the term 'computer printmaking' remains for me an exercise in banality as it indiscriminately addresses both the computer and the print. Here I will map out a territory of ideas that has formed in the back of my mind as a fine artist printmaker working both with print and with computing.

This chapter addresses the complex relationships between print and the computer. It will also consider the extent to which the technologies of print and photography determine (and have changed) the expectations we have of visual representation, the amount of information we assume those representations give us, and the unquestioned qualities that influence those assumptions. The chapter is divided into two sections, the first concerned with establishing the historical and cultural significance of print, the second with relating this to the computer as an increasingly dominant force in contemporary society and culture.

However, there is an essential difficulty in talking about print and this is that over time it has accumulated a number of identities. These are: print as craft-based picture-making; print as typography; print as industrial manufacturing and print as fine artists' medium. My primary concern is with print as fine art. In the context of printmaking, however, it will be necessary to look at a number of related areas such as typography, publishing, computer graphics and physics on the way.

Print

Cultural Dynamite

William Ivins, Jr. in his book 'Prints and Visual Communication'[1] explains very lucidly the significance of print for our ancestors:

> For our great grandfathers, and for their fathers back to the Renaissance, prints were no more and no less than the only exactly repeatable pictorial statements... Until a century ago, prints made in the old techniques filled all the functions that are now filled by our line cuts and half tones, by our photographs and blueprints, by our various colour processes, and by our political cartoons and pictorial advertisements. If we define prints from the functional point of view so indicated ... it becomes obvious hat without prints we should have very few of our modern sciences, technologies, archaeologies, or ethnologies – for all of these are dependent, first and last, upon information conveyed by exactly repeatable visual or pictorial statements. This means that, far from being merely minor works of art, prints are among the most important and powerful tools of modern life and thought.... We must look at them from the point of view of general ideas and particular functions, and, especially,we must think about the limitations which their techniques have imposed upon them as conveyors of information and on us as receivers of that information.

Ivins, who was the first Curator of Prints at the Metropolitan Museum of Art, is here expressly concerned with pictorial print. Marshall McLuhan, who respected and built on Ivins's ideas in the course of his career, looks more towards typographic print. For McLuhan it is Gutenburg's invention of movable type that provides the impetus behind the cultural revolution of the Renaissance and the development of the modern period.

Print Culture, Computer Culture

In the crudest of terms (which cannot do justice to the complexity and richness of his ideas) McLuhan breaks up social and cultural history into four technologically determined phases[2]: the pre-literate, the alphabetic, the typographic and the electronic. Until Gutenburg's invention of type, culture is described, despite the technology of the alphabet, as being tribal, society being organised around the oral/auditory transmission of information. This phase is followed by a print-dominated culture, where the aural and holistic emphasis of tribal culture is replaced by a visual, linear way of looking at the world. The final phase in McLuhan's technological sociology begins with the invention of electricity and electronic technologies.

The computer, according to McLuhan, is a machine that has much more in common with the holistic environment of the tribal culture than that of its logical and linear print-based forebear. McLuhan writes in the 'Gutenburg Galaxy'[3]:

An age in rapid transition is one which exists on the frontier between two cultures and between conflicting technologies. Every moment of its consciousness is an act of translation of each of these cultures into the other. Today we live on the frontier between five centuries of mechanism and the new electronics, between the homogeneous and the simultaneous.... The sixteenth century Renaissance was an age on the frontier between two thousand years of alphabetic and manuscript culture, on the one hand, and the new mechanism of repeatability and quantification on the other.

Elsewhere [4] he expands:

> The 'Simultaneous field' of electric information structures today reconstitutes the conditions and need for a dialogue and participation, rather than specialism and private initiative in all levels of social experience. Our present involvement in these new kinds of interdependence produces in many an involuntary alienation from our Renaissance heritage.

More specifically still [5]:

> . . . culture that is engaged in translating itself from one radical mode, such as the auditory, into another mode like the visual, is bound to be in a creative ferment, just as was classical Greece or the Renaissance. But our own time is an even more massive instance of such ferment, and just because of such 'translation'.

As our age translates itself back into the oral and auditory modes because of the electronic simultaneity, we become sharply aware of the uncritical acceptance of visual metaphors and models by many past centuries.

What emerges from the ideas of these two writers is a particular vision of print – print as a technology that fuelled the development of European culture from early in the fifteenth century until late into the twentieth. Both writers observe a fundamental shift in the evolution of human society that corresponds to the period when print first emerged. They also agree on tracing the dramatic developments of the 'modern period' back to a deep restructuring of society occasioned by a new visual emphasis on culture that was demanded by the technology of print [6].

McLuhan, however, is writing about print directed towards a different end. McLuhan is asserting that technology determines the way that human society is organised. A culture that uses the ear as its primary cultural sense will be organised in such a way that the idiosyncrasies of that sense are put to most effective use. This implies that when a culture encounters a new technology that places a new sensual emphasis on its society, an intense period of transition and translation must take place before new forms can become completely assimilated.

Ivins ends his historical account of the development of the printed image at around the end of the nineteenth century with the invention of the ruled, cross-lined, half-tone screen [7] – the final word in verisimilitude. This is also the historical point at which McLuhan detects the return of the pendulum to a non-linear, tribal mode of information exchange. It is a significant period in terms of the history of print as it relates both to our modern notion of fine art printmaking and to the rise of McLuhan's electronic age. Our period of 'creative ferment', transition and translation starts here.

The Challenge of the Photographic

In his summing up, Ivins[8] makes reference to various of the effects that photography had on both the traditional print industry and the further development of human sciences and ideas:

> The photograph and the photographic process, having taken over the business of visual reporting from the hands of the pictorial reporters and the engravers, [left the tradition of print without direction, for this tradition] had regarded verisimilitude as the purpose and justification of [its] work.

> The photograph has made it obvious that what for four centuries the European world had acclaimed as purpose and beauty in art was no more than a peculiarly local prejudice about subject matter and mode of presentation[...]this prejudice was to a great extent based on the methods of production through which artistic and factual report alike had reached the public[...]For centuries the European world had been unable to distinguish between factual reporting, with its necessary requirement of verisimilitude (of which perspective was an essential part), and that expression of values, of personality, and of attitude towards life, with which verisimilitude is always at war.

> In addition to all this, the exactly repeatable pictorial statement in its photographic forms has played an operational role of the greatest importance in the development of modern science and technology of every kind... The modern knowledge of light, like that of the atom, would have been impossible without the photograph. The complete revolution that has taken place in basic assumptions of physics during the last fifty years could never have been accomplished without the data provided by the photographic emulsion.

Ivins makes three important assertions in this extract. First, he shows that photography spelt the demise of print in its traditional form. We can see the evolution of print marching into a cul-de-sac of visual reportage, where emphasis on verisimilitude turned the art into a formal concern devoid of content.

Second, when he talks about Europe's inability to distinguish between the factual and expressive components of images, he illustrates McLuhan's statement[9] that:

> As our age translates itself back into the oral and auditory modes because of the electronic simultaneity, we become sharply aware of the uncritical acceptance of visual metaphors and models by many past centuries.

Third, he implicates photography and photographic print technologies in helping to create that greatest of philosophical leaps from Cartesian space to Einsteinian; from Newtonian determinism, to quantum probability. McLuhan's electronic 'Global Village' starts here. It is also at this point that printmaking begins to surface in a form we would recognise today.

From Print to Printmaking

The relationship of print to fine art has been an evolving one, confused by the changing historical definitions of the terms 'art' and 'artist' over time. Print-making, as I use the term here, describes the artist's use of the medium of print. However, the artist of today is a very different animal from the artist of the Renaissance. For this

reason, the term printmaking is used here more specifically to describe only the print-based artworks of the last hundred years or so.

Looking at artistic media generally, it is clear that print constitutes the first 'modern' image technology. Whereas painting and sculpture have a heritage stretching back to the very beginnings of human cultural awareness, print is a mere 500 years old.

Print provided the 'exactly repeatable pictorial statement', and that these statements were by definition 'pictorial' meant that artist painters became closely associated with the history, character and development of print. Apart from its many other 'novel' qualities, print was, in its first incarnation, the original consumer product. It was capable of mass production and the commercial opportunities it suggested induced many artists to set up print workshops. There they produced folio editions of their own works or of images of distant places, buildings or artworks. But print was much more versatile than to be solely of interest to artists. Prints became ubiquitous, fulfilling all the pictorial and textual needs of the society.

The technology and process of printing demanded a production-line approach to manufacturing prints. The publisher of printed images would decide on the content of a folio. He would commission an artist to illustrate it, would pass the artist's drawings on to an engraver's draughtsman (who would translate the work into the mannered contrivances demanded by the process of engraving) and these draughts would finally be realised in copper by the engraver.

It becomes easy to see how distortion could arise in the attempt to produce accurate visual documentation – draughtsmen interpreting the work of other draughtsmen, until a finished print emerged, a third hand impression of some scene or artefact. The entire history of pictorial printed representation is one in which the subjectivity of the process could not be apprehended until photography arrived. Photography provided the ultimately detached and objective point of view from which to observe visual information. The photograph, as Ivins notes above, entirely relieved the print of its traditional role of visual reporter to the world.

Sadly for the engravers of the time, photography made them redundant. However, for print (that body of techniques and processes), the development of a way of representing photographic imagery without the need for special chemically treated photographic papers or the intervention of a subjective hand, marked the final triumph of the medium. Whilst culturally and historically the invention of photography, coupled with the new technology and ideas behind quantum physical theory, was laying the intellectual and material groundwork for McLuhan's electronic society, the new technology of the half-tone printed image became the force behind the reassessment of every field of knowledge where images were primary sources of information.

The study of the history of art seems like a suitable example. Until the development of photography, art historical study was dependent upon engraving for its visual resources. We have noted the constrictions that the technology of engraving imposed upon the making of accurate representations of objects. In the context of art history, this led to the creation of images that were hopelessly inadequate for anything other than the comparison of composition. Yet the shortcomings of these images, so

obvious to our photographically literate eyes, must have been impossible to perceive at the time (impossible to perceive on the grounds that without a precedent for photography one could not imagine that an engraving was not the best possible solution to the problem of reproducing and circulating visual information). One result of the invention of photography, and more essentially in this context, the technology of translating the continuous tone surface of the photograph into the discrete half-tone image of the print, was the complete rewriting of the history of art with the aid of photography. So whilst one breed of print practitioners became extinct, the power of print grew as it mastered the means to reproduce the photograph.

Photography shook the foundations of the image-making world. Not only print, but painting too felt the huge void left by photography's annexation of the field of visual documentation. The reaction of the fine arts began with the Impressionists' use of the optical theories of light that were part and parcel of the new technology of photography. Art, freed from the restrictions of representation, began the process of self redefinition that has given us the last hundred years of modernist art.

Printmaking Arrives

Printmaking as an artistic manifestation of print, finds its identity crystallising from within the modernist art movement of the last century. It was not a seamless progression from the artisan-led print practice of the last 400 years to the artist-led printmaking of the modern art movement. Print-making might better be described as the result of an artistic avant-garde's new-born interest in the material qualities and processes of Print. From Toulouse Lautrec to Sherrie Levine, printmaking has provided an artists' medium with a range of visual qualities stretching from the primal to the photographic – a totally modern historical and conceptual environment within which to frame the work of art, and ultimately, a visual language expressing the culture and development of modern Europe over the last 500 years.

However, whilst the visual integrity and stature of the great prints of this century are as rich a source of wonder and profundity as its great paintings and sculptures, these prints are almost exclusively the works of artists trained as painters or sculptors. There has undoubtedly been a conspicuous absence of significant, progressive artworks by 'printmakers' in the canon of modern art, but now the computer has arrived and everything is different.

Computing

Considering Computer Art

For print, in all its guises, the computer has been a radical transformer of practice.

Given McLuhan's theories about changing cultural forms, one can see that during the transitional phase between two technological modes it is the process of translation that characterises the development of new forms of communication and expression. When we are initially faced with a new technology, we have only the experience of working within the constraints of an older technology to guide us.

If 'computer art' is taken in this instance to mean art made solely with the computer, it is clear that the first phase of works will be concerned with exploring new

possibilities as they relate to older concerns. Virtual Reality as an artistic medium provides a good illustration of this.

Virtual Reality has, with few exceptions, only become available to the artist in the last five years. Whilst works of art are being produced using Virtual Reality, their overriding concerns seem functional. They address questions of how we orientate ourselves in virtual space and about the sorts of visual conventions emerging in the medium. The formal qualities of the new technology are being explored but are not yet 'understood' in the same way that the conventions of painting are. It would, of course, be unreasonable to expect any more at this moment in time and it seems safe to predict that if public use of Virtual Reality becomes common, the formal qualities of the computer will ultimately become invisible through the ubiquitous (and improved) nature of the technology.

The 'computer as pure medium' has a completely different set of internal debates, emphases and relationships to those expressed within traditional artistic forms. So, whilst acknowledging that the future seems ripe with the potential for new computer forms of artistic expression, the situation at present is one in which the rules of the medium are still being discovered. At this stage in the development of computer artwork, a consensual language of visual conventions is not yet in place and this absence makes the creation of powerful, resonant artwork a secondary concern to the establishment of a commonly understood visual code.

Print, Photography, Computing and Quantum Physics?

Consider the image opposite. It was found in an electronics magazine, in the bottom left hand corner of a page given over to short news items, and was printed as a relatively low resolution half-tone screen, suitable for the low grade recycled paper on which it was printed. Underneath the image was the caption: 'Silicon Atoms'.

I was struck by this photographic testament to a human technology that could 'look' right into the very heart of matter itself. The image is made up of a lattice of fuzzy, figure-

of-eight blobs, light on a dark background, looking very much as one would imagine atoms to look. Yet (intellectually speaking) I know that atoms do not exist visually.

Taking this image as an instance of optical fact (whereby one assumes that it is the result of photons striking photographic paper), I ask myself what I am looking at. These blurred objects are figures of eight because silicon is a covalent atom: it is two atoms of silicon bonded together. And so I must assume that their blurred quality is the optical effect of electrons moving extremely rapidly around the outside of the nucleus. Yet an electron is not a tiny little 'thing' in the manner of a grain of sand. If truthful statements about the quantum world can be offered up at all, they can only be expressed in mathematical terms. Verbal language does not contain the words necessary for an accurate description of the strange world of the atomic particle. What can be said about the electron, however, is that it has only a tendency to exist in a particular place given a particular set of circumstances – a somewhat less concrete visual reality than that of an atomic moon circling a nucleic planet.

Given, then, that the image could not then be one with (chemical) photographic origins, how did it come to be? The answer: it was a computer visualisation of the atomic structure of Silicon as it was perceived by a tunnelling electron microscope.[10]

This image is of interest to me for a number of reasons. What had originally impressed itself upon me as the signifier of an incredible photographic event, displayed with a disconcerting nonchalance and sense of familiarity, turns out to be not a visual but a tactile examination of the atomic surface. The data gathered by the tunnelling electron microscope is first interpreted by software, and then presented as a wireframe, three-dimensional, virtual object. This wireframe image is next rendered as a continuous surface, placed in a virtual space, lit by virtual lighting and, finally, virtually composed and photographed in readiness for output as a computer printout. The subsequent processing of this image for printed publication leaves us with a printed image for which we automatically assume a photographic origin because of the ubiquitous language of the half-tone screen method of printing photographs.

Apart from the strange provenance of the image, what cannot be missed is the coincidence of photography, print and the computer.

McLuhan's returning pendulum has picked up an enormous amount of speed since the turn of the century. During that time print has become largely photographic on two fronts: it became photographic in the way that so many of its processes became photo-mechanical and it became photographic in the way that much of its visual content became photographic. Photography, meanwhile, has taken on the role once borne by printer/engravers. Photography has come to carry the burden of truth (much to its present discomfiture) and it is the computer that is now shaking up the bag of media relations.

One of McLuhan's key ideas is the 'ratios between the senses' as they are disturbed by particular technologies. When he talks about a 'visual culture', he is talking about a culture in which the dominant vehicle through which the world is apprehended is the eye. In this case, the technology that places visual emphasis on the culture is Print. McLuhan[11] describes the concept in terms of colour:

Sensation is always 100%, and a colour is always 100% colour. But the ratio among the components in the sensation or the colour can differ infinitely. Yet if sound for example is intensified, touch and taste and sight are affected at once.

We have looked briefly at how, and to what extent the technologies of print and photography changed the ratios of human sense experienc. It is now time to look at computing.

The Wapping printers' strike of 1986 signalled the economic arrival in the UK of 'the electronic age'. Digital technology is still dragging the world into a time and space for which intellectuals and cultural workers are still inventing names. The dramatic down-sizing of the print industry in the 1980s was a direct result of the rise of new communications technology provided by the computer. That the printer's demise did not take place earlier was due only to the limitations of the software technology of the time. As soon as the technology was in place, however, the seemingly unlimited possibilities of a digital medium urgently beckoned. With the soon to follow development of WYSIWYG[12] technologies in the early 1980s, the digital method of print production was ready for its annexation of the print industry.

Before the introduction of computers, the design and preparation of printed material was a completely photographic, and hence analogue, process. This form of print production relied on the skills and expertise of a wide range of specialists (designer, typographer, page layout artist/paste up artist, proof reader, transparency/plate maker, printer). Since the introduction of computers, the process of print production has become completely digital. Digital manipulation of text and full colour photographic images now enables a single person to complete a 'print job' from the design stage right through to the plate making/printing end of the procedure. The only person indispensable (to date) to the process besides the designer is the printer.

Waters Design Associates was amongst the first design companies to adopt wholesale the digital design process, which at that time cost many hundreds of thousands of dollars. Even at a time when the technology (compared to today's personal computers) was primitive, the economic incentive in terms of product delivery time and cost-effective use of employees' time and skills was significant enough to invest the huge sums of money required.

One immediate result of the print industry's digitisation was the arrival of the colour daily newspaper. This innovation, until then considered an economic impossibility in terms of cost and production, illustrates admirably the radical possibilities that digital treatment of text and image held for the print industry.

The Future Beckons

WYSIWYG was not the only new technology with major implications for print production. The Internet, already established for many years before the computer's take-over bid for the print industry, promised the perfect environment (McLuhan's 'Global Village') for a completely different form of information exchange, that of electronic publishing.

The technology for McLuhan's electronic age has arrived. It is perhaps the greatest unsettler of sensual ratios that this turbulent history of communi-cations technologies has so far encountered.

Once again, relationships between our communications technologies are shifting and their meanings evolving. If at the beginning of the Renaissance the cultural quake measured a six on the Richter scale, the computer inform-ation technology revolution promises to measure an eight.

0-1, not A-Z

McLuhan describes the technology of the alphabet as 'an aggressive and militant absorber and transformer of cultures'. Writing in the 'Gutenburg Galaxy' [13], he expands:

> Any society possessing the alphabet can translate any adjacent cultures into its alphabetic mode. But this is a one way process. No non-alphabetic culture can take over an alphabetic one; because the alphabet cannot be assimilated; it can only liquidate or reduce.

The 'digital' method of quantifying data is very much like an ultimate alphabet. At the very least, it is possible to say of computers that they are (currently!) driven by electricity and that they are binary. All information handled by computers is written in fundamentally the same language. This is regardless of whether that information is visual, musical, time-based, textual, numerical or interactive. It is this bottom line that makes 'digital' the ultimately flexible language that it is. It is similarity at a fundamental level that makes computers the great upheavers that they are.

Before the computer arrived in the creative world, there were groups of specialists: composers, film makers, painters, publishers, choreographers, woodworkers, weavers, poets, etc. Their tools were highly specialised, and the languages of their disciplines were different to one another. The computer offered a digital alternative to traditional ways of working, often more economical and efficient for artists and designers. The computer can produce a digitally altered photograph that is visually unidentifiable as having been altered. It can produce what many people would call a passable rendition of a symphony. It can publish electronically and produce quality printed material that would satisfy the sternest of publishers. It can model and animate a human figure in a virtual space, viewable from any angle, in an anatomically accurate way, allowing a choreographer to create a dance without hiring dancers. It can also translate the binary description of my DTP document into the binary description of a music document. Sound, text, image, object, animation and film, previously separated from one another by incompatible practices and materials, are now, at a fundamental level, expressed in the same language.

The relationships among the three prime movers of print, photography, and computing are still evolving, but they are rich with possibilities. Let us consider them in more depth.

For print, the computer has rendered all of its historically evolved techniques and idiosyncratic qualities redundant. Its dependence on photographic materials and processes is a thing of the past. Everything except the paper and the ink has become unproductive, uneconomic, non-existent. Whereas the painter's art is one that emerges out of magic, no print was ever commissioned without regard to economics. This statement refers just as much to the fine artist's print as to the commercial print, even though the reality of economics may be glossed over or ignored in the practice of the former. Materials, consumables (solvents, rags, inks, etc.), workshop rents or machine costs all demand an appreciation of economics. If that appreciation is absent, the fine artist will become bankrupt sooner or later.

For photography, the digital language has deep implications. Digital photography has proved to carry with it the loss of photography's claim to being society's champion of truth. The camera that never lied is making up for lost time with huge quantities of often crude visual untruths, liberally saturating the newspapers, magazines and adverts that surround us. The assertion that the camera never lies is, of course, a myth, as can be seen from the earliest days of photography, and that digitally propagated photographic untruths abound is more a case of visual carelessness than grand conspiracy. But if we previously could not see the photographic image as capable of distortion and deception and now (as a result of the computer) we can, are we experiencing a similar revelation to that of a hundred years ago, when the veracity of print was undermined by the new technology of photography?

'Computer Printmaking'
Analysing the products of computer printmakers, we become quickly aware of the bewildering array of different relationships that exist between an image and its status as print and between an image and its status as computer art.

Looking at the 'computer print', there are various ways in which the computer can be said to be involved. The most involved use of the computer in the context of the 'computer print' must be in the instance of that artwork that is simultaneously about the computer, manufactured on the computer and printed out by some computer-operated output device. The least intrusive use of the computer in the context of the 'computer print', is the digitally colour separated image presented as photograph, screen print, lithograph or etching. The computer can appear completely present in all aspects of a 'computer print', or it can invisibly simulate an existing technology. If these respectively opaque and transparent examples represent the poles of the computers involvement in a 'computer print', there is room for every nuance of computer involvement in between.

Taking the 'printmaking' aspect of the term 'computer print', this manifests itself in similarly diverse ways. A computer print may, on the one hand, be completely produced through software and hardware, using devices such as laser printers, colour Xerox copiers, pen plotters, Ink Jet printers, Dye Sublim-ation printers, etc. In this instance, the artists hands may have touched nothing other than the keyboard and the pencil that signs the print. On the other hand, a computer print may be the result of a completely autographic or photographic interpretation of digitally-created source material via the media of screen print, lithography, relief print, letterpress or etching.

The Problem with Computer Printmaking
What will have become clear from this constellation of ideas is some sense of the fatal attraction that exists between print and computing, a sense that the technology of the computer cannot be other than of central importance to the development of print, a sense that the artist printmaker now holds the reins of a medium whose destiny is inextricably linked to the developing technology of the computer.

But there is a problem with this body of work that identifies itself as computer printmaking. To qualify as a computer print it is often only necessary for an artwork to be something on paper that is generated by a computer. In the light of the ideas discussed so far, this definition of the computer print seems a little impoverished as a response to the relationship between the print and the computer. There is, of course,

the objection that any criticism (along the lines of that above) misses the point that this is the nature of the new medium, and that a viewpoint so expressed springs out of a reticence to move away from traditional models of art practice and understanding into new forms of art. However, it is not very hard to redefine the problem in such a way that this objection can be neatly overcome. Imagine first that I take a series of photographs and, using the techniques of John Heartfield [14], create a skilful photo-montage. Then imagine that I take that same series of photographs, scan them into a computer, execute the same montage using image manipulation software and output the result as a high resolution black and white negative for development on photographic paper. The computer's incredible powers of simulation (in a Baudrillardian sense) would allow me to create the ultimately convincing digital illusion of a hand developed photo montage, to such a degree that the true heritage of the image would be visually unfathomable. But to what extent is this a computer print?

Alternatively, imagine that I make a series of drawings, colour separate them using the computer and print the images as screen prints. To what extent is this a computer print?

My point is this: both of the above examples use the computer in conjunction with print and yet the emphasis in the production of these images is either reproductive in nature, or a simulation. The qualities of the Computer itself are as absent as the aesthetic and material qualities of the print are ignored. In both instances, the less awar we the spectators are of the involvement of the computer the better. The use of the computer in the production of these images is solely as a replacement for already existing, but more expensive /time consuming, processes.

The graphics industry, which pushed onwards the development of digital methods of print production, has been using the technology that is now becoming available to artists and printmakers in exactly those ways described above for nearly ten years now. Graphics, however, is still graphics. It is not 'computer printmaking' and yet it uses the technology in exactly the same way that the 'computer printmaker' often does.

Imagine now that I have made a computer image using a paint software package. In the resultant printout, it is my goal to represent the on-screen image as accurately as possible. To what extent is this a computer print?

Although this may at first seem a more likely candidate for the title of computer print, it strives to reproduce an image created with luminous light as an image realised through reflected light. This initial paradox is followed by the realisation that not only has the most important quality of the original image been sacrificed, but the image's status as print is irrelevant as long as it creates the satisfactory illusion, or at least alludes to its on-screen appearance. In this case, as opposed to the two examples above, the involvement of the computer is plain for all to see. However, it is central to this last image's success that the print side of the equation be as invisible as possible. This is not to deny that the final printed image is indeed a print, since that is clear to all, but the print involved must exist in such a way that it does not enter the viewer's consciousness as a variable to be accounted for in his or her understanding of the image.

I am not simply drawing a distinction between fine arts and commercial uses of computers and print, but revealing a symptom of the fact that computer printmaking seldom has anything to do with print in terms of what the history, materials and processes of the medium bring to the finished artwork.

Towards a Printmaking Practice Aware of Computing

Given that the medium of print has been directly and radically challenged by the rise of the computer, it seems natural that printmakers would have a powerful motivation for getting to grips with the new media of digital imaging and print production. Indeed, in many art colleges it is the printmaking departments that have pressed for computer equipment long before the sculpture, painting and time-based departments. Unfortunately, looking at the artwork emerging, it seems the significance of print (socially, culturally, aesthetically and technically) in the computer print equation is mostly passing the contemporary printmaker by.

The translation of culture from one form into another; the new and the old locked in a struggle that can only result in the supremacy of the new; the culture of literacy versus the culture of the tribe – this is a rich territory of ideas, and one of immediate relevance to the future development of society and culture. But where is the artwork of the printmaker who is aware of these ideas? Printmakers should be looking at the disparity between the digital and the analogue. The computer stands in complete opposition to many of the central principles of the society based on print technology. By using the technologies of print and computing in the same artwork, we are using the same building blocks of incompatibility that are apparent all about us. Print is challenged by the computer whether we acknowledge the fact or not. Where once we were unable to see the character of the medium of print because of its ubiquity, perhaps we are at present unable to see the character of the computer. Since the computer has taken hold of our society, print and printmaking have found themselves exposed in a radically different cultural context to the one they originally engendered. The cultural, social and intellectual tensions that thrive in that space between the digital and the analogue dwell also in the place where print meets computing.

Conclusion

The ideas herein developed through my art practice. They lead to no single thesis, more to a collection of relevant associations and facts. When I first started looking at computers I was interested in them as 'a curious (if not slightly alarming and alien) thing' to come to terms with and not as a potential tool. What always interested me the most about them was their essential character. Yet the computer is the grand simulator; it is always in disguise – as word processor or photo montager, for example.

Special effects have never engaged me in the way that failed special effects have and it is with the eyes of a 'failed special-effects' spotter that I approach the technologies of print and computing. The idea of using commercial software in order to make obedient, prescribed pictures seems contrary to the business of making art. When Microsoft asks me where I want to go today, I immediately think they are inviting me to Hell.

Amidst all the noise being made by artists and cultural commentators about the radical new possibilities of computer aided art, it pays to remember that more often than not we are looking at clumsy and superficial entertainment with extra bells and whistles. Computer printmaking often falls victim to the techno-evangilstic streak in artists and it is symptomatic that the great majority of computer prints are insubstantial and lacking truth to the media and materials that enabled their creation. By and large, however, the computer software we use as computer printmakers was

manufactured for industry. Its primary function is to provide the client with increased productivity for less expenditure. This means that the software can deal only with content since the form (the computer) is always in disguise as something else.

Printmaking sits at a crucial junction in its development. Print has had its heyday as the organising influence behind the structure and management of our societie,s after conditioning and guiding the development of Western Europe for 500 years. Its strength as a contemporary artistic medium lies in the tension that currently exists between it and the computer. The relationship of print to the computer is a strong one (indeed microelectronics would not exist if printmaking technology had not provided the means of production of circuit boards and integrated chips). It was a print based society that invented the computer.

Contemporary printmakers must decide whether or not these relationships between computer and print are relevant and useful. If they are, then we may look forward to an exciting explosion of interest in a medium that has, up until now, been largely undistinguished in the arena of avant-garde contemporary art. If they are not, then the traditional printmaker will doubtless rumble on unconcerned, making backward-looking illustrations for an era on the brink of eclipse.

References

1 Ivins,WM (1969): *Prints and Visual Communication.*, p3. New York: Metropolitan Museum of Art.

2 McLuhan,Marshall (1965): *Understanding Media: The Extensions of Man.* New York: McGraw-Hill.

3 McLuhan,Marshall (1962): *The Gutenberg Galaxy: The Making of Typographic Man.*, p141. London: Routledge and Kegan Paul.

4 ibid.

5 ibid, p72.

6 According to McLuhan, print places a visual/linear emphasis on culture in several ways. Compare the reading of a manuscript to the reading of a typeset book. In the former, the text is read aloud. The character of the calligraphy is idiosyncratic. It is difficult to read a manuscript faster than it can be read aloud. In a teaching situation, the manuscript is aurally given to the student, who then transcribes the dictation, conveniently providing their own copy of the textbook in the process. It seems clear that this form of reading is more aural than it is visual. The way a type set book is used is very different. The regularity of the letter forms allows for a silent reading. The writer becomes an author and not simply a scribe. A change in habit has occurred and for McLuhan this is symptomatic of an aural culture becoming a visual one, a culture which relies on the eye for its information and not as previously, its ear.

7 A ruled cross-lined half-tone screen is the print term for the technology by which a photograph is translated into a printable form. A newspaper photograph, made up of a lattice of dots is described as being a 'half-tone' image.

8 See ref 1, pp178-9.

9 See ref 3, p72.

10 Hey,T. and Walters, P. (1987): *The Quantum Universe.* p.59. Cambridge: Cambridge University Press, gives a description of this microscope:

 [It] consists of a very sharp needle point that surveys the surface of a specimen very accurately. When a high voltage is applied between the surface and the needle, electrons can tunnel from the tip of the probe to the specimen under investigation. This tunnelling current is very sensitive to the height of the probe above the surface. In the microscope, the height of the needle can be adjusted as the needle moves over the surface so that the current remains constant. In this way, the up and down movements of the needle map out the detailed contours of the surface…

11 See ref 2.

12 WYSIWYG stands for 'What You See Is What You Get'. This refers to the relationship between what a desk top publisher sees on the computer screen and what appears out of the printer.

13 See ref 3, p50.

14 John Heartfield was a German artist associated with the Dada Movement who made convincing photo montages using analogue photographic materials and techniques.

Jeremy Diggle is an artist who trained as a painter at St.Martins and the Royal College of Art in the 70s and 80s. He taught time-based and multimedia art within the Fine Art course at the University of Plymouth, Faculty of Art and Education, in Exeter. Jeremy is now Professor and Head of School at Gray's School of Art. He has exhibited widely in both Europe and North America, the work with which he is most associated is questioning the relationship between humanity and technology. This has been particularly reflected in work such as the holographic 'Memory Wreck' series of the early 80s and in technologically referential installations of the late 80s and the 90s. Included amongst these are '*69200 a cosmological model*' and more recently the multimedia works '*Carpet Bomber*', '*Field Glasses*' and '*Vision*'. His most recent work is the narrative, multimedia CD-Rom set and installation work and web site '*The Globe conservator*' and '*The Salmon Fishing Woman*'.

Jeremy Diggle

A year and a day on the road to Omniana

As artists working with computers, what exactly are we creating? What is going on when we confront the user with a computer art work? Communication most likely, if not it's a non-starter, regardless of any reference it might make to other art genres. All media create fashions, conventions and rules which are variously lumped together as styles, techniques and forms. These are generally integral to the identity of the artist or artists who originate the work. The history of art shows us that these are multifarious. Currently a lot of computer artists are working in multimedia but is the art that they produce necessarily multimedia art?

Multimedia is the most significant area of activity for the majority of artists currently engaged in the use of computers for art. This is the case whether the artist is ultimately dealing in virtual realities or producing hard copy. The impact of multimedia upon our conception of what can be achieved in the realm of art cannot be underestimated. For the artist, working with multimedia is different from preceding forms of art- making. Computer multimedia platforms and software offer us a virtual set of media tools and what we produce with them and the way that we use them can become uniquely their own. Multimedia is a conglomerate, but can it be a hybrid medium in its own right?

74

As artists we must be careful not to straight-jacket our thinking; careful not to define too clearly what multimedia computing is by adopting, at the very root of our creative process, the mechanistic and modular term 'multimedia'. If this is our structural model for the creative process, we might miss a potentially liberating opportunity. Multimedia computers are our tools, multimedia software is our technical support, the art activity is something else.

Artists have the potential freedom to work in an ever- increasing range of media. We can acquire from extensive communications networks, such as the World Wide Web, large amounts of information as text or imagery. Artists, for the first time, can begin to bring together fragments of all things. The unique potential of multimedia is that it brings together a full orchestra of powerful communication instruments within one platform (onto one stage). One keyboard and a handheld mouse that acts with the score as a baton of control for co-ordinating the various instruments of the multimedia orchestra. To use another analogy, we could think of multimedia as the painter's palette. The mouse/key board combination is the brush for working the individual palette items onto the surface. Using the first analogy, we can conjure up the image of an auditorium, with the second, perhaps, a blank canvas. In the auditorium the instruments of the orchestra are replaced by moving light and drama. Sound is there, of course, but so are text, photographs and digital movies. This multimedia has a cast of powerful performers. This can be the opera or the ninth symphony of the multimedia artist. The imagined blank canvas, similarly, has its expressive field filled with colour and movement. Possibly figurative, maybe purely abstract with dynamic, moving, geometric and morphing forms that slip into narrative.

There is a delicate balance required of the artist here. At its most banal we have the potential relationships of sound and coloured light, text and narrative conforming to the structure and mind set of shoot 'em up games and crossword puzzles or, worse still, corporate marketing aids.

For a more romantic, conceptual model, take again the blank canvas of our earlier analogy. Imagine the digital, blank canvas as metaphor for the human skin. Imagine that this most primal surface for painting now seamlessly metamorphoses into the reflective face of a mirrored window. This surface becomes liquid, the surface of the sea, with the colour (the multimedia palette) just poured in. The sea water evaporates, forming clouds. The rain falls. It is collected, bottled and drunk. A total absorption of the multimedia into our thinking has taken place. Internalised, it is converted into energy and then into thought. Multimedia becomes an interdependent element of our thinking with no clearly identifiable barriers between any of its elements. The modular multimedia of separate elements is perceived holistically and absorbed into our thinking. This is omniana, where the user stops thinking about the range of media and starts to deal with the interrelated fragments of all things as one interdependent realm within which to work. Thus can multimedia software be used as a single instrument at the disposal of the artist to create meaning and to communicate. This is what I call omniana.

But what else is omniana? Well, it certainly isn't a place hidden over the next horizon. It's not a virtual Shangri-La. Omniana is quite real and its potential lies in the fragments of all things brought together and given form. Omniana is a way of

working that encompasses the full range of media and ideas available to us. It does not, however, need to be all-inclusive at all times. (When dealing with an idea that might encompass fragments of everything, much of the work lies in deciding what to leave out). Omniana at its simplest is a liberation from the self-consciousness of attempting to work in a multiplicity of media. It is one media.

To be a manipulator of multiple media forms is to fail to escape the preconceptions and rules of established practice within each as an identifiably distinct medium. The potential of the new multimedia platforms is that they are neither individual nor combined media. Multimedia becomes intrinsically a medium of its own and the way that we choose to use the potential of this medium is all important. Thinking through the requirements of an idea, we can draw upon found and acquired materials. We can work in a free-ranging way with fragments of all the things that are available to us. We can connect to information of all kinds and borrow from the massive collections of data and artefacts available globally. This synthesis ranges through human thought, language and science, absorbing elements from perhaps all religions and philosophies without barriers. The only barriers are those of our own conventions.

The work does not even have to exist solely within the machine. It can have a real correspondence to the world. Virtuality is but one dimension of the omniana experience. We can choose to use any quantity of information - microscopic or macrocosmic. The traditional venues for the artefact are not necessarily relevant as omniana is no longer necessarily a physical art. It can be, but it can also be all things to all users. The key is to use the new and improving capabilities of graphic-based multimedia machines without the burden of preconceived rules for the individual elements. In fact, forget that there were ever individual demarcations between forms of communication. That was past practice; the moment is now.

There is no need to look to the future - that is, to be futuristic when acting in the present; moving beyond the past and entering the future is the reality. The user can interact with or be led by, or can input or respond to, forms and environments created in the machine. These created environments are not limited to the machine, to its screen or to fixed location in time and space. The computer can increasingly control and effect external objects within both real and virtual environments. It can control sound, light, digital film, virtual reality, electrical switches and external objects. The subject and material of art, therefore, which may include music, sociology, politics, subjective and objective thought, history and philosophy, can all be explored in non-linear interrelationships and can be given form. Its form derives from a mighty stream of potential and the artist constructs this form within the computer for the user to extract and make sense of through interaction.

Where in the work does this interactivity lie? It seems that at present it lies in the notion that if the user has to move a mouse, make a keyboard command or move an object on the screen then the work has fulfilled its function of being interactive. Increasingly in fact, the term is spreading beyond the computer world and into common parlance, to mean anything that makes the viewer or audience respond in any way, whatever the merit or conceptual validity of this so-called interaction. I recently had a painting described to me by the artist as interactive. This claim was made because viewers could construct any narrative interpretation of its content that

76

they so wished, particularly as it contained a passage of painting in the tradition of anamorphic projection. (An anamorph is an image that is so distorted in its rendering, owing to mathematical manipulation, that it reconstructs either an acutely angled view or one reflected on a distorting plane. At first it appears to be one thing and then another. The most famous example of this in the history of Western art is the skull at the feet of the Ambassadors in Hans Holbien's 'Ambassadors' painting of 1533.) This particular anamorph represented, at one and the same time, an apparent landscape and also a view of water seen from another angle. This surely is not true interaction but merely a game of hide and seek. As a device this can be very interesting and is full of potential but it is not interaction.

A painting is inanimate. It cannot react to the viewer but can only offer up its secrets discreetly. Viewers can fool themselves into thinking that an interaction is occurring between themselves and the wit and intelligence of the artist. The transaction, however, is all one-way (artist to viewer); no transaction at all. So what can interactivity be? Interaction, by definition, requires a reciprocal activity, one which operates between participants. There is a strong argument that the internet offers an environment within which reciprocal interaction can take place between artist and audience. But is interaction necessary?

A Year & A Day

At this point I will illustrate my argument with an art work created for an Arts Council commission entitled 'Emotional Computing'. 'A Year & A Day' runs on Macintosh computers and can be downloaded from the Arts Council of England internet server site: The HUB (http://www.ace.mdx.ac.uk/Hub/Hub/.html). The restrictions placed by the commission on the work were that it had to be interactive, should work on an emotional level and should be no larger in file size than could be downloaded onto a floppy disc (1.4Mb). Its primary distribution is via the internet to a user's floppy disc.

'A Year & A Day' is a work to which an audience of any size can relate. My main intention was to create a situation where it was possible for the user to input on a regular basis. 'A Year & A Day' works as a clock: it measures time. This is not done by numbers but by the passage of time being delineated in small changes in the image or marked by sound tolling significant moments. The piece introduces the user to its key graphic elements systematically on opening and in doing so provides the procedure for using the work.

Its introduction is very straight-forward. It starts with an extinguishing of a candle. There is a title page introducing you to an image of a candle and the tolling of a bell. The next screen sequence includes a dedication to Andrie Tarkovsky (the Russian film director who died in 1986). We are introduced here, for the first time, to the possibility that the work is an aid to memory, for instance as an act of remembrance or mourning. There is the sound of a tumbling, spinning coin; a sound evocative of the work of Tarkovsky. The next screen presents us with the animated flame cursor, a key symbol through out the work. Here is a red screen with the word 'Month' and a number beside it. By moving the mouse the flame cursor passes over the word 'Month' and if it passes over the number then the number becomes progressively larger. If the flame is moved back to the word 'Month' then the number decreases. The user is thus instructed in the primary control of the cursor operation as the key to

accessing the work. By moving the flame over the numbers they increase until they reach 13 at which point the screen adds both textual information (telling us to move the flame cursor over the words in order to progress) and the sound of water pouring. Thus we are taken through several pages of textual information about the work to come and have reinforced both the use of the cursor and the role of sound within the piece.

The final introductory screen offers us three choices for accessing the work: by starting at the beginning of the 366-day vigil, by choosing a month from one to 13, or by accessing it for one day only. When choosing to start for a year or for a day the work branches to the main score script and opens the work at day one of 366. If, however, you have chosen a month at which to start, then the work branches to an intermediate screen where you can choose the number of the initial month. Those who choose the thirteenth month as the shortest route to the end of the piece are redirected to the beginning of the twelfth month. The work requires as a minimum participation a vigil of eight weeks.

On starting the work proper the user is confronted by the image of a sleeping form, apparently human. The body might be floating, as if levitating, but it could also be in suspension; this is open to interpretation. Levitation has a significantly different conceptual meaning to suspension. The figure appears to be sleeping rather than dead because it can be heard to breathe, and our experience tells us that whilst the breathing is not troubled, neither is it completely relaxed. The work draws upon our interpretative and natural instinctive capability to read an image or a sound. This sleeping figure does not attempt to interact with us. It lies there rich with potential; it is latent.

An opportunity is immediately presented to the user to respond to the program running on the screen. A flame is burning in the bottom right of the screen and a candle in the top left. The lower flame is alight, the upper flame is not. Tradition and ritual tell us that we can, and probably should, light the candle at the top. There is a message on the screen that tells us to light the candle, reinforcing what is probably an instinctive act. Provided we have already learnt the rules of multimedia, we also understand and expect the potential to be there to move this flame. When the flame has been dragged by the cursor to light the candle, the sleeper is lit up by a white light source. Of course, all of this reality is only virtual but its strong visual and symbolic correspondence to reality is such that the flame seems real in all but heat. Certainly in an emotional and symbolic sense we have lit the candle; we have entered the vigil, even if only momentarily.

Nothing else, however, appears to be happening; but within a minute a small symbol appears beneath the sleeping figure. This symbol has been randomly selected by the program from a pool of potential symbols, one of which will appear in the same position on the screen every minute. These symbols all have precise definitions and uses in the real world; they are classic examples of speech without sound. Some have religious meaning; some chemical and others directional. This sequence will continue for two hours until the candle appears to be extinguished by a draft or breath from off the screen. The figure is returned to virtual darkness and the sound of a bell tolls once. The bell and the virtual darkness are a call for us to (symbolically) tend the body.

78

A text cursor now appears and it is possible to input four or five lines of text at this point. We have only a minute to do so and if we miss this window of opportunity the program moves on. The body is now in another virtual light - blue – and will remain so for the next two hours at which time it will again be possible to tend the flame. If the flame is tended then the body is again illuminated in the white light. Symbolic forms continue to appear relentlessly on the minute, marking the passage of time. The text which is input every two hours, will reappear exactly 24 hours later and can then be edited or replaced. At the beginning and end of each day there is an opportunity to enter as much text as you may wish into a scrolling text area beneath the reclining figure. When the candle is lit or left unlit there is a pause (a time out) of one minute and 40 seconds during which any text is absorbed and may or may not reappear 24 hours later. Throughout the year there are five scrollable text boxes in operation and therefore text will eventually reappear and can be edited, add to or replaced.

The work soon becomes a continuing, day-by-day, hour- by-hour diary or vigil. It has the potential to become a multi-user platform for communication or an individual meditation upon the passage of time. The sleeping figure can symbolise a friend, a lover, someone departed or ill or it can be an image of oneself. The possible interpretations are manifold. The longer the work is running, the more important it becomes to be aware of the stability of the computer unit. Computers crash. A piece that runs for such an extended period is going to require vigilance over the power supply and the machinery. The vigil, conceptually framed within the program, starts to become apparent as a physical vigil over the machine itself. This goes beyond the conventional, multimedia, virtual reality and enters the world of physical reality, time and space.

The program is very long and therefore the computer's ability to access data becomes slower the further into the program it gets, particularly bearing in mind that the text inputs are placed directly into RAM. As the program nears its end the action of moving the flame to the candle at each interval becomes more laborious (more physical) since the mouse is considerably slower to move the flame. The last day is much the same as the first but now the screen image changes from that of the preceding 365 days. The figure is still there but this time appears to be absorbing into itself all the activity of the previous years. It doesn't get up and walk away or resurrect itself but the user will realise eventually that this process of absorption will not end without intervention. The user can, however, by following a simple cursor procedure, move deeper into the program and be presented with all the text that has been input throughout the year. The flame is still burning; a window at either the top left or right indicates the way to move on but you can wait at these screens indefinitely. You can scroll through the text and idle. When you attempt to move the cursor, it moves painfully slowly. There are five screens of text in all. Once you have moved on beyond the text there is no returning, the data is lost irretrievably.

A final lighting of the candle takes you to the last screen on which is a full screen still life (tableau mort). The flame burns on. We realise that we cannot return, we can only watch. Eventually we must turn away or turn off the machine. We have to switch off the life support, power down and start again.

Using a multimedia workstation without being overtly conscious of the distinctions between the elements of the media available can leave one's thinking free to focus on making the work and using the tool to do it. 'A Year & A Day' was thought through as a complete concept before it was made. The idea was formulated both with knowledge of the capabilities of standard workstations in mind and for a specific format required by the commission. The piece clearly can only exist within the computer. The means of distribution determined the extent to which the idea could be developed. Given greater opportunity to use more memory, the work could be more graphically sophisticated and a number of additional, visual options could have been used. The work was conceived solely as a work for the computer screen. It is intended to be interactive over an extended period of time, allowing the number of users to vary. This means that the work could become distinctly personal either to an individual user or between collaborative users. The piece is technically straight-forward, its only major problem having been the development of a script that would allow the work to run for as long as 366 days whilst retaining the possibility of inputting to it every two hours, all within constraints of the 1.4Mb storage limit. The images were made by drawing and visualising the screen environment and the character of the sleeping figure; entering the visual information into the computer was trivial. Once the visualisation had taken place it was simply a matter of finding the material to drape over the body, setting up a video camera on a tripod to record the scene and then lying on a table to become the model. The video image was input directly into the computer. The images I wanted to work with were selected and then manipulated in Photoshop but at no time was I consciously aware of using photographic or video media as such (in the sense that these might be different media). They simply became the imaging process, an extension of the visualisation process in the mind and on paper. Positioning the images on the screen and in the Director score was straight-forward and changing the colouring of the figure according to conditions within the script was both an aesthetic and symbolic consideration.

Developing sound within the score followed a similar pattern of events. I could imagine the sounds that I required as part of the dramatic nature of events and it was simply a matter of finding corresponding sounds in the real world and recording them directly onto the hard disc. These sounds were edited and reduced in file size and then imported to the score. Once again the activity was not one of self-conscious audio recording but a case of acquiring directly that which would form a synthesis with the whole. All aspects of the piece were worked upon not as independent parts but as a whole - a conceptualised, interdependent set of fragments.

Conclusions
Digital multimedia offers artists a completely fresh set of possibilities to those that previously existed. They afford the artist access to an extensive range of technical facilities and expertise that would previously have been undreamed of. The personal computers that are now available to an artist are the personal super computers predicted in the 1980s. The investment of time and money needed to appropriate the range of media which is synthesised by multimedia software and workstations would have been beyond most practitioners before the advent of these new machines. Similarly, a working knowledge of the technical procedures needed to utilise such a

vast range of media effectively would have previously taken many years (and favourable circumstances) to acquire. The computer now offers the potential to work in many combinations of media and also allows for the integration of multiplicities of forms of communication and thought. It is these combinations that have become known as multimedia (e.g. digital video, animation, audio recording, photo processing and text in combination).

Artists are now in a position to liberate themselves from the restraint of having, in the first instance, to acquire process-specific technical skills since it is possible today to acquire most technical skills virtually in the form of software. There is clearly a wholly new potential for an artistic viewpoint in the development of this new medium of communication in both the arts and the sciences. We currently call it multimedia and it requires skill to use it. This skill, however, is different from any specific to the individual technical skills associated with the constituent media embraced by multimedia. The skill lies in unifying the constituent parts. The difficulty lies in applying these technical facilities to making sense of our world and to communicating with others. So multimedia is effectively the potential to use a number of media forms in combination, through software that integrates them into a rational set of cross-referenced relationships.

A temptation for the artist is to mimic the already established forms of production. For example, when using an element of digital video the material is made to conform to the structures of film and video editing genres: a photograph is inserted as an illustration, text is used as explanation and graphic events unfold in time like those in a board game. It is so easy to put all the elements of an idea into separate compartments and to deal with them as individual elements as if in an unfolding linear narrative. Video, sound and text in motion move and animate the screen. Annotated text quickly creates references within the work, not only illustratively but linguistically. The potential for non-linear relationships within the computer environment can blow conventional structures apart.

We now have a powerful tool for illustrating arguments, expressing ideas and providing a platform for aesthetic hybrids. For the artist, a remarkable potential is opened up by the ability to make previously unrealisable connections between the elements of a work in time and space in a non-linear way. The old convention of a story unfolding as a series of events in a specific fixed relationship in time and space is no longer sacrosanct. The artist can now create a series of edited elements to form a pool of material from which the computer can access and construct strings of events in response either to user input or simply by random selection. The artist can pre-ordain all possible combinations of a time-based sequence in any relationship in time and space. The artist can build in annotations or multiple media relationships between external objects and events. The artist can orchestrate and structure a vast number of pre-determinable fragments. A work can be different every time it is used. Giving form to omniana is the challenge for multimedia artists.

Martin Rieser was born in 1951 in London, and educated in English Literature and Fine Art. He has exhibited internationally using a variety of media, including graphic arts and photography. He works as a lecturer, writer and media artist. He curated *The Electronic Print* (Arnolfini 1989), and directed *Media Myth & Mania* for the *Silver to Silicon* CD–ROM (1993), exhibited at Watershed Gallery (Bristol), Focal Point Gallery (Southend), Photographer's Gallery, London, ICA (London), Milia(Cannes). Interactive exhibitions include *Screening the Virus* website (ArtAids 1996), *Understanding Echo,* Interactive installation (Cheltenham Festival of Literature 2000) and *Labyrinth,* CD-ROM and installation 1998 (F-Stop, Bath), *Electronic Forest* interactive installation 1990-91 (Prema/Bristol). He has presented papers and work at international conferences including the Oberhausen *Kurzfilmtage,* Germany 1997, ISEA 95 Montreal, ISEA 96 Rotterdam, ISEA 97 Chicago, *Creativity and Cognition* 1999 (Loughborough University). He has been involved with digital media as an electronic artist since 1981 and has worked intensively with interactive multimedia for the past ten years. Currently he is Senior Lecturer in Digital Media at Bath Spa University, formerly he lectured at Napier University Edinburgh and the University of the West of England, Bristol.

Martin Rieser

The art of interactivity: interactive installation from gallery to street

Introduction

In this chapter, although I intend to concentrate on examples of haptic or physically responsive interactive art in 'real' space and time, I recognise here a fascinating problem of definitions. For 'space' in the late 20th century also means the infinitely expanding region of cyberspace and the web. The philosopher Paul Virilio's term for this advent of virtual technologies, or bifurcation of our realities, was the 'accident'. I do not give these two realities equal status, but recognise that they now co-exist. The same syntax and grammar of experience applies to both types of digital art. What Virilio also makes clear is that the new technologies are progressively diminishing

and even finally eliminating a fundamental condition of human perception: spatial distance, and with it the conceptual distance between subject and the object. In his reading 'distance' is a positive quality of vital importance to the development of meaningful art. For Paul Virilio an evolutionary 'accident' has occurred and the universe is henceforth split into two competing, but equal realities: the virtual resulting from an accident of the 'real', asserting that a 'substitution', rather than Baudrillard's 'simulation', has occurred.[1] The artists in this discourse are living with and examining the contradictions embodied in this 'substitution' of realities. Thus at the end of the 20th century, the question for artists has become not the authenticity of the image and its relationship to a set 'reality', but who controls the generation of simulations or substitutions and the context of their presentation. New practice in digital art is intent on creatively exploring these issues of control. The gap between non-digital practice and technological art is finally closing after many years in which form supplanted content.

This leads us to the question of interactivity. Is this the defining feature of new media installation? In most cases on-screen interactivity of the point and click, variety is almost invariably put to trivial uses. While interactive games give immediate feedback in terms of action and reaction, they clearly do not engage the whole person in the same way as a novel or painting, usually leaving no imaginative space in which to do so. 'Interactivity' on the Internet, even in Net Art often seems to most resemble the use of a glorified encyclopaedia (indeed we still talk of web pages and bookmarks); CD-ROM looks like a dying technology relegated to the 'edutainment' sector; Interactive Television offers home shopping as its level of audience involvement and Virtual Reality has become an entertainment fairground ride. Where then can one locate the promised potential of digital media as an artistic vehicle? The truth is that old forms of media habitually graft on to new forms in a highly unimaginative manner, until they mature by stages into unanticipated means of expression. Photography in its early days mimicked the forms and appearance of oil painting. It was only through the recognition of its unique response to framing, time and motion that a new language could be created. Luc Courchesne is a media artist whose long engagement with interactive narratives and expanded cinematic interfaces has led him to the same conclusion:

> A formula that perfectly integrates medium, content and participants has still to be invented and developed. Once it is found we will have the basis of an industry of new media turning the spectator into a visitor and the storyteller into an author of worlds in which the visitor is invited to behave and bears the consequences of his or her actions.[2]

Certainly public understanding of interactive forms is severely limited. Throughout the 1990s, institutions like ZKM in Germany, Banff Centre for the Arts in Canada, NTICC in Japan and Festivals such as Ars Electronica led the way in developing new media installation art. Technology was central to the early interactive artworks of the 1990s, but content was often an afterthought to a cleverness of interface and a largely uncritical techno-fetishism on the part of some artists.

> Media technology is now often seen as the leitmotif from which all social, cultural and economic changes shall emanate. Today, for instance, the meaning of

'interactivity' is essentially defined through the electronic media. Interface and software designs specify the framework of this technologically determined interaction from human to human via a machine, or solely between human and machine.
Dieter Daniels[3]

Later in the decade, this began to change. However, this experimental work has been largely ignored by mainstream art galleries. At a recent conference session at the Tate Modern, discussing the role of new media in the gallery, the majority of the audience clearly had no knowledge of the recent history of interactive installation.[4] Although galleries showing video installations playing from DVD are now commonplace, galleries supporting truly interactive work are still relatively few.

Haptic Interfaces
This brings us to the principal subject of this paper, the nature of physical interaction. Two strategies – intimacy or collaboration – are both legitimate modes for the experience of interactive art. One of the pioneers of such interactive artworks was Jeffrey Shaw, now visual research director at ZKM. Perhaps because of his background in architecture, Shaw has always included strong physical elements for interaction in all his works.

His famous piece **The Legible City** (1989) combines a highly physical interface with virtual reality. The City is a computer controlled and projected virtual urban landscape made up of solid three-dimensional letters that form words and sentences instead of buildings, along the sides of the streets. The architecture of text replaces exactly the positions of buildings in a plan of the real cities (New York and Amsterdam). This spatial transformation of narrative is literal in every sense. The viewer navigates the virtual landscape by the physical act of pedalling a bike. Bicycling through this city of words is a journey of reading, choosing a direction is a choice of text and meaning. The image of the city is projected on a large video screen in front of the bicycle, which is fixed like an exercise-bike.[5] His **'Revolution'** (1990) was an interactive videodisk installation which allowed the user to turn the mill of history, tracing 200 years of turbulent history from 1789 to 1989. The considerable physical effort required to turn the installation on its own sufficient to give 'gravitas' to the content, demonstrating a perfect synchro-nisation of metaphor and interface.[6]

In **The Golden Calf** a flat screen with gravity sensors altered a 3D image of the calf, orientated to the viewer's physical manipulation of the device in 3D space. In later work Shaw has developed work with viewing systems that interact with the audience's gaze in the round, extending the 19th century panorama experience into the computer age.

While Shaw's works required a single user, Perry Hoberman created another experimental interface, which prefigured multi-participatory public works, at the Banff Centre in Canada. **Bar Code Hotel**[7] was an interactive environment for multiple participants. An entire room was covered with printed bar code symbols and an installation was created in which every surface can become a responsive object, making up an immersive interface that can be used simultaneously by a number of people to control and respond to a projected real-time, computer-generated, three-dimensional world.

Each 'guest', who checks into the Bar Code Hotel is given a bar code wand. Because each wand can be distinguished by the system as a separate input device, each guest could have their own consistent identity and personality in the computer-generated world. In addition, since the interface was the room itself, guests could interact not only with the computer-generated world, but with each other as well. The objects in Bar Code Hotel were based on a variety of familiar and inanimate things from everyday experience: eyeglasses, hats, suitcases, boots, teddy bears, paper clips, cheese wedges, bread loaves etc. move around the virtual space, under the control of the bar code wands of the users in the room. The artist anticipates the objects' behaviours, defining the limits of the space, determining what happens when they collide, etc, so that all such possibilities are considered in advance. After such choreography, whatever happens within the space, whilst algorithmically determined, is still quite unpredictable. Thus the co-dependence of our two universes (virtual/real) was established through the simplest piece of supermarket technology.

In 1995, through the direct physical control of breathing, Char Davies's **Osmose**[8] allowed the participant to explore a poetic virtual universe. In the form of a virtual reality vest and headset, this interface provided real-time motion tracking based on breathing and balance. This meant that viewers could inhale to rise and exhale to descend and could move forward or backward in the virtual space by leaning forward or backward in the physical world. Viewers navigated a complex world made of natural forms, such as trees, and synthetic elements, such as three-dimensional Cartesian wire frame grids. Because of the unusual interface, many participants found it parallel to near death experiences, particularly as the virtual world throws you out at the end of your time slot, by shrinking to a bubble in infinite space.

The public installation of **Osmose** included large-scale stereoscopic video and audio projection of imagery and interactive sound transmitted in real-time from the point-of-view of the 'immersant'. This projection enabled an audience, wearing polarizing glasses, to witness each immersive journey as it unfolded. Although immersion took place in a private area, a translucent screen equal in size to the video screen enabled the audience to observe the body gestures of the immersant as a silhouette.

Her most recent work, entitled **Ephemere** (ephemeral in French), was also created with a team of designers and programmers and premiered in 1998 at the National Gallery of Canada in Ottawa. Whereas in **Osmose** the immersant could move through a forested glade populated by static objects, in **Ephemere** every object is in a state of flux. Organized in three levels, this new work also makes use of organic and natural metaphors, except that this time an analogy is suggested between nature and the human body. As in **Osmose, Ephemere** uses the breathing and balance vest interface to propel the viewer in space, makes creative use of three-dimension sound, and can only be fully experienced with a virtual- reality headset.

VR: Spatial analogues and multi-user environments

In Virtual Reality (VR) the spatialisation of audience experience is naturally derived from the need for a participatory spatial environment. While the spatial mapping of audience experience is common in multimedia all the imagery is pre-created. Uniquely in VR, only the model is generated. The audience creates its uniquely

individual journey on each engagement. Although the spatial metaphor is a prevalent form in many interactive work, as Andy Cameron points out this is:

> More than just the change from a simple line to a more complex diagram or space, it involves moving from one kind of representation to another.[9]

The role of the artist is challenged in the construction of such immersive environments. The action of the artist/author begins to resemble the designer of a model and, although the artist may describe its properties in great detail, s /he is no longer author of the events set in motion by the audience. In his VR installation work Bill Seaman's **Recombinant Poetics** engages virtual reality with audience-directed modes of creative access and control of content. He coins the phrase 'vuser' to describe the active participant in virtual space:

> The technologies of virtual environments point to a cinema that is an immersive narrative space wherein the interactive viewer assumes the role of both cameraperson and editor.[10]

His **World Generator/The Engine of Desire** is a generative virtual environ-ment. The virtual interface comprises a series of spinning container-wheels and is physically interfaced through a table, track-ball, positioning-ball, and two selection buttons. This interface enables the participant to generate and navigate virtual worlds in real time. One spins the container-wheels and selects from a vast collection of media-elements and digital processes. The media-elements that can be positioned and repositioned in this mutable world include 3D objects, sound objects, digital video stills, digital video loops, and an elaborate poetic text.[11]

The participatory aspect of audience as performer displayed in **Osmose** is also evident in the work of Brenda Laurel, who explored this in her **Placeholder**[12] experiments at Banff Centre in the early 1990s, where local Canadian Native Indian myths were incorporated into a multi-user 'performance'. Participants could create their own stories within the broad boundaries set by the artist. Laurel' s work fused improvised theatre with the cutting edge of VR simulation, combining sensor feedback for arms and torso as well as hands and head. The participants could alter their voices electronically to match the mythic characters whose identity they assume, and could swim or fly through the recorded video landscape mapped onto a computer 3D model. The result may in its experimental form have relied solely on the improvisation skills of trained actors, but could potentially allow any user to convincingly construct their own personas. Her extension of drama into Virtual Reality marked an important step in the development of haptic immersive art.

> Laurel developed the Placeholder scenario with Interval researcher Rachel Strickland after she noticed that kindergarten children played make-believe roles and switched among them almost at random. Two people at a time can participate in the Placeholder universe. They don white helmets and stand on green circles of indoor-outdoor carpeting in an unobstructed space. Wires run from their headgear to an overhead gantry, leaving them free to move as they view a virtual world populated by whimsical creatures such as a snake, a spider, and a crow. Each person can 'inhabit' one of the creatures merely by pushing into the virtual space that the creature occupies.

Seen from the outside, the helmeted figures look absurd, ducking, turning, and flapping their arms as they fly through a computer-generated landscape. "In our experiment", says Laurel, "the main thing we proved is that it takes about 15 seconds to make grown people act silly." But this is a measure of how subjectively real the experience feels, despite relatively crude sound and graphics and a relatively slow frame rate. The images inside the helmets make the players feel as if they're in a huge amusement park where they can soar, perch, and even dive underwater, swapping identities like suits of clothes [13].

In speaking of the pleasures and engagement within VR environments, Janet Murray of MIT Media Lab identified 'three key pleasures' that are uniquely intensified in virtual media: immersion, rapture, and agency. Immersion, she says, is *'the sense of being transported to another reality'*, such as a game world. Rapture is the *'entranced attachment to the objects in that reality'* – in other words, the addictive trance that gamers fall into for hours at a time. Agency is *'the player's delight in having an effect on the electronic world,'* which is possible because the player is a free agent who can make choices. While these certainly identify the pleasures of the medium they do not, of themselves, create the complexity of meaning found in the fixed structures of traditional forms. [14]

This stripping away of personality is experienced as a liberation by the audience, but, as Sally Anne Norman points out, this is not a new condition, but one endemic to revels, carnival, ecstatic religious ritual and early theatrical models:

Virtual space frees us from social commerce based on face value, enabling us to assume guises and disguises at will. Insofar as behaviour means 'how one conducts oneself,' this raises a burning question: how can 'one' be defined in a situation of free floating identity, i.e. what are the minimum prerequisites for the existence of a perceptible entity, someone who 'behaves'? Casting one's cyberself into the virtual ocean means creating a quantum persona recognizable not just for one's virtual counterparts, triggering and enabling cyber intercourse, but moreover recognisable for oneself as prime mover. Hanging onto a kernel of identity fixed enough to uphold exchange, while sounding the mutability favoured by cyberspace, calls for a delicate balance.

Many spectacular traditions derive their strength from precisely this balance, where seminal affinities with a mask or persona allow players to fully invest their roles [15]

Telematics and the collapse of distance.

While philosophers such as Paul Virilio imply certain unease with the 20th century collapse of conceptual 'distance', many artists greet the physical telescoping of experiential distance with wonder and utopian enthusiasm. The confounding of immediate presence and art is a questionable mental manoeuvre, if the context and content do little more than embarrass or confound the public. Galloway and Rabinowitz[16] created **Hole in Space** in 1980 using a direct video live link installed between LA and NY streets allowing direct dialogue between public in the two locations. People turned out in droves to speak and to and wave at distant friends and relations.

Paul Sermon's later experiments with telepresence such as **Telematic Dreaming** 1992[17] (an interactive bed where, through an aligned projection of a similar bed, two

people displaced by distance could indulge in interactive foreplay with each other's video ghost), exploited similar human behavioural traits. But while the sheer variety of human behaviours is endlessly fascinating to audiences, the art remained closer in spirit to a 1960s 'Happening'. Sermon often makes use of an open network structure to offer direct real-time interaction and coexistence of multiple participants in a visual/virtual environment. The user actively takes part in initiating as well as processing a story, within a sensory meeting space. His later works have all elaborated on this theme, for example **A Body of Water**[18], 1999, commissioned by the Wilhelm Lehmbruck Museum Duisburg for the exhibition *Connected Cities – Processes of Art in The Urban Network*. It integrated the telematic interactive communication into a water-based interface and projection screen, within a very site specific narrative, questioning the influence digital technology has on the former industrial coal mining area in Germany. The audience could see images of historical footage of miners showering projected onto one side of a curtain of water and on the other side of the curtain, distant gallery visitors pretending to shower - telematically displaced from the actual physical space of the installation which was sited in an old mine shower room.

Other media artists have not been content to transmit mere images of telematic presence. Stelarc started out as a performance artist famously suspending his body on meat hooks in Sydney and New York. From this use of the body as a sculptural object, he extended his performance work to include synergy between prosthetic machinery and his own body. From living with an artificial third hand wired to secondary muscles in his arm, actuated with EMG signals, he went on to develop technology inserted into the body (the Stomach Sculpture - a self-illuminating, sound-emitting, opening/closing, extending and retracting mechanism operating in the stomach cavity) and Net-connected (the body becoming accessed and remotely activated by people in other places), allowing his body to be a host- not only for technology, but also for remote agents. Seeing the Internet now as a way of accessing, interfacing, and uploading the body itself, Stelarc maintains that:

> 'Instead of seeing the Internet as a means of fulfilling out-moded metaphysical desires of disembodiment, it offers on the contrary, powerful individual and collective strategies for projecting body presence and extruding body awareness. The Internet does not hasten the disappearance of the body and the dissolution of the self- rather it generates new collective physical couplings and a telematic scaling of subjectivity. What becomes important is not merely the body's identity, but its connectivity- not its mobility or location, but its interface....[19]

He developed this idea further in 1995 at Telepolis with **Fractal Flesh** event, Paris (the Pompidou Centre), Helsinki (The Media Lab) and Amsterdam (for the Doors of Perception Conference) were electronically linked through a performance website allowing the audience to remotely access, view and actuate Stelarc's body via a computer-interfaced muscle-stimulation system based at the main performance site in Luxembourg.

Although the body's movements were involuntary, it could respond by activating its robotic Third Hand and also trigger the upload of images to a website so that the performance could be monitored live on the Net. During so-called **Ping Body** performances,

What is being considered is a body moving not to the promptings of another body in another place, but rather to Internet activity itself - the body's proprioception and musculature stimulated not by its internal nervous system but by the external ebb and flow of data. By random pinging (or measuring the echo times) to Internet domains it is possible to map spatial distance and transmission time to body motion. Ping values from 0-2000 milliseconds (indicative of both distance and density levels of Internet activity) are used to activate a multiple muscle stimulator directing 0-60 volts to the body. Thus ping values that indicate spatial and time parameters of the Internet choreograph and compose the performances. A graphical interface of limb motions simulates and initiates the physical body's movements. This, in turn, generates sounds mapped to proximity, positioning and bending of the arms and legs. [20]

The Body

Stelarc has extended his relationship to the body in numerous other ways. His **Walking Machine** (1999) was a six-legged, pneumatically powered walking machine constructed for the body. The locomotor, with either ripple or tripod gait, moved fowards, backwards, sideways and turned on the spot. It had an exoskeleton on its upper body and arms. It had individual flexion of the mechanical fingers, with thumb and wrist rotation. Stelarc actuated the walking machine by moving his arms. Different gestures made different motions - a translation of limb to leg motion. Stelarc's arms guided the choreography of the locomotor's movements and composed the *terrifying cacophony of pneumatic and mechanical and sensor modulated sounds....'* [21]

He is currently considering the possibility of constructing an extra ear positioned next to the real ear. A balloon would be inserted under the skin and then gradually inflated over a period of months until a bubble of stretched skin formed. The balloon would then be removed and a cartilage ear shape inserted and pinned inside the bag of excess skin. A cosmetic surgeon would then cut and sew the skin over the cartilage structure. The ear could not hear but would rather emit noises. Implanted with a sound chip and a proximity sensor, the ear would speak to anyone who came close to it. It would also act as internet antennae to amplify RealAudio sounds to augment the local sounds heard by the actual ears. The only barrier to completion seems to be the unwillingness of any plastic surgeon to flout the law.

Orlan is a French performance artist, similarly prepared to subject her own body to technological change. Her use of technology includes broadcast video of her operations, where she alters her face by surgically attaching organic prosthetic additions such as horns or a strange nose shapes. Unlike Stelarc, hers is an avowedly feminist stance, resisting the body images promoted by the mass media:

Carnal Art is self-portraiture in the classical sense, but realised through the possibility of technology. It swings between defiguration and refiguration. Its inscription in the flesh is a function of our age. The body has become a 'modified ready-made', no longer seen as the ideal it once represented ;the body is not anymore this ideal ready-made it was satisfying to sign, As distinct from 'Body Art', Carnal Art does not conceive of pain as redemptive or as a source of purification. Carnal Art is not interested in the plastic-surgery result, but in the process of surgery, the spectacle and discourse of the modified body which has become the place of a public debate. Carnal Art is not against aesthetic surgery, but against the standards that pervade it,

particularly, in relation to the female body, but also to the male body. Carnal Art must be feminist, it is necessary. Carnal Art is not only engages in aesthetic surgery, but also in developments in medicine and biology questioning the status of the body and posing ethical problems. [22]

Agency, independence, and the role of AI.

In the search for narratives and artworks without predetermined scripting, the use of artificial life algorithms is increasingly leading towards the granting of autonomous agency to individual characters. Ken Perlin and Athomas Goldberg's **Improv** system at New York University, the **Oz project** [23] and Barbara Hayes-Roth's **Virtual Theatre** project at Stamford University have engaged for many years with the problems of 'interactive drama' and 'liquid narrative'. **Oz** is a computer system developed to allow authors to create and present interactive dramas. The architecture includes a simulated physical world, several characters, an interactor, a theory of presentation and a drama manager. A model of each character's body and of the interactor's body are in the physical world. Outside the physical world a model of mind controls each character's actions. The interactor controls the interactor's actions. Sensory information is passed from the physical world to the interactor through an interface controlled by a theory of presentation. The drama manager influences the characters' minds, the physical world and the presentation theory. The goal of the **Oz** project at CMU was to build dramatically interesting virtual worlds inhabited by believable agents - autonomous characters exhibiting rich personalities, emotions and social interactions. In many of these worlds, the player is himself a character in the story, experiencing the world from a first person perspective. Typically, the player's representation within the world - the avatar - is passive. The avatar performs actions as fully specified by the player and reports events (by, for example, rendering a 3D scene or generating descriptive text)

More recently Naoko Tosa and Ryhohei Nakatsu at ATR research Labs in Tokyo have created Play Cinema, where controllable avatars act under the audience's direction, creating new scenes from **Romeo and Juliet (in Hades)** as the characters journey through the underworld. The dialogue and plot are unconvincing and by no means free-form. At least here gestures recognition and speech synthesis, as well as facial and emotional state recognition software, has been fused to create a variety of responses and variations on the basic plot. The neural net software is about as adept as a human observer at detecting emotional nuance in audience response. In an earlier experiment Muse, a software agent talked poetry to which the audience responded in set phrases or in their own words. The animated **Muse** responded in turn with emotional expressions controlled through a neural network that also recognised emotional nuances in the audience's own phrases. The responsive nature of such systems opens up a potential new craft for the playwright, where the encoding of mood, emotion, and their syntax takes precedence over plot and traditional forms of narrative technique.

Interaction based on emotion recognition
The main plot of the story is as follows. After their tragic suicide the lovers' souls are sent to Hades, where they find they have totally lost their memory. The two start a journey to rediscover who they are and what their relationship was. They gradually

find themselves again through various kinds of experiences and with the help and guidance of characters in Hades and finally go back to the real world.

(2) Interaction

There are two participants, one plays the role of Romeo and the other Juliet. The participants stand in front of the screen wearing specially designed clothes with attached magnetic sensors and microphones. Their avatars are on the screen and move according to their actions. Basically, the system controls the progress of the story with character animations and character dialogues. The story moves on depending on the voice and gesture reactions of the participants and as described before, interaction is possible at any time. When the participants utter spontaneous phrases or sentences, the characters react according to the emotion recognition results. Consequently, this system can go anywhere between story-dominant operation and impromptu interaction-dominant operation de- pending on the frequency of the participants' interaction..,[24]

Artificial Life

In the mid-eighties, a light-hearted computer program called **Little Computer People** allowed users to watch and poke at a tiny animated person living in a simple computer house. Ten years later once the power of computer hardware had advanced by several orders of magnitude, the world's first virtual pets, **Dogz and Catz** were released. Subsequent versions of **Virtual Petz** offered increasingly sophisticated animation and AI, allowing them to grow into a popular and successful product line that has sold over two million copies worldwide. Since then artificial life creatures have become commonplace, notably the dreadfully primitive **Tamaguchi** key chain toy from Japan which became a hugely successful fad, truly making 'virtual pets' a household word. **Creatures** soon followed this – the first full-blown commercial entertainment application of Artificial Life and genetic algorithms. In Creatures users are able to train and breed fantasy-like mammals whose behaviour is controlled by the integration of a neural network, a model of biochemistry and an artificial genome with crossover and mutation.

Only a few years ago, the state of the art in artificial life seemed to be at the level of MIT's attempts at programmed behaviours, exemplified by Bruce Blumberg's virtual dog in the **Artificial life Interactive Video Environment.** This was developed at MIT under the direction of Pattie Maes and Alex Pentland, where a computer-generated ball-fetching creature was mapped onto a mirror image of the real user's environment. **Norns** were even more sophisticated entities, evolving and breeding in virtual environments through genetic coding embedded in software. They have even been known to evolve independently patterned behaviours such as playing collaborative ball games. The artistic exploration of such forms has not been slow to follow the scientific and the commercial versions

Sommerer and Minnoneau have consistently worked with artificial life environments, often controlled through highly physical interfacing. From their **interactive Plant Growing** (1993) where virtual plants grew by the electrostatic reaction of plants to human touch, through to the water-covered interface of **A-Volve** in 1994 – a survival-of-the-fittest virtual aquarium where creatures created by the audience struggle to swim, eat and die. Audience attention through touch prolongs

the life of the creatures. The advent of a biological interface between real and virtual space had arrived.

> In their interactive installation entitled 'A-Volve', the Austrian Christa Sommerer, and the French Laurent Mignonneau created a unique metaphor of artificial life by merging tangible and intangible elements. The work premiered at the international electronic arts festival Ars Electronica, in Linz, Austria, in 1994. In 'A-Volve' the European duo, currently residing in Japan, allowed digital images generated in real time by anonymous viewers to acquire life-like behaviors and to interact among themselves in a 15-cm-deep water-filled glass pool measuring 180 x 135 cm. Viewers accustomed to traditional computer animation discovered that these animated organisms were unpredictable in their motions and acquired idiosyncratic behavioural patterns in this real-time interactive environment. As viewers approached the installation, in addition to the water pool they saw a pedestal with an embedded touch-screen monitor. Asked to draw freely on this monitor with their fingers, viewers improvised and sketched both the profile and the top view of an artificial organism. Moments later they saw this creature emerge from the depths of the water pool and start to swim with its own unique behaviour and motion pattern. The creature also interacted with other artificial organisms already in the pool in complex ways, following survival rules that included mating and predatory patterns. Viewers could look into the pool and observe the creatures 'in the water' because a projection screen formed the floor of the water pool, and the real-time images were projected upward from a video projector embedded in the base of the water pool. [25]

Narrative and Interactive Cinema

It is not surprising that interactivity in multimedia tends to involve trivial 'point and click' actions on the part of the audience. The elevation of interface over content and meaning, has rightly been identified by Grahame Wienbren as a product of software dominating narrative form:

> However the structure that appears to have become established is based on the viewer's choosing what he or she wants to see next and in most computer programs this is determined by where on the screen the viewer has clicked or which key has been depressed. The underlying program is organised in a tree structure of image segments with branches at selection points. The main reason for the adoption of this model in my view, is that someone who has invested substantial time in learning a program that takes a specific approach to interactivity, may begin to believe that it is the only, the right, or the best approach. [26]

It is my contention that so-called ' interactive' media contain the potential to liberate writers and artists from the illusion of authorial control in much the same way as photography broke the naturalist illusion in art, exposing it not as an inevitable form, but as another set of conventions. It is perhaps more inertia in artistic practice and commission which ensures that, although interactive narratives will soon become commonplace through broadcast on cable, satellite, network or CD-ROM, such forms as exist often remain unoriginal extensions of spectator modes such as video, or cinema. They can only becoming truly interactive when authors attempt to transcend the established syntax of earlier forms and the platitudes of multimedia and invent a coherent artistic language for interaction.

Grahame Weinbren also proposes an alternative model, a two-way transaction, only partially achieved in his own interactive cinema piece 'Sonata'

> The ideal is a responsive representation machine, responsive in its capacity to change according to how the viewer responds to it. With such a machine, a new language of cinematic communication will be possible and a different type of narrative can unfold.[27]

In Grahame Weinbren's **Sonata** the viewer can only control aspects of the narration – moving from the murderer of Tolstoy's Kreutzer Sonata telling his story in the railway carriage to the events themselves, which can in turn be overlaid with the mouth of Tolstoy's wife berating the author, references to Freud's wolf man case, Judith and Holfernes etc. In one sense, Sonata is linear, with time's arrow pointing forward, but it never reads the same way twice.

In Jon Dovey's piece on **The Toybox** CD ROM, 'The Desktop Theatre of Amnesia'[28] these techniques of parallelism were tested. The emotional transformations of an unhappy love affair and its visually equivalent symbolic analogues are mapped in front of a matrix of QuickTime mini-movies. A simple click reveals the underlying talking heads, each one narrating a separate epiphany. Like multiple personalities locked inside one mind, but still aware of the others' presence, they reinforce poetic resonance by proximity and association. This approach has been also employed by practitioners such as Bill Seaman[29] as a way of neatly side-stepping the strait-jacket of articulated narrative, allowing the audience to set the selection criteria of matching components: thereby creating a form of associative narrative flow. As in a card game, the turning up of a particular image forces the computer to turn up a matching narrative fragment. Here we begin to approach Weinbren's responsive 'representation machine'.

In 'Database as Symbolic Form'[30] Lev Manovich argues that in the same way cinema privileged narrative as a form of cultural expression, the computer age has privileged what he refers to as 'database form'. As he points out, many new media objects do not tell stories; nor do they have a beginning or end. Instead, they are collections of individual items that have the same significance as any other. Manovich argues that there is a connection between the computer's ontology and the new forms privileged by computer culture. By considering the works of such filmmakers as Peter Greenaway and Dziga Vertov within a tradition he calls 'database cinema', Manovich argues that databases and narratives have merged into a new form that anticipates one of the key problems of new media art.

A brief history of technology, Public Art and performance

In its applications to public art, interactive work often attempts to gain critical purchase through a tension between its electronic space and its physical and mechanical one. Consistent themes and uses for electronic art in public contexts were established early in the century and threads of similar practice may be traced through from Dada, Futurism and Constructivism and the Bauhaus to the present day. Tatlin was playing with motorised architecture in his monument to the Third International in 1920. The distant relationship between artist and architect has also created problems in the proper integration of public art in cities, let alone that of

digital art into public spaces. It is no accident that architecturally trained artists, most notably Shaw, Moller and Diller & Scofidio, have produced some of the more successful examples of actual or potential public art works using new technology.

In researching the origins of interactive work of this nature I was profoundly embarrassed to discover a common tendency (including my own) to repeat the experiments achieved nearly 70 years ago. Worse still much of the technology evident today in public installation works is largely unchanged since the mid-60s! So much of what we think of as innovative was explored in some way during that period. **EAT** – Experiments in Art and Technology – was founded in 1966 and by 1969 it boasted a worldwide membership of 3000 artists and 3000 engineers.

EAT's seduction by technology was to culminate in the Expo 70 Pavilion in Osaka. Sponsored by Pepsi it was an attempt to create a 'living responsive environment', a non-hierarchical theatre space. It was a reprogrammable space with a giant 'mirror room' full of interactive sound areas, a giant fog sculpture and motorised exterior sculptural elements or 'floats' by Robert Breer. Innovative work was done with individual wireless handsets and programmed laser displays. Visitors were responsible for their own experiences. The world of Fluxus and the Happening governed what was little more artistically than 'son et lumiere'

One of the most successful works of computer art of the late 60s and early 70s, in terms of a fully realised interactive installation, was produced by Edward Ichnatowicz. The giant public piece, which performed a seminal role in the realisation of what was artistically possible with computing and robotics was the **Senster**.[31] It was an active metaphor playing on an audience's techno-fear and its simultaneous ability to control the products of nightmare remotely. Installed at the Phillips' industrial exhibition **Evoluon** at Eindhoven in 1971, it represented an extremely ambitious technical and artistic feat. About fifteen feet long and eight feet high, the Senster consisted of six independent electro-hydraulic servo systems based on the articulation of a lobster's claw, allowing six degrees of freedom. The Senster had a 'head' with four sensitive microphones, which enabled the direction of the sound to be computed, and a close range radar device which detected movement. The whole was controlled in real-time by a digital computer which sent feedback from the movement and sounds of visitors to the Evoluon, so that the servos could reposition the head anywhere within 1,000 cubic feet within a couple of seconds.

Using a predictor, the programme put the machine through a complex series of accelerations and decelerations for the maximum efficiency of motion. The net result was convincingly lifelike in its movements and would shy away from loud noises. Unlike the automata of earlier ages the Senster did not try to conceal its inner workings, never-the-less the public's response was to treat it as if it were a wild animal. The **Senster**, which works on so many levels of meaning, has never been surpassed in a robotic piece.

Contemporary work

This sense of play, curiosity, and inventiveness is reminiscent too of the fairground attraction and in many ways Ichnatowicz's approach mirrored that of Toshio Iwai whose entire oeuvre including his public art is based on play. In **Another Time,**

Another Space created in Antwerp central station in 1993. Toshio Iwai made an electronic hall of mirrors using a tree structure of video screens. The installation featured 15 video cameras, 30 computers, 30 video monitors, and a videodisk recorder. The comings and goings of people through the station were filmed by the cameras, and manipulated in real-time by the computer to deform shape, time reference, and showing a different time-space environment in each movement. Video processing software reflected back crowds like fields of wheat, where algorithms interpreted successive layers of crowd as wave-like motions. Sober-suited businessmen leapt and cavorted in front of these magic mirrors.

> I used the 'Another Time, Another Space' system to create an experi-mental event as part of an NHK television program. People passing in front of Shinjuku Station were photographed by a video camera and the images were altered and projected onto the giant Alta Vision screen across the street. It caused a much larger commotion than we expected. The moment the image appeared on the screen, hundreds of people started gathering in front of the station and waving their hands and moving their bodies as they watched their images on the screen. In that moment the big screen that everyone had been taking for granted suddenly became a giant interactive event.'[32]

In contrast to this rather formal and monumental project, there have been a number of attempts to create interactive architectural spaces by British artists. For example Simon Biggs with his installation **'Heaven'**, commissioned by the European Media Art Festival 1993 for a projection onto the ceiling of the Dominikanerkirch, Osnabruck, Germany, 18 metres above the viewers heads. The Cathedral uses remote visual sensing techniques to track the viewer. Each viewer was allocated an angel (or demon, depending on location), which followed the position of the viewer on the floor analogously on the ceiling. The viewers' actions control not only the behaviour of the angels/demons but also a large range of other images, which are dynamically composed on the ceiling using audience movement to alter virtual architectural features such as angels and gargoyles projected onto the roof space. In the 1993 River Crossings public art project, Susan Collin's **Tunnel**, similarly mapped responsive soundscapes, and video projections into a pedestrian tunnel under the Thames.

Interactive Art and Architecture

If we look next at the possible fusion of physical architecture and public art works, we see another discrepancy. Materials technology in the 1990s is beginning to deliver the means for artist-architect collaborations, which might finally realise some of the 1960s dreams of adaptive or 'liquid' architecture – dreams of groups like Cedric Price's Archigram and later visionaries like John Fraser[33]. Developments include electro-heliological fluids which transform from liquid to solid state at the passing of a current, piezo-electrical ceramic which can change colour to order, SMA-shape memory alloys which act like muscles and liquid crystal glass, paint and inks that respond to tiny electrical or temperature changes allow a building or artwork to behave in a biological manner. New research in nanotechnology combined with artificial life programming implies self-repairing and 'living' systems grown around human needs.

However, realistically, even at the basic level of combining existing archi-tectural materials with digital artwork, very little has been achieved. Although the techniques

are already in place, more permanent integration of such work in public contexts remains elusive. An exception to this curious reluctance to engage with new materials is Christian Moller.[34] His pioneering work points the way, with buildings such as the ZeilGalerie in Frankfurt (1992) which changes colour at night according to wind direction and speed, while a sine wave of light ripples its length governed by ambient noise from the street. People gather at night to clap and create sounds that alter the wave. How seriously one should take such interaction as art is another question.

Moller's more thoughtful gallery piece **Electronic Mirror** confounds our narcissism with a distance sensor and electroresponsive LC glass, clouding-over our image on close approach so we are literally swallowed by the glass like digital prisoners-shadowing the original myth. In **Space Balance** (Ars Electronica 1992) a virtual interior architecture mirrors the hydraulic tipping of the viewing platform. The participants can roll virtual balls which click as they collide by the movement of their bodyweight on the platform. A similar device was used in **The Virtual cage** in Frankfurt in 1993.The viewer dances on the platform in relation to a virtual swarm that interacts with the viewer's movements. This use of a tilting floor is being developed by Grahame Weinbren as a way of allowing audience participation in his interactive films and by Miroslaw Rogola in his 1994 ZKM installation **Lover's Leap.**[35]

It sometimes seems there are as many types of interactive digital art as there are artists. As we have seen, successful practice must place content and meaning above technology. It must achieve 'distance' in its true sense of all elements in clear relationship. However, if it fails to engage with the full potential of those technologies, it fails to find the new form and meaning for which all art ultimately strives. The old voices may be saying the same things, but, as always, only the new voices can be heard by the tired ears of the 'Public'. To quote Regina Cornwell:

> These explorations are crucial to how the world can be re-drawn and viewed in an art whose power is in its open-endedness and polyphony. And for the participant the installation too is hard work. To be meaningfully experienced demands time and serious attention.[36]

Footnotes

1 Crary, Jonathan, Techniques Of The Observer: On Vision and Modernity In The Ninteenth Century, Virilio, 'Big Optics,' Cambridge: The MIT Press, 1990, and see also an interview in 'Ctheory' 1995

2 Rieser, Martin and Zapp, Andrea, (Eds.) New Screen Media:Cinema/Art/Narrative , BFI/ZKM. London 2002

3 Daniels, Dieter, Media Art Interaction: Strategies of Interactivity
 <http://www.swensonia.com/database/pdf/daniels.pdf> and
 <http://www.hgb-leipzig.de/ffimareio/daniels/daniels_e.html>

4 Tate International Council Conference: Moving Image As Art: Time-based Media in the Art Gallery Friday 1 June - Saturday 2 June 2001

5 Shaw, Jeffrey, The Legible City 1989
 <http://www.jeffrey-shaw.net/html_main/frameset-works.php3>

6 'Revolution' 1990 in InterAct :Schlusselwerke Interacktiver Kunst Wihelm Lehmbruck Museum Duisberg 1997

7 Bar Code Hotel, Perry Hoberman, Banff Centre for the Performing Arts, Canada 1992

8 Char Davies's 'Osmose' Museum of Modern Art , Montreal , September 1995 and Serious Games Barbican, London 1997

9 Cameron, Andrew, Millennium Film Journal, (Vol: Spring 1993) New York

10 Rieser, Martin and Zapp, Andrea, (Eds.) New Screen Media:Cinema/Art/Narrative , BFI/ZKM. London 2002

11 Seaman, Bill <on1.zkm.de/zkm/werke/TheWorldGeneratorTheEngineofDesire>

12 Placeholder, Banff Centre for the Performing Arts 1992. See Laurel,Brenda, Strickland, Rachel, Tow, Rob, (Interval Research Corp) Placeholder: Landscape and Narrative In Virtual Environments, ACM Computer Graphics Quarterly Volume 28 Number 2 May 1994 see also
 <http://www.tauzero.com/Brenda_Laurel/Severed_Heads/CGQ_Placeholder.html>

13 Originally published in Veredas, Ano 3, No. 32, 1998, Rio de Janeiro, Brazil, pp. 12-15, and Blimp - Film Magazine, N. 40, Graz, Austria, 1999, pp. 49-54

14 Beyond the Screen: New Directions in Interactive Art Eduardo Kac
 <http://www.immersence.com/newinteractive-B.html> and also
 <www.ekac.org/newinteractive.html>

15 Norman, Sally Jane, Dramatis Personae: Casting Cyberselves Fifth International Conference on Cyberspace June 6 - 9, 1996. < http://www.telefonica.es/fat/ecyb.html>

16 Galloway and Rabinowitz, Hole in Space
 <http://www.ecafe.com/getty/HIS/index.html>

17 Sermon, Paul ,Telematic Dreaming, 1992
 <http://www.hgb-leipzig.de/ffisermon/nmpft.html>

18 Sermon, Paul and Zapp,Andrea, A Body of Water, Willhelm Lehmbruck Museum
 < http://www.hgb-leipzig.de/ffisermon/herten>

19 www.stelarc.va.com.au

20 www.stelarc.va.com.au

21 www.stelarc.va.com.au

22 Orlan Website, Carnal Art Manifesto < www.cicv.fr/creation_artistique/online/orlan/index1.html>

23 The Oz project , Carnegie Mellon University < www-2.cs.cmu.edu/afs/cs.cmu.edu/project/oz/web/oz.html>

24 Nakatsu, Ryohei, Nicholson, Joy and Tosa, Naoko Emotion Recognition and Its Application to Computer Agents with Spontaneous Interactive Capabilities, Creativity and Cognition 3 Conference, Loughborough University,1999<http://www.lboro.ac.uk/departments/co/cc_99/>

25 Sommerer and Minnoneau, A-Volve <http://www.mic.atr.co.jp/ffichrista/WORKS/A-VolveLinks.html>

26 Weinbren, Grahame String, Leonardo , 28 , no.5 (1995) ps 403-408

27 Weinbren, Grahame String, Leonardo , 28 , no.5 (1995) ps 403-408

28 The Toybox CD ROM, 'The Desktop Theatre of Amnesia', Video Positive 1994

29 Seaman, Bill <www.cda.ucla.edu/faculty/seaman> and
 <www. research.umbc.edu/ffiseaman/resume.html>

30 Manovich, Lev 'Database as Symbolic Form'
 < http://www.nettime.org/nettime.w3archive/199812/msg00041.html>

31 Ichnatowicz, Edward, Senster. <http://www.senster.com> and
 <http://home.iae.nl/users/pboaia/evoluon/senstere.html>

32 Iwai,Toshio, Private e-mail to author 1997

33 Fraser, John . See Architecture Association website
 <http://www.gold.net/ellipsis/evolutionary/evolutionary.html>

34 Moller, Christian: Interaktive Architektur, Christian Moller Gallerie fur Arkitektur und Raum Berlin, 1994

35 Rogola, Miroslaw, ZKM installation, Lover's Leap, 1994.

36 Cornwell, Regina, Actes , ISEA 1995 Proceedings
 <www.isea.qc.ca/symposium/archives/abstracts95/abs51.html>

Paul Brown is an artist and writer who has been specialising in art & technology for 30 years. He began using the internet in 1984 and from 1992 to 99 he edited fineArt forum, one of the internet's longest established art 'zines. In 1984 he was the founding head of the United Kingdom's National Centre for Computer Aided Art and Design and in 1994 he returned to Australia after a two-year appointment as Professor of Art and Technology at Mississippi State University to head Griffith University's Multimedia Unit. In 1996 was the founding Adjunct Professor of Communication Design at Queensland University of Technology. From 1997-99 he was Chair of the Management Board of the Australian Network for Art Technology and he is a member of the Editorial Advisory Boards for both Leonardo, the journal of the International Society for Art, Science and Technology and Digital Creativity. His computer generated artwork has been exhibited internationally since 1967 and is currently on show in Europe, the USA and Australia. During 2000/2001 he was a New Media Arts Fellow of the Australia Council and he spent 2000 as artist-in-residence at the Centre for Computational Neuroscience and Robotics at the University of Sussex in Brighton, England.

Examples of his artwork and publications are available on his website at: http://www.paul-brown.com

Paul Brown

Networks and artworks: the failure of the user-friendly interface

Abstract

This essay describes how communication systems have been used by a few artists and attempts to place their practice within the historical and critical context of post-modernist dialogue and, in particular, the evolution of a new commun-ication paradigm. It also questions the value of 'user-friendly' user interfaces. By adopting metaphors which reflect existing media usage, these interface tools reinforce traditional points-of-view and make it difficult, if not impossible, to investigate and develop a new multimedia context and 'language'.

Preamble

In 1990 I was driving north from Los Angeles to San Francisco on US Highway 5. The billboards flickered mindlessly past, promoting the usual commodities: Camel cigarettes, United Airlines to Hawaii and the telco wars between MCI, Sprint and AT&T. Then a huge billboard advertising an obscure integrated circuit caught my eye! We were, of course, in San José, the capital of Silicon Valley, and these unique billboards had been created to catch the attention of the few commuting engineers who design and build tomorrow's personal computers.

Just recently, some five years later, one of my graduate students, who is attending a weekly seminar on computers and the arts, brought along a receipt from her local supermarket. On the reverse side, along with the usual two-for-one video offers and dry cleaning ads, was a promotion by a local Internet service provider. Unlike the niche-focused billboards of Silicon Valley, this advertisement was pitched squarely at average consumers who shop at any suburban mall in middle-class Australia.

In just two short years the Internet has blossomed into public attention. An anarchistic information bush track, created by hackers and academics, has caught the attention of a public which was, in any case, well primed by the rhetoric of the corporate 'InfoBahn' and the emphasis on new technologies contained in media hype and national government initiatives like the Australian cultural policy statement 'Creative Nation'.[1]

This general 'net awareness' also provides a perfect dessert for the moves to pluralism instigated by post-modern socialism that will, hopefully permanently, replace the legacy of right-wing nationalism that dominated the middle years of this century. The Sydney-based writer Ross Gibson recently defined the new 'nationalism' as a boundary that contains difference rather than similarity.[2] And now the Internet promises to remove those geographic boundaries and create an egalitarian global information exchange.

Let's put to the back of our minds, for the time being (this essay has to be short), the fact that four-fifths of the global population probably desires a reliable source of food rather than information. And let's try to ignore the disturbing fact that many of those who are most eloquent in espousing this new electronic democracy are none other than the right-wing fundamentalists of the US Republican party.

Background and history

Today's Internet has its origins in the so-called 'Cold War' between the USA and USSR. The US Defence Department was concerned that a Soviet strike could seriously affect communications between the military command and control centres. The Rand Corporation's 'Think Tank' suggested a new and unique method of connecting military units that would enable the communications infrastructure to survive such an attack. It was a linked network of individual nodes. A message could be successfully transmitted from one node to another so long as only one of the many possible routes connecting them still existed.

Also a new and unique method of content communication was used. The original message was digitised then broken up into smaller 'packets'. Each packet would be transmitted and find the most direct route to the receiver node. Individual packets

could take any of the different possible routes available by taking the least used exit from any given intermediate node. The receiving node would reconstruct the message by unpacking each component packet in its original order. Missing packets, or those containing errors, could be re-requested by the receiver.

The system was implemented as the ARPANet (named for the Defence Department's Advanced Research and Procurement Agency which commissioned the project). It was followed by the US National Science Foundation's NSFNet. Other countries developed similar networks like JANET (the UK's Joint Academic Network) and AARNet (Australian Academic Research Network). IBM built its own international network called BITNET. Other companies built both internal networks and access provision for other smaller companies and individuals. Each of these networks is 'gated' to others to form an international network. The Internet proved remarkably sturdy and reliable and grew within academia as well as the military and information technology corporate sectors during the 1970s and 80s.

Since the mid-80s many novel, and easy to use, human interfaces have been developed for the Internet and the proliferation of independent Internet providers has enabled rapid growth into the corporate and domestic sector. Soon it will be the dominant communications medium of the military/ industrial complex.

Although packet switched networks were originally a text- only medium, recent advances in digital compression have enabled the successful transmission of both audio and video using these 'packet switching' networks. Now international telecommunications agencies are developing packet switched high-bandwidth networks that have been collectively dubbed the 'information superhighways' or 'Infobahns'. We can consider today's Internet as a 'bush track' that will evolve over the next five years into these international superhighways.

By the millennium many people in the developed world could be connected to such facilities and receive most, if not all, of their information needs via interactive multimedia networks. Already they offer content and resources for education, entertainment and work. Provider companies are competing ever more ruthlessly for market share of this information future. Significant legal, moral and ethical questions are raised by both the nature of the network itself as well as by the behaviour of governments, corporations and lobby groups who are working either to dominate or in some way to control this marketplace.

What is multimedia?

The phrase 'computer graphics' is believed to have first appeared in an engineer's report at the Boeing aerospace company in 1963. By 1968 the visionary Ted Nelson had coined the term 'hypertext' and by the turn of the 70s he and colleagues like Dick Schoup, Alan Kay and John Warnock, all working at Xerox PARC, were developing the tools of personal computing. However, the technology that would eventually deliver integrated multimedia on a cost-effective personal computer platform didn't appear until the mid 80's and standards are still in development ten years later.

If we pursue a historical metaphor and consider either photography or motion pictures, we find a 40 to 50 year hiatus between the invention of a technology and its assimilation into the creative process and the evolution of a aesthetic language that is

unique to that particular technology/medium. It's tempting to speculate about what multimedia may become as it matures as a means of expression and to predict just how grotesque today's CD-ROM and network offerings will appear once that mature perspective is in place.

Will the very large investment in multimedia that is currently underwritten by both the corporate and government sectors enable this evolution to be accelerated or will it instead impede a 'natural' development, slowing it down or, perhaps, even prevent it from maturing at all? In an age of economic rationalism most of this investment is in the creation of product - product which is very quickly remaindered or, once purchased, becomes a '15 minute wonder' and afterwards put into the drawer and forgotten.

Artists have a reputation for experimentation with their medium. In the high modernism of the 1960s the medium actually became the message for many artists. Now, in the waning years of post-modernism and the resurgence of what Peter French has described neo-modernism, many are promoting the role of the artist in developing a multimedia language.

Mail art

Artists have been actively working in communication media for many years. Mail art flourished in the transition years of the 6os. My first introduction was in a Liverpool bedsit in 1968. A postcard pinned to the wall invited the reader to 'Pin this card to the opposite wall'. The Japanese artist On Kawara was sending postcards consisting of a bold declaration of the precise time or date of posting or the simple message 'I am On Kawara'. One of my own first works was made in the early 7os. A large statement was cut up and posted to several recipients as single postcards each containing a small part of the text. Although a few of the recipients knew each other, it was unlikely that the 'message' would ever be reconstructed in full. I was excited by the potential of enigmatic deconstruction in contrast to the dominant logical reductionism of the day.

The commercial artworld has shown itself to be extremely resilient to attempts to undermine its power. Many of the formats developed in the 6os and 7os were intended to create art that could not be venerated by the establishment or turned into investment fodder by the gurus of Green Street, Bond Street and the Latin Quarter. Stuart Brisley's 7os performances, where he immersed himself in a bath full of offal or vomited over himself, were specifically designed to be unmarketable. Now, as pension day becomes inevitable, Stuart sells limited edition prints of those performances via the same art market he so earnestly confronted 30 years ago.

Telecommunications art

Mail art has, to some extent and perhaps thanks to its lowly stature, survived the parasites of the commercial artworld. It remains an artform of enthusiasts. Then, during the 1980s, the growth in the use of the fax machine provided an excellent and ephemeral medium for communications art. 'Fax Art' is a fairly meaningless phrase and serves to marginalise the practice and diminish its value. The varieties of artworks that have been enabled by the fax medium defy such a simplistic title.

Art Reseaux is an international telecommunications art group based in Paris. In its 1992 book[3] Eduardo Kac comments:

The social impact of the telephone sparks the idea of art as a dialogue, going beyond the notion of art as object making. The understanding of art as intercommunication moves us away from the issue of what is it that art or the artist communicates? to question the very structure of the communication process itself.

He goes on to state that 'Telematic art ... is inventing the multilogue of networking as a collaborative art form'.[4]

Art Reseaux's 'Connect' was led by group member Gilbertto Prado and is typical of its approach. Several international locations are linked via fax connections. Each location has two fax machines. One is receiving, the other sending. The two machines are similarly linked by a single roll of paper which constantly emerges from the receiver and tracks down a long table before being consumed by the sending system. Whilst the paper is on the table, participants add to the content with drawing materials and collage. The piece is a complete loop which simultaneously connects all participants regardless of their geographical location. The long fax 'scrolls' that emerged from the piece were exhibited at the Art Reseaux exhibition at the Gallery Bernanos in Paris in April 1992. Each long scroll was suspended from the ceiling, forcing viewers to walk along below and stare upward as they walked.

Their best known and most ambitious piece is Karen O'Rourke's 'City Portraits'.[5] In his assessment of the project Frank Popper says:

Another aspect of this project concerns the fact that it is not the ideas or the images that are important in it but their interaction, their articulation in a context where the mind and the imagination are at play.

It can be maintained that this connecting tissue is at the heart of all telematic networking and could even be considered as constituting part of the essential equipment of all Technoscience Art.[6]

Network art pioneer Roy Ascott comments in his essay about the work:

What the new technology, the new consciousness, the new spirituality augur is worlds within which a multiplicity of realities can co-exist, interact, collide join, bifurcate in an endless dance of cultural transformations. As neural networks meet planetary networks and make the connection, so our brain will invade the city and the city will enter our brain'.[7]

With the development of virtual reality and the establishment of the 'cyberspace' of the networks, humanity can now be weaned from its dependence on a single root reality which measures all others as illusion or fantasy. Now we are faced with an infinite spectrum of consistent immersive realities that coexist as equals alongside the 'everyday' reality of common sense. As I have expressed elsewhere reality and illusion are converging[8, 9] and new belief systems are emerging.[10]

Stéphan Barron is a member of the international 'Aesthetics of Communication Group'. He originally studied engineering but, since 1983, has been creating international installations based on communication technology. His best know piece is 'Lines' (1989) which connected eight locations in Europe which each received regular fax transmissions as Barron and his partner Sylvia Hansmann travelled along the Greenwich meridian from the English Channel to the Mediterranean. The work is

documented in an essay by Barron[11] in the special telecommunications issue of the art and technology journal *Leonardo*.[12]

Network art

At the 1996 Adelaide Festival Barron exhibited two works which weave together the technology of the Internet with some of the aesthetic, social and political agendas that globalism implies.

His piece OZONE is a timely comment on the residual colonial arrogance of the 'First World' nations of the northern hemisphere. Their high rates of overpopulation together with their commitment to the ethics of redundancy that are implicit in consumer-oriented economic rationalism allow them to generate immense quantities of chemical pollutant gasses that are destroying the protective ozone layer of the earth's atmosphere. As most Australians are aware, this destruction is focused in the southern hemisphere ozone hole and is manifested as higher than normal levels of ultra-violet radiation and the promise of high skin cancer incidence in years to come. During 1995 several of the culprit nations announced their intention of reneging on previous agreements to cut the output of these noxious chemicals, using the excuse that doing so would undermine the competitiveness of their national industries and economies.

OZONE addresses this global nationalistic conflict of wills. The artist precedes his description of OZONE with a quotation from the American composer John Cage: 'The function of Art is not to communicate one's own personal ideas or feelings but rather to imitate nature in her manner of operation.'

The piece also reflects Cage's own work with 'prepared pianos'. OZONE uses two pianos, one in the Sym Choon Gallery in Adelaide, the other in the Donguy Gallery in Paris, France. They are 'played' by an automatic procedure that has two sources. One measures the amount of ozone pollution produced by automobiles in the streets of Paris; the other measures the high UV levels due to ozone depletion over Adelaide. Barron describes the process:

> Two acoustic computerised pianos located, one in Europe, and the other in Australia, exchange sounds produced according to the ozone coming on one side from the Parisian automobile pollution, and on the other side according to the hole in the ozone stratospheric layer.

> This installation is a metaphor of an 'Ozone Pump' between the ozone produced by pollution and the natural ozone.

> An 'Ozone Pump' between Europe and Australia, between man and nature.

> This music is elaborated not by one person but by human activity on a planetary scale (pollution of the ozone) and by interaction with the sun.[12]

OZONE links North and South in a dynamic dialogue regarding the future of the planet. It's also a healing process that converts the symptoms of the problem as manifest into digital tokens that simultaneously express sorrow for the harm whilst also creating a symbolic exchange, a gift of ozone, that inverts the process of depletion and invokes reversal of the physical damage that is being done.

'The project also expresses the immateriality and complexity of the phenomena with which contemporary man is confronted. The ozone and the UV rays are factors of complex phenomena where human physiology interacts with economic development.'[13]

Barron's other work DAY & NIGHT links east and west across a 12-hour time difference that gives the work it's name. It's based on an earlier piece 'Le Bleu du Ciel' (The Blue of the Sky) produced by Barron in 1994. Here two French sites, one 1000 km north of the other, were linked and the average of the colours of the sky above them was calculated and displayed. Barron compares the work to the blue monochromes of Yves Klein:

> The purpose of this project lies in the imaginary sky, an ubiquitous sky that exists somewhere between north and south, somewhere in our imagination. A never ending sky. The never ending phone network.
>
> These live and imaginary monochromes, cosmic and in harmony with the real skies distant by a thousand Kms, follow Yves Klein's project and his monochromes.[14]

DAY & NIGHT changes the axis of the work from north-south to east-west and connects the Museum of Contemporary Art in Sao Paulo, Brazil with the Sym Choon Gallery. This axis, of the revolution of the Earth is also the axis of time. The geographical distance gives a 12 hour time difference and since the piece will be exhibited at the Equinox, the division of day and night should be almost exact – as the sun sets in Sao Paulo it will rise in Adelaide.

Cameras at each gallery continuously record and transmit the colour of the sky above them. The two images are averaged and displayed at each site. Apart from the conjunction of dusk and dawn, the resulting images are a mixture of day and night.

It's a simple piece that nevertheless embeds a profound poetry. Barron discusses the concept of Planetary Interdependence:

> It becomes more and more apparent that our destinies and gestures are linked with those of all humans, even the most far removed.
>
> A solidarity, a planetary consciousness slowly elaborates itself.
>
> The beauty, the poetry of distance is essential. It allows us to redefine the dimensions of our consciousness.[15]

The richness of the allusions that are embedded in these pieces unfold in our minds: fractal chaos or non-linear theory where we are all subject to the effects of minuscule and distant changes; the Noosphere of the Jesuit philosopher De Chardin; Jung's 'Collective Unconscious' and; the dawning awareness of symbiosis and interdependence, of the erosion of individualism. As these implications flower in our thoughts we too are drawn into the piece, we become a part of the matrix, the network, the Tao:

> The nameless was the beginning of heaven and earth;
>
> The named was the mother of the myriad creatures.
>
> . . .
>
> These two are the same

But diverge in name as they issue forth.
Being the same they are called mysteries,
Mystery upon mystery -
The gateway of the manifold secrets.[16]

Marvin Minsky has described language as a set of tools for building ideas in other peoples minds.[17] The poet William Burroughs has described language similarly, but more subversively, as a virus. It is this power, that results from the rejection of intrinsic self-referentiality in favour of extrinsic indicators, of semiotic initiators, that gives telecommunication-based art its value and context in a post-modern era. It becomes a set of tools, a virus, an initiator, a language.

So it's not surprising that many of the artists working in communications and networked media trace their roots to the art language, performance and conceptual art of the 1960s. It's here that we find the first concerted attempts by artists to undermine modernism by questioning both the value and significance of the visual arts after a century of experimentation that had been forced on them when photography usurped the tradition of representation in the mid-19th century. These artists confronted the gallery system, in a time of post-war plenty and long before recession set in, with work that resisted monitarisation and defied reveration.

What is particularly interesting about Barron's work is his historic evocation of modernist artefacts like land art and dadaism whilst his use of telecommunications undermines the need for the object and simultaneously adds layers of reference and implication. Whilst his work encourages us to expand our perception out of the world of art and into the realms of people, politics and economics, it also evokes relationships that indicate its roots in, and consideration of, the traditions of art and art history.

As mentioned above Barron is one of the artists associated with the 'Aesthetics of Communication Group' which also includes Derrick de Kerckhove and Fred Forest, amongst others. De Kerckhove is director of the McLuhan Project in Toronto and the idea of telecommunications as a McLuhanistic extension and connector of human minds is a common theme in their work. Another group member, Mario Costa, is quoted from a 1983 statement by Frank Popper:

> *In this type of event, it is not the exchanged content that matters, but rather the network that is activated and the functional conditions of exchange. The aesthetic object is replaced by the immateriality of field tensions and by vital and organic energy (mental, muscular, affective) and artificial or mechanical energy (electricity, electronics) that transform our mundane object-centred sense of space and time. Equally the subject is transformed, being no longer defined by rigid opposition of self/not-self, but becoming part of this same flowing field of energy.*[18]

In Barron's work the act of digital sampling of the 'content' (the ozone level, sky colour, UV levels, etc..) converts everything into the same form. Myriad os and 1s are transported back and forth on the network then post-processed and reconstituted as sensory phenomena – as the colours and sounds of the actual artworks that we perceive installed in the gallery spaces. But these are merely the terminators of a network and process and their purpose is as a catalyst - to connect the human participants into the project.

In this way the artwork ceases to be an object that we appreciate for its own sake and becomes instead a gateway, or a portal, to a virtual space that we experience in participation – a space that exists as much in the participants head as in the frenetic binary signalling of the computational metamedium. A space where serendipity replaces logic and where the singular words of Kurt Schwitters, the architect of Merz 'I am the meaning of the coincidence' are made plural and subtly shifted: 'we are the coincidence of the meaning'.

At the International Symposium on Electronic Art , ISEA 94 in Helsinki, the British Artist Paul Sermon exhibited his piece 'Telematic Vision'. It was located at two sites – Helsinki's Museum of Art and the cafe of the main conference hotel – the Marina. Each contained an identical chromakey-blue settee. Both had video cameras trained on them and both images were transmitted via an ISDN line and then composited together on large video screens which faced the sitters. The simplicity of the idea belies its power – people saw themselves sitting next to virtual but 'live' companions from across the city. It was fascinating to watch them learning how to accommodate and communicate with these real ghosts. Kids played pillow fights and adults dropped inhibitions and made overt sexual contact with complete strangers. In the catalogue Sermon notes:

> *The question of what existed before language is impossible to answer, as our consciousness resides entirely within a perception through language . . .*
>
> *We are in another period of transition from language to medi-age, it is impossible to speculate when and what will change, but when the question of what existed before 'mediage' arises – if, indeed, there is such a question – the transformation will have happened.* [19]

The kind of real-time video hook-ups used by Sermon were pioneered by artists like Carl Loeffler (and others) in 'Send/Receive' and Kit Galloway's and Sherrie Rabinowicz's 'Satellite Arts Project', which both took place in 1977. Galloway and Rabinowicz went on to found the Video Cafe in Santa Monica, which remains an international focus for network-based art and performance, and Loeffler established the ArtCom BBS at the Whole Earth (e)Lectronic Link (or the Well) as one of the first artists' facilities on the Internet.

With the advent of personal-computer-based Internet video clients like CU-SeeMe, the technology became available to many other artists albeit at much lower spatial and temporal bandwidths. These 'user friendly' internet tools have led to a rapid growth in artistic activity on the networks.

The world wide web

In 1990 Tim Berners Lee, at the European Particle Physics Laboratory - CERN in Geneva, developed a multiple media network protocol that he called the World Wide Web (Web or WWW). This was in response to the theoretical physicists who needed a rich-media publication medium in order to circulate their ideas in a more timely fashion than the printed journals allowed. An integrated authoring and browsing client was created using NextStep and a simple terminal-mode browser (called www) enabled text-only dial-up access.

One of the institutions using the Web was the USA's National Centre for Supercomputer Applications, where an undergraduate student intern called Marc Andreessen decided to create a user-friendly web browser he called Mosaic. Beta-test versions of Mosaic started to appear early in 1993 and the product was released on 1 January 1994. Two year later the 22- year-old Andreessen is worth about US$50 million.

Mosaic had the same effect on the Internet that the Desktop/Windows style of user interface had on personal computing. Many people who would have previously felt too intimidated to use network facilities were given confidence by its point and click simplicity. They quickly discovered that creating Web documents was also pretty easy. Many of them were artists who saw in the Web an ideal format for their entry into the virtual domain.

The result has been a meteoric growth in the number of art 'sites' on the Web. In January 1994 there were a few tens at most. The Visualisation Lab. at the University of Illinios, Chicago, and FineArt Forum Online were two. Now there are tens of thousands. Most of them have little if any relationship to the kind of developments described above. They consist of art placed on the network in the format of a virtual gallery and have little in common with post-modern ideology or communications-based art.

Most of these sites document object-centred artworks and use the Web only to promote and/or market these traditional forms. There are exceptions but they're dogged by the poor response times of the web and its lack of in-built dynamic interaction. This will change as new 'plug-in' tools like Macromedia's 'ShockWave' and Sun's 'Java' get more widely integrated and the bandwidth of the networks improve.

But the real culprit is the traditional media dogma that we ourselves bring to the Internet. We call Web databases 'pages' and the data servers 'sites'. The metaphors to traditional print media and architectural spaces abound. It's just like those early photographs that pretended to be academic paintings or the first dramatic movies that copied the theatre stage and mapped the film frame onto the proscenium arch.

Conclusion – the user-friendly dilemma

It's our lack of ability to perceive the true nature of this new multiple medium that is the most significant limitation on its use. It's also my opinion that the more user-friendly tools haven't helped. On the contrary, they have actually impeded the development of more intrinsic methodologies by reinforcing the old paradigms.

There is, of course, some excellent documentation and information on the Web. It's a valuable library that is international in scope and comes straight into your home. But I'm still waiting to see artworks that have the impact of the earlier work described above.

User-friendly tools work by adopting existing paradigmatic metaphors. In essence, they tell the user 'there is nothing new to learn; your existing knowledge and skill can be applied to these new systems'. It's not surprising therefore, that they cauterise creative development and could possibly delay (and may even prevent) the evolution of new methodologies and critical dialogues.

What confuses many is the social egalitarian value of user-friendly tools which have introduced many, who may not have otherwise got involved, to the computational

metamedium. Whenever I speak about my concerns many get angry, believing that I am threatening their gateway to the new media or that I am arguing for an elitist position. On the contrary, it's my belief that access by non-professionals is almost an essential prerequisite for a new language to evolve. Those who are already trained in the arts have too much to unlearn and to much to lose when the paradigm that nurtures them shifts into something new and unknown. In photography it was the amateurs, thanks to Eastman's 'Box Brownie' cameras, who broke all the rules and established new foundations for the photographic language to evolve.

The problem is that a user-friendly computer system is not a simple Box Brownie camera: it's an extremely sophisticated system pretending to be something else. Pretending to be simple. Just like the aliens in 'Invasion of the Body Snatchers' who pretended to be the folks next door, dependable people who you had known all your life. So you trusted them. And that's what concerns me.

References

1 Australian Federal Department of Communication and the Arts (1994), *Creative Nation - Commonwealth Cultural Policy.*

2 Gibson, Ross (1995) speaking at James Cook University, Queensland, September.

3 O'Rourke, Karen (coordinator) (1992), Art Reseaux - ouvrage collectif project art-reseaux, Editions du C.E.R.A.P.

4 Kac, Eduardo, 'On the Notion of Art as a Visual Dialogue', in ibid, pp21-22.

5 O'Rourke, Karen, 'City Portraits: an Experience' in the *Interactive Transmission of Imagination*, see ref 12, pp 215-219.

6 Popper, Frank, 'Assessing City Portraits', see ref 3, pp.66-67.

7 Ascott, Roy, 'Mind City - City Cerveau', see ref 3, pp. 68-69.

8 Brown, Paul (1992) 'The Convergence of Reality and Illusion', Proc HiVision 92, Tokyo, Japan.

9 Brown, Paul (1992) 'Reality versus Imagination', *ACM SIGGRAPH Art Show Catalog*, ACM NY.

10 Brown, Paul (1991) 'Communion and Cargo Cults', *Proc. Second International Symposium on Electronic Arts (SISEA)*, Groningen, the Netherlands.

11 Barron, Stéphan. Lines: A Project by Stéphan Barron and Sylvia Hansmann, see ref 12, pp. 185-186.

12 Ascott, Roy and Carl Loeffler (eds.) (1991) *Connectivity: Art and Interactive Telecommunications*, a special issue of Leonardo - the journal of the International Society for Art, Science and Technology (ISAST), vol. 24 no. 2.

13 Barron, Stéphan (1996, 1995) Project notes for the Sym Choon Gallery show, Telstra Adelaide Festival.

14 Barron, Stéphan (1994) Project notes for 'Le Bleu du Ciel'.

15 See ref 13.

16 Lau, D.C. (translator) (1963) *Lao Tzu's Tao te Ching*, London: Penguin Books.

17 Minsky, Marvin (1987) *The Society of Mind*, London: Heinemann.

18 Popper, Frank (1993) *Art of the Electronic Age*, Thames and Hudson.

19 Sermon, Paul (1994) 'Telematic Vision', *ISEA 94 Catalogue*, Helsinki, p.43.

Parts of this chapter first appeared as 'Stéphan Barron at the Sym Choon Gallery', a catalogue essay written for the 1996 Telstra Adelaide Festival.

Joanna Buick is Director of Broadcast & Digital Media at the Arts Council ofEngland. She also makes sculpture and photographs which explore the viewers'awareness of their own perceptions of the world, occasionally using sound, video and electronic interfaces. She has studied architecture,physics, psychology and poetry, graduating with first class honours in sculpture from Chelsea College of Art in 1991. After takingan MA in sculpture, she researched 'Virtual reality as a fine art medium'before taking teaching in the Electronic Media Studio at the Slade School of Fine Art at University College, London. After graduating she taught in various British art schools and tutored courses in Communications and Technology for the Open University. Joanna worked in the BBC for a number of years before studying art. Since then, apart from teaching, she has worked as an analyst, software trainer, internet producer and writer – her book Cyberspace for Beginners was published by Icon Books in 1995. She continues to make work for exhibition and, through her role in the Arts Council, aims to support artists producing and exhibiting their work using digital communications media.

Joanna Buick

Virtual reality and art

Wherever I look in the virtual reality arena, commercial enterprises and technical wizards are racing towards ideals of faster computation, perfect simulation and life-like stimulation. In art things are somewhat different. . .

I come from a background that includes both arts and sciences, from physics and architecture through television and the Internet to art and psychology. My preferred occupation is making sculpture: objects, images and environments that persuade the viewer to consider the space of the work and the space of their body in relation to it. I try to find the form and material that is appropriate to the feelings and ideas that I want to convey, using whatever is necessary to generate the experience I'm trying to communicate.

Perhaps a description of sculpture as I was taught and as I understand it would be useful here. It is an art form which is not bound by a specific technique or medium; it is rather a process of research and investigation into the nature of a medium, or a subject, through practice. The best art schools in the UK, for which it is rightly

famous, have allowed for exploration and contemplation which would be impossible in most other disciplines. They are research and development facilities serving culture and industry across a broad spectrum – the range and success of art school graduates is well-known. Art has ceased to be a collector's item and has entered the culture as conscience and commentator: it addresses every aspect of life. One can go to extremes in art: anything is possible and everything is attempted. It is this essential characteristic of fine art sculpture, the infinite possibility, the empty page, that brings me to VR.

The fantasy of cyberspace is of a place where one can be anybody or any body, do anything, have every experience available, invent heaven - the virtual worlds of multi-dimensional space tempt and beckon. Those who understand the technology have scoffed at the rhetoric, giving timescales for believably real simulation speeds some distance into the next century and saying they'd rather go for a walk on a beach anyway. The general public, having been bombarded with a frenzy of hype about VR and shoot-'em-up computer simulation games in the last couple of years, are already disappointed - they think it's all over. In art, at least, these arguments and evaluations don't apply. Not only do artists not have to choose between technology and 'nature', we can use whatever technology is available to us *now*: art is pragmatic.

The traditional concerns of sculpture have been shape, space, texture, light... Many historical and contemporary artists also take account of position, context, duration, sound, rhythm, colour, temperature, size, motion, height, direction, interaction and, ultimately, meaning. In VR likewise all or none of these considerations may apply *and* they may change: shape may shift, spaces turn, textures grow, light move... nothing is fixed, not even gravity, and nothing has to be presupposed.

The only certain requirement (and even this will vary) is that of the interface. We need to see and hear and be aware of both our real body position and that of our virtual existence via the proprioceptive senses. In the real world we know how our bodies feel and behave, having learned throughout our lives, but for the VR user anything imaginable is possible. Strange and different bodies will be 'tried on' and psychological experiments will explore physical self-perception, but we will not leave our flesh behind. All new virtual physicality can only be experienced through our knowledge of our real bodies.

Being a lobster or a slime-mould or a door knob in VR requires us to experience ourselves *as if* we were those things, using our human senses. There is no direct physical sense of altered states - all is necessarily mediated by experience, both conscious and subconscious. The hedonistic ideal of virtual disembodiment can only be mental and therefore imaginary, by definition; literature is a good example of the production of an imaginary virtual existence in the reader. For the appreciation of most static visual material the imagination is sufficient and normal, but any participatory interaction or spatial mobility will introduce actions of the body in both real and virtual spaces simultaneously and will therefore involve actual physical sensation.

In Vernor Vinge's ground-breaking science-fantasy novella *True Names*[1], in which computers are controlled by thought and therefore have direct interface to the brain, he convincingly argues that the response of the 'imagination and subconscious to the cues' presented by electrodes directly into the brain would convey 'full sense imagery'.

Using the example of writing, Vinge claims that, given a 'sympathetic reader', the author can 'evoke complete internal imagery with a few dozen words of description'. Direct access between the computer and the brain, wiring from hardware to 'wetware', might theoretically produce sensations of physical experiences that are entirely new or impossible to achieve through external (to the body) physical interfaces or activities, but they will be perceived in terms of what we already know. Body-altering and mind-altering phenomena have long been a part of human experience and the 'unimaginable' VR experience seems like hoping for a new colour – there is nothing new under the sun, only new combinations of things and colours, mental and physical experiences that give us new meanings.

VR conjures a geeky picture: bodies weighed down by helmets and gloves, trailing wires, aiming for 'immersion' in a totally new 'world'. But we are already familiar with similar technology that uses mental rather than physical immersion: computer games supply minimal information and depend on adrenalin, humour and competitive ambition for their addictive appeal. Perhaps in VR art only minimal cues may be required, the imagination of the person in collaboration with the stimuli supplied by the artist doing the work of art.

VR seems to provoke a hostile reaction from some who see it as irresponsible and disconnected from reality. The fact is that it is part of our reality and will become a greater part. It is, I believe, one of the responsibilities of artists to deal with whatever artifacts the culture produces and to find artistic and aesthetic meanings in it and for it. The fear that VR technology is or could be a total substitute for the real world is misplaced. VR will inevitably feed off the real and the person experiencing it will always bring their own real world experiences to it, even more so with VR than with the classical painters! Being overwhelmed by a particular VR world is not necessarily any more dangerous than raptly gazing at a Sassetta painting. We all recognise the feeling of being lost in reverie or contemplation, sometimes for hours, but if interaction calls for physical action or concentration the reverie is broken. The desire, for example, for a cup of tea, will often take precedence over the virtual; the urgency of the real will always win in the end, no matter how exciting the VR may be. A phenomenology of VR will refer to parallel physical experiences between the virtual and the real and attempt to bridge between them,

When discussing VR and the experience of 'the user of the interface' I have found myself in difficulty finding the right word to describe the person actually doing it, as opposed to the maker of the virtual world under consideration, or an observer external to the VR set-up. In computer games or theatrical VR, 'player' or 'participant' may be accurate, and in commercial situations 'operator' or 'client' could be used. To cover all the possibilities of VR without excluding particular aspects (e.g. viewer, listener, experiencer, audience) or sounding too technical (perceiver, interactor) or becoming ungraceful (VR-er!) has presented me with a problem. I propose, for the rest of this writing at least, a generic term: VeRa - to stand for the person 'doing' the VR, the one in the headset, with the joystick, the people dealing with VR on a big screen... whatever form the VR takes. VeRa has the advantages of being short and pronounceable and relating the virtual to the real through a serendipitous association with veracity, from *veritas*. In using the term I am not describing what the VeRa is doing but where they *are*, for *themselves*. This addresses my particular interests in VR for use in the practice of

sculpture: the experience of being in two places at once, simultaneously experiencing the virtual world and the normal fatigues and pleasures of the body, halfway to paradise.

I am more concerned with the VeRa's own physical sensibility than with representation of the figure in digital space or in analysis and animation of a virtual human form. The possibility of distortions, reflections and dis-integration of representations may become interesting but for me experience is far more important than the technical accuracy of mimesis. Reports of motion sickness caused by the bodily and spatial disruptions of VR suggest that the disparity between the physical experience of the VeRa and their mental construction of the VR with which they are engaging is considered by VR manufacturers to be a technical failing to be overcome. This aspect could be a stimulating starting point or an essential part of VR art. In analogous situations we provide an external reference that gives a frame to dislocating experiences - the spinning ice-skater's fixed point, the pause just before and after the 'big dipper', the wall beyond the frame of the painting, the ornaments on top of the TV. We are used to dealing with seeing two worlds at the same time. The difference in VR will be immersion: sickness and vertigo, even paranoia, may become serious problems, especially when the VR has a goal, carries weight, putting the VeRa under pressure. The awareness of the VeRa of the onset of those feelings may well be part of what a VR artist is trying to achieve and they will construct a VR world that deals with them. This is an area I find fascinating, and reminds me of a line from Rilke that often occurs to me when making art: 'Beauty is the beginning of terror we're only just able to bear'.[2]

Until the sophisticated interfacing devices envisioned in the science-fantasy works of Vinge, Gibson[3] and Cadigan[4] bypass the nervous system entirely, plugging computers directly into the brain, our bodies will remain an inevitable factor in VR. Even VeRas of the future will have to eat unless they plan to spend all their time in the equivalent of intensive care, so art that deals with the body will always be relevant. What kind of art will it be?

Art has always been made with the technology of its age and with any means available. It has pushed frontiers in technology where industrial research had neither the time nor inclination to explore. Design projects have goals and aims which, for reasons of speed and commerce, don't normally allow meandering exploration – art works differently. What it has always done is to reflect, to dwell on mystery and give time to ideas which have no immediate return or reward. It looks at the long term, it changes course and it asks questions.

Steve Bryson of NASA, a keynote speaker at the VR Applications Conference in Leeds in June 1994, described a 'new design paradigm' of virtual reality in which feedback occurs at every stage of production, from concept, specifica-tion and design through to manufacture and use.[5] From the old model of design, in which the client supplied a specification and later received a product, he went on to suggest that VR revolutionises the creative process though constant feedback, to make it fully interactive at every stage. In our computer age, with ever tighter budgets, it would be reasonable to presume that a great deal of industry already works this way, because of both opportunity and necessity.

But this is how fine artists have always worked and it is this process of generation and modification that artists have been trained to deal with: it is a position of fertile insecurity. Not only is the production of products using VR technology a process with which artists will feel familiar, but the process itself is one which they will grasp and explore confidently.

Contemporary technology is not merely a tool but gives us ways of looking at ourselves, at our culture and at what we value and find meaningful. It generates artifacts which remain as witness to our activities. Art uses these artifacts, producing evidence of our feelings and our attitudes. Where once, in the Enlightenment, truth and beauty were paramount values, the society of the late 20th century, of information technology and electronic imaging, is more concerned with the ephemeral and communicative. In sculpture one has, traditionally, viewed the work. In my own work I have been preoccupied by the translation of experience into things and images and have also required the 'viewer' to listen, touch and play. The viewing of a lot of contemporary art involves incorporation, taking it into oneself, allowing the work to become part of and affect oneself, relating the visual to the visceral. Virtual reality technology has the capacity to facilitate both this and the reverse process, the incorporation of the self into the virtual world. Interaction invites the VeRa to be specific, to choose and to reach out. It questions the authenticity of the artwork by forcing the VeRa to participate in its creation, by opposing the universal and particular experiences of repeatable VRs. The VeRa is perfectly placed for exploration of ideas about the body, alienation, subjectivity, incorporation and appropriation - all important issues in philosophy, politics and the culture at large, and in art in particular.

One can only conceive of making things with the tools and methods available. Sometimes tools surprise the maker by producing the unexpected, which then becomes part of their repertoire. VR has great potential to surprise by its very nature and will stretch the limits of making and using, not only though its unpredictability but because of its capacity to behave unlike anything in the familiar, real, world. Many people are capable of doing several things at once - talking on the phone while driving, for example, and the television industry is beginning to cater for those who want to have a number of channels in view simultaneously. The ability to discriminate and select becomes important when one is inundated with information. Perhaps selection will be a rich area of possibility for VR artists. Most VR presentations I am aware of involve no editing, assuming continuous visual stimulation with no switching of viewpoint, no blinking. TV and film viewers are already familiar with sophisticated time-and-space editing. To present space as singular and time flow forwards in 'real time' is banal when one considers what the technology is capable of. It is easy to be dull and present a sci-fi environment through which a VeRa can meander: stereotypical scenes and lowest-common-denominator images abound in the iconography of computer art. A good VR artist would create not merely a vision but an entirely substantial VR world which was stimulating and provocative, harnessing the meander to a stumble or a flight, as dictated by their own aesthetic truth. Precision is crucial - just struggling with technology isn't enough, the artist must be an expert in this medium, as they would be with any other. The artist is always responsible for what they have made, every brush stroke, every angle; but just as people always find things in

a painting of which the artist was unaware, a VR artwork will throw up surprises. It will be a performance by the VeRa of an interactive environment, different every time.

This is more interesting than reality simulation and is possible now. Verisimilitude in a street scene is years away and is unlikely to be as interesting as the real thing: I would want to include random events in my street, banana skins and dog-ends, but even so I would have to place them there. The reality that each of us experiences is individual, mediated by our particular senses and our mental constructs, simulations becoming personal, particularly through interaction. The production of VR indistinguishable from reality is a Hollywood notion, as in *Total Recall*, the film starring Arnold Schwarzenegger. It isn't even the concern of training simulators where accuracy of representation is important because of safety. Flight simulators with images similar in quality to those in games arcades are used to train pilots because it is cheaper than using real aircraft, and a qualified pilot may step from the simulator to actually landing at a new runway for the first time with a plane load of paying passengers. The difference in the training simulator is that the cues and conditions are real, so that the experience of the pilot is one of intense *awareness* rather than pretence. What is important here from the point of view of art is the experience of the artwork by the VeRa, and not necessarily of the medium by which it is presented: the highest aim of art is to transcend media by its particular and specific use. A great deal of contemporary art is reflexive and sociological in its subject matter, drawing attention to its means, and it is to be expected that some VR art will similarly celebrate or fetishise the technology. There are many curious aspects of VR and I have seen quite simple VR constructions that are as much art as those made in other media, in the same way that the skilled use of simple tools applied by an acute sensibility to a good idea produced Michelangelo's David, the Eiffel Tower, Cartier-Bresson's photographs, Monet's water-lilies and James Turrell's light works.

Common to all these examples are the concept, the execution and the presentation – the quality of a work of art can be judged by considering the quality of the decisions made in order to produce it. For the lay consumer of art, judgement of quality has often started with a comparison of the art-work to what the viewer thinks it should look like, what it's supposed to correspond to in the visual world. But re-presentation of recognisable appearance is only one of the aims of art. When presenting (or representing) ideas, feelings, thoughts, the strategy of the artist can produce an infinite variety of forms in a multiplicity of media. Even when these are in the form of representational images, the art is not merely in the skill of replication and mimesis but in the contextualising, articulation and combination of those images. The artist attempts to focus attention on particular ideas or experiences: representational images, paintings and prints, are no less effective as art by being obviously not real. So-called abstract art requires a different kind of appreciation from searching for likeness in an image, but it doesn't involve suspension of disbelief: one is always overwhelmingly in the real world while witnessing or being transformed by a depiction of a world of imagination.

The popular and arbitrary division of fine art into figurative and non-figurative is misleading and unhelpful: all art distils and constructs meaning, all art is generated by some gesture, some action of the person. To think this position elitist or

inaccessible is to reduce art to part of the entertainment industry. If appreciation of art is difficult, then one's experience of it is enriched by successful effort – you could have missed it! And as always art, like science, is for anyone... but it may not be for everyone.

The spaces of literature, film and music are linguistic and narrative, depending on memory for association and reconstruction in the mind. The space of VR can be all these things: it is the physical space of the imagination. In the hype one is presented with the frightening and intriguing possibility that it could become a space for imaginative and imaginary experience beyond what is already known. If we start making VR art without any parallels to physical reality, without even a Cartesian model of space, we begin, as Galeria Virtual[6] of Barcelona puts it, with the 'non-experience of the virtual void'. But as soon as any colour, shape or sound is placed in the void-VR we know where we are with it because we have something to interpret. This is the most telling moment, when the first, smallest information determines the character of the experience for the VeRa. Just as one's actions as extraordinary virtual bodies will make one more aware of one's own, real, body, all information in the virtual space of the VeRa will remind us and embody our knowledge.

Even time will become susceptible to the theatre of altered perceptions but the three second pulse of the human attention will still mark the only *real* time we can know. Everything that moves is a clock and, as in theatre and film, manipulated events dilate and contract our experience of time passing. Engagement and interaction with VR environments may dispense with the durational conventions of film and TV, as *Total Recall* suggested, allowing other 'worlds' to envelop us for much longer periods. Memories of these experiences will be as valid as any others, the virtuality of experience becoming collective and therefore a 'commonplace'. In *Poetics Of Space*[7], Gaston Bachelard examines ideas of the house of memory, the spaces of childhood forming spaces for our imagination; VR reseachers have referred to Frances Yates' *The Art Of Memory*[8] and likened the technique of using an imaginary building in which thoughts and information may be placed, as furniture or decoration, to the construction of virtual architectural space. In their *Placeholder Project*[9], Brenda Laurel and Rachel Strickland took this idea literally, placing 'voiceholder stones' in the virtual space. If touched with the virtual gloved hand, a stone would record a message which could then be replayed at the touch of the same or another VeRa. When training memory according to the ancient method discussed by Yates, familiar objects and spaces are chosen, an extension of naming one's own world in order to control it or feel mastery of it. The role of the artist in such a VR might be to seed a space with sounds or information to generate a particular kind of journey.

The possibilities for VR art are immense and could be wonderful but because of the art/science divide, the huge costs involved and the traditionalist fetishes for oil and bronze and stone, it seems unlikely that VR will be used by artists as often and as creatively as a new and expansive medium should be. Artists will find themselves hired to put the gloss on commercial works (the virtual public statue in a corporate 'world'?) as usual, and may occasionally be invited to play with the scientists in an effort to make technology seem friendly. There are still some exciting possibilities here for those lucky few who get their hands on the toys! I would be thrilled, for example, to realise the

fantastical modern physics world of George Gamow's character Mr Tompkins[10], constructing spatial parameters governing the VeRa such that they could only 'exist' in electron shells, or play tennis with electrons against Maxwell's demon. Voice control technology will provide good interface mechanisms for lay VeRas and PR budgets will make it possible for them to engage with, for example, the nuclear reactors of Sellafield, in ways that will make playgrounds of life-threatening industries.

But artistic gloss isn't art and we can only hope that there will be leftfield hackers without sponsorship who can, as Renaissance figures, deal with both the media of technology and the ideas of art to make truly great works which question the assumptions of the culture from which they emerge. If one of the projects of fine art has been to simulate reality then, for example, photo-graphy has surely superseded painting. The life painter today must therefore have other agendas, other aspects of the work involved in making a painting, that they feel a need to present. To use computers only to simulate the traditional arts, whether as Van Gogh draw-alike tools or polygonal Rodinesque 3-D forms, is to avoid the challenge of making art with these new media. If we make not VR art but art using VR, that art will inevitably be of its technology and of its time. The transcendent aspiration of fine art is to overcome material and technology by focusing on it. In VR this entails accepting the existing constraints of the technology and working at their limits. It is in pushing the envelope of thought and experience that art speaks most clearly and beautifully. Art deals in the now, and by positioning the VeRa at the intersection between dailyness and dreaming we will transcend the novelty of VR technology and make art which is timeless and true.

Examples
Virtual Slide – *Michael Scroggins, Stewart Dickson*
Using a headset and simple platform interface, the viewer navigates the surface of a coloured mathematical solid in virtual space. Speed and direction are controlled by the viewer, whose experience involves their whole body and is overwhelming, to the extent of falling off the platform occasionally! The VR includes sound, a kind of whooshing noise dependent on speed. Awareness of one's body simultaneously in both virtual and real space was a powerful feature of this VR. The work was a prototype, without a gallery environment, and was made in collaboration between an artist and a technical expert with an interest in art.

Handsight – *Agnes Hegedus*
An eyeball 'camera' held by the VeRa reveals the virtual interior of what appears to the external observer as a clear sphere. The virtual imagery is of Hegedus's grandmother's heritage - an east European tradition of placing objects and images in glass jars as remembrances. One feels that there is some possibility of seeing through another's eyes, sharing their memories.

Telematic Vision – *Paul Sermon*
Using the virtual space of telecommunications technology, this widely-shown work allows people sitting on the 'same' sofa in separate cities or countries to interact with each other. They see a combined video image of themselves and the other participant(s), allowing a shared space for play and intimacy. The behaviour and participation of the public transcends the technology and addresses issues of time, space and communication in cyberspace in a relaxed and pleasurable way.

Bar Code Hotel – *Perry Hoberman*

A number of barcode-reading pens create and control the behaviour of simple virtual objects and their environment. Attributes including size, shape, colour, bounce, spin, pattern and sound can be varied and the objects can be made to chase and capture each other. All visitors wear 3-D glasses to view the large screen display of the VR and the arena suggested a foyer space or bar. This work allows an audience to be involved in the events by calling out suggestions and encouragement to the barcode operators and contributing to the atmosphere of play.

References

1 Vinge, Vernor (1987) *True Names And Other Dangers*, Baen Books, USA.

2 Rilke, Riner Maria (1963) *Duino Elegies*, trans. Stephen Spender, London: Chatto & Windus.

3 Gibson, William (1984) *Neuromancer*, London: Harper Collins. (and others)

4 Cadigan, Pat (1995) Fools, London: Bantam Books.

5 Information given to me by Kevin Atherton, Project Leader of Virtual Reality as a Fine Art Medium Research Project, Chelsea College of Art and Design, London.

6 Galeria Virtual is a virtual reality art project developed by Narcis and Roc Pares, Institute of Technology, Barcelona, Spain.

7 Bachelard, Gaston (1969) *The Poetics Of Space*, London : Beacon Press.

8 Yates, Frances (1966) *The Art Of Memory*, London: Routledge & Kegan Paul.

9 *The Placehoder Project* of Brenda Laurel and Rachel Strickland was presented at the Virtual Reality and Fine Art Conference at the Banff Centre for the Arts, Alberta, Canada in May 1994

10 Gamow, George (1993) *Mr Tompkins in Paperback*, Cambridge.

Richard Wright is a media artist specialising in digital effects and animation. His previous films include *Heliocentrum*, a computer animation about Louis XIV and the technology of leisure and *LMX Spiral*, a film combining animation and live action about the eighties. Richard also writes widely on technology and culture and received a PhD in the aesthetics of digital film making from London Guildhall University in 1998. Recent work includes a BAFTA award nominated online screensaver called *The Bank of Time*. Future projects include a porn version of Kafka's The Castle, an anarchist skinhead film and a larger scale project which he describes as "Lost in Space set during the English civil war...".

Richard Wright

Visual technology and the poetics of knowledge

Imagery is now the most common scientific artifact and it provides the most prevalent means for diffusing scientific knowledge through media, television and publications. The results of new research are now experienced rather than strictly explained, though this may still entail advantages for its general understanding. As well as scientific visualisation that is produced for both epistemological and promotional purposes, many of the graphical and animation techniques commonly employed for arts and entertainment productions come about as a result of methods developed for scientific modelling. Many computer animators that have achieved popularity in recent years also come from partly scientific backgrounds and use many of the mathematical skills and techniques acquired from those disciplines. I am thinking here of the work of Karl Sims, Yochiro Kawaguichi, Jon McCormack and William Latham, artists who all (with the exception of William Latham) have degrees in the sciences as well as arts. But when we view this work with its very unusual stylisations and startlingly unfamiliar transformations, feelings like distance and alienation often ariseowing to its very strangeness. Could these side effects be caused by the fact that this kind of work can owe its origins to practices so far removed from cultural imperatives? Computer animation produced by scientists or through new algorithmic procedures often seem to resist more than a superficial cultural

interpretation, always 'too technical', but is it because we, the audience, have not yet become literate enough to appreciate the references of this new form, that we have not yet developed the 'algorithmic vision' necessary to read this imagery?

Through electronic imagery, we seem to have been given direct access to scientific research, in a form often set adrift from the usual accompanying texts and explanatory materials. When our perception of scientific ideas are mediated in this way it can lead to conflicts of context with bizarre results. The introduction of this material into culture presents us with various challenges. Can we construct cultural readings of scientifically derived imagery that are more than just an enigmatic confrontation with seductive visuals? Can we propose an aesthetic or cultural practice that articulates and is informed by scientific knowledge but can function in a wider cultural context? Such a practice, if it existed, we might call a poetics of knowledge.

The fractility of media

The computer's classic role as a creative medium was invented many years ago, when its technical restrictions and logical simplicities made the workings of its mathematical sequences self-evident and unavoidable. Its extension as a means for the Constructivist and Systems artists' interest in numerical series, relations and rational procedures defined the 'poetry of the medium'. But when those previous limitations in machine power and software capabilities were overcome in the early 80s, its full power of 'universality' was fulfilled.

No longer constrained to the pedestrian logic of its predecessors, computing devices can now offer an algorithm for anything, simulating the structure of any signifying system and possessing no 'intrinsic language' of its own. The aesthetic character of computer imagery has shattered into a thousand fractal fragments.

New electronic media often develop out of non-cultural practices. Techniques are presented to artists that have resulted from the curiosity of scientists working in industrial environments, estranged from the context of cultural traditions and sensibilities. Their formalisms produce new 'effects' with little relation to anything previously known, becoming remote and meaningless - detached from a living situation. Functions multiply so rapidly that enough names cannot be thought of for them, and the curse of Babel is felt across the land.

The place where the impact of electronic transformation is most clear is in videographics for TV broadcasts, especially in youth and magazine programmes. The end of every shot is punctuated by some freeze-frame, flip, strobe or recolouring in a continuous jamboree of arabesques. Here, digital effects are exploited specifically for their strangeness, to attract attention and to try to break through the haze of apathy that threatens to engulf the viewer and deaden their response to the adverts. For this reason, there is a constant pressure on the video editors and graphic designers to create new and startling visuals and to avoid any semantic debris that might hamper the strongest impact. Any attempt to redirect the use of video special effects to convey certain subject matters must struggle to overcome its lack of reference to any wider language outside of the TV screen. You can chose from an infinite variety of special effects but they all mean the same thing – Keep Watching.

The computer does not seem to fit our idea of what a machine is, it does not have the physicality of a mechanical digger or the explosive potential of a power station. Every attempt to clarify and categorise one of the manifestations of digital graphics is soon made obsolete by its next incarnation. Tireless efforts of critics to define the poetics and grammar of the new medium are relentlessly overtaken and rendered trivial or hopelessly short sighted by another barrage of innovations. Critics now search for artwork that 'is only possible with a computer', the default definition that is their last recourse. But the computer does not even have any specific function of its own; it is defined as being able to simulate any other machine. It is a 'universal' machine, wrestling with abstract symbols instead of dirt and energy, its dynamic is the neutral ahistoricism of the black box.

If the computer had its own aesthetic language we would surely expect it to be most recognisable in the form of the algorithmic image, the often strange and unpredictable result of the interaction of systems of equations being conjured up into a tangible state. There are several very well-known animators that now base their work on mathematical processes - Karl Sim's and John MacCormack's simulations of dynamic systems of turbulence and flow, Kawaguchi's growth and movement algorithms and Latham's implementation of evolutionary principles. But these images of landscapes 'beyond imagination' do not seem to exhibit the poetry that we have come to associate with a traditional oeuvre like abstract lyrical painting for instance. These mathematical objects coaxed out of their remote worlds of ideality by electronic visualisation make no appeal to us to any aesthetic language of pictorial forms, they are not part of an established aesthetic programme. They are generated directly from logical relations; they seem to exhibit a literalness, a facticity. In doing so they appear to bypass the poetic and become pure visual technology.

The numerical image always seems 'too technical', fascinating for its novelty but ephemeral in its appeal. Not like the 'pure form' of the modernist era either, for now the pristine and continuous electronic surface disguises the structural properties and construction processes integral to the workings of that art practice. Today we don't believe in the purity of any form as such, but for many artists and scientists the computer's products are indicative of a way to escape worldly issues for a purely subjective space, or a purely personal 'aesthetic'. The computed image becomes a kind of literal image existing for its own sake, a new fact to replace the historical fact, as Paul Valery once described in his critique of the products of technology.[1]

The technical status of these images drives some people to try to 'signify' them by explicitly referencing a subject. Intimidated by the stridency of visual technics, they try to compensate and result in polarising its dynamics into a naive idea/expression dichotomy, forcing issues from memory and identity to feminism and militarism onto a form that seems to remain aloof from them by its own bland acquiescence. Computer art is all technology and no content, we hear these people cry, and locked into an outmoded model of creative dynamics, they try to pour 'content' straight into the computer as though it were an empty bucket, thereby reducing the problematics of subject matter into yet another technical issue. But this does not best describe the situation we are confronted with when trying to read a stark mathematical visualisation or a bland assortment of smoothly shaded whimsies. More accurately,

when a cultural practice becomes technologically restructured, its modes of production can become specialised to the extent that its artifacts fail to address a wider context.

This is not the fault of a technological overemphasis as such but of a practice becoming fractured into closed areas. The technology then comes to have the effect of defining a practice in and of itself which then bifurcates into specialisms that do not relate to each other except in technical terms. It is in fact quite a natural way for technology to be used in accelerating a process of social specialisation that has been a basic strategy in the West since the industrial revolution. Digital media is utilised under these social and economic imperatives as a force for the exacerbation of a fractalised and fragmentary culture.

Yet the promise of computer media is in the hands of those who use it. A fractilised culture need not be a divided one. To expand the metaphor, although a fractal can be generated down to the smallest scale or tiniest nuance of detail, every point on its surface remains connected to every other point, forming a perfectly interlocking mosaic. Historically, a restructuring in the cultural and social patterns of a period is often accompanied by a cross fertilisation among different cultural groups as new insights suggest common interests and break up old divisions. One possible way to resolve the 'crisis of meaning' that afflicts electronic arts may be to develop and exploit its references to the wider bodies of knowledge that its practice implicates.

Towards a poetics of knowledge

Throughout the 70s and 80s many scientists have continued to submit imagery and animations produced during the course of their research to international art festivals and competitions. There is, in fact, quite a tradition in graphics research for mathematicians and engineers to gear some of their output towards set pieces which are designed for exhibition purposes rather than purely for professional dissemination. A good example of a venue that caters for this form of work is the SIGGRAPH Art Show, which since the early 80s have provided a forum for members of the computer graphics community including researchers and practitioners, to show their work to each other. Such a positioning of a show within a professional discipline which was typically located in the same vicinity as academic presentations and industry trade shows failed to attract the attention of the mainstream art world, and indeed rarely attempted to. But these events do seem to have had a cumulative effect over the years, building up a momentum amongst the scientific community to the point at which submissions from academic sources are now commonly received by mainstream arts events focusing on technologically -based culture.

Probably the oldest festival of technological arts is the Austrian Ars Electronica which developed out of the Brucknerhaus experimental music festival in the 70s. In 1987 under the sponsorship of the local ORF radio station, it launched the Prix Ars Electronica, a competition aimed specifically at computer generated arts. It is a quite separate event from the main Ars Electronica (which focuses on installation work and live art) and was originally driven by a selection panel drawn largely from a computer graphics fraternity which would not have seemed out of place at a SIGGRAPH conference. Over the years, though, an increasing amount of expertise has filtered across from the Ars organisers to the Prix Ars organisers to the extent

that, in terms of the composition of its panels and the presentation of its final catalogue, it has achieved quite a confident status within the established art world.

A common problem for arts events that focus on one particular aspect of culture is to define the scope of its interest in non-trivial terms, and in recent years the Prix Ars has struggled to define what it means by 'computer arts'. In keeping with its position as the most prominent electronic arts competition, Prix Ars sees its role as helping to indicate new directions and to promote in particular works 'that were impossible to produce before the invention of the computer … even unimaginable'.[2] In 1992, in the prestigious computer animation section of the awards, a second prize was given to an animation that visualised the hyperbolic geometry of knots, while the first prize was given for two animations by Karl Sims, one of which in particular demonstrated the use of certain kinds of genetic algorithms for generating imagery. In the computer graphics awards as well, first prize was given to a pair of computer scientists for an image demonstrating a mathematical modelling technique applied to the design of texturing functions. The scientific elements in these works was part of the reason for the jury panel's decision, as the jury statement makes clear:

> "'Not Knot', directed by Charlie Gunn and Delle Maxwell … is such an example of the unimaginable that is rendered imaginable and visible by the computer. It is only secondary that 'Not Knot' also proves to be an outstanding example for the scientific visualisation of abstract theories and that the jury want that direction of research and application of computer animation to get more attention and tribute"[2].

> Even though 'it is only secondary', the scientific content of such animation work provides a good criteria to mark it out as possessing a content which is deemed appropriate for a work of 'computer art', to possess the required amount of 'computer specificity'. At the sametime, the rhetoric continues of science providing a world of 'unimaginable' forms that can be accessed aesthetically. On describing the winning animation pair by Karl Sims the catalogue states, "The algorithmic beauty of plants and their growth is simulated in an abstract manner. 'Primordial Dance' is a virtual laboratory where genetic algorithms create an uninterrupted play of colours and shapes. This work too, rather proves the beauty of scientific simulation and in this respect it is a close relative of 'Not Knot'. There, too, we are dealing with scientific artists (or artistic scientists) who develop those custom programs necessary for the creation of their images".[2]

The most successful attempt by scientists to give their work wide appeal was the series of exhibitions and books produced in the

mid-80s by a group of German mathematicians working with fractals and chaos theory, principally Otto Peitgen and Peter Richter. Their exhibition 'Frontiers of Chaos' and book 'The Beauty of Fractals' were a daring venture by scientists to juggle the immediate seductiveness of fractal imagery with their importance as scientific artifacts.[3] Indeed, in their book they state that at first they thought that the attractiveness of their pictures would be enough to satisfy their audience without the need for any further explanation. There have been other groups of scientists and sometimes artists as well who have sought to present work derived from scientific visualisation experiments in a cultural context, but mostly by restricting the images to a visual appreciation, as though a kind of mathematical ornament. It is sometimes as

though a scientific graphic can acquire a cultural status simply by cutting off its scientific function.

Science itself is then presented as a practice dealing in a realm of pure knowledge where social interactions and daily practice become discounted. This appears to be avoiding the possibility of levels of value in scientific imagery that we now routinely expect from artwork in terms of political or social dimensions, issues and polemics. Although since Peitgen's and Richter's heyday, pictures from fractal geometry and chaos theory have become tediously repetitious, their banal graphics inspired more ideological fervour than any other algorithmic imagery we have seen praised since. And what of other kinds of scientific visualisations seemingly excluded from these cultural debates - how would the simulation of the ozone layer be seen in a computer art competition? Is it possible to construct cultural readings from scientific visualisations, perhaps not from the examples here, that addresses the public meaning of scientific issues through a language of algorithmic imagery?

Computer graphics provides a way in which scientific ideas can take effect in culture and society in a much more rapid and potent way. We need to ask what particular scientific concepts are being assimilated in this way and how media technology is affecting their interpretation. Computer media has also given people in the scientific community access to cultural production and has given rise in some instances to scientific work being exhibited by scientists themselves as art or appropriated by others for other cultural purposes from fractal T-shirt designs to rave videos. The perception of the scientific community of cultural activity also determines its own exploitation of these opportunities. If we compare what is happening now to cases in the history of modern science where new research has informed cultural debate we can get a better idea of what the culturally active aspects of scientific work are and how the mechanism of their agency has changed.

For example, in the 16th century the pioneer anatomist Vesalius had to enlist the help of the painter Titian and his studio in order to accurately depict the structure of the bodies he was dissecting. The drawings that resulted not only proved invaluable reference material for surgeons but also gave the world a new image of the human body as a structure of mechanical parts performing technical functions like clockwork, the images of which went on to become icons for this idea. Similarly, at the turn of this century Edward Muybridge devised a technical system of photography to produce sequences of images showing animals and humans in states of motion. These images became a focus for the notion of the human body as a dynamic system rather than a static structure, a constantly changing biological process that had much in common with the functioning of other animals.

Today there are many new ways for modelling human and natural systems that are often visualised using electronic imaging techniques. But scientists often seem to have problems finding a contemporary cultural form for these new scientific concepts. One recent example is the application of artificial intelligence techniques to the animation of animals that move in large groups such as flocks of birds and schools of fish. In 1987 Craig Reynolds of the Symbolics company wrote a system for modelling this behaviour and in his research paper presentation included animation of simple objects such as triangles that appeared to swoop and congregate just like

birds.[4] By treating animals as information processing systems, Reynolds was able to show how a few simple rules of interaction could give rise to a wide range of apparent behaviour. This questions our definition of intelligence as a complex phenomena and how it can be reproduced and perceived - as simulated, modelled or imitated. However, the most common form in which Reynolds work is seen is a promotional video produced by Symbolics called *Stanley and Stella* about a cartoon fish and bird that fall in love, completely obscuring the wide ranging issues raised by his research animation.

Sometimes it seems as though scientists do not have the confidence that artists do in order to express their concerns lucidly without subordination to very genre-orientated cultural forms. Popular forms of culture have become alienated from their functions of creating dialogue and promulgating knowledge. Disciplines such as science see the arts as unable to provide any points of reference with their own field apart from formal devices and graphical themes. So when a computer graphics research team comes to apply the results of its work to some tangible cultural product, the most obvious artistic genres are chosen, almost having the effect of emphasising the distance that exists in our society between different areas of human creativity. These separated practices of art and science often only make contact at such banal levels, but instances do occur when researchers become so articulate with the dynamics of the imagery they are developing that they want to celebrate them in their own terms, often producing sequences of startling originality. Sometimes we need more technology and less art. Sometimes the appropriation of an artistic genre can lose the content that depends upon extra-artistic or scientific references, and that have the power to cross epistemological boundaries and specialisations. Such an emasculating aestheticisation of science and technology results in a closing down of meaning. Instead the promiscuity of media might open up channels that connect levels of knowledge rather than fragment our culture further and release its potential to restructure our perception of the world.

It seems clear then that for scientific concepts to become mobilised they are typically aided by both the diffusion of image media technology and their wider resonances in everyday life. As for chaos theory, its cultural impact was primarily through its ability to unify notions of determinism and freedom in one scientific mythology. And crucially these features could be expressed through their imagery. It was their status as objects of knowledge that gave chaos images their full cultural meaning and which gave rise to 'chaos culture'. If Benoit Mandelbrot's work on fractal geometry had not found this wider application and relevance, then fractals would have remained just an aesthetic curiosity.

When visualisation tries to appropriate 'content' by assuming a ready-made artistic genre or by restricting the matter to a straight visual decoration, it can lose the significance of its wider scientific and social references. In different fields of human activity such as science and culture, the same words, rituals and images can have different meanings. When these different texts are passed among these fields their meanings will inevitably change, like a poetry. The challenge is to make these changes lead us to new insights and knowledge. If computers and visualisation can create these connections among different disciplines and their means of perception then perhaps they will result in a new cultural practice, a 'poetics of knowledge'.

References

1 Valery, Paul (1990) "Remarks on Progress" *Mediamatic* ("IMAGO"), Vol 5, no 1&2

2 Weibel, Peter (1992) Jury Statement Pris *Ars Electronica Catalogue*. Linz: VERITAS-VERLAG.

3 Peitgen, H. O. and Richter, P. H. (1986) *The Beauty of Fractals*. Berlin, London: Springer Verlag.

4 Reynolds, Craig (1987) 'Flocks, Herds and Schools. A Distributed Behavioural Model' *SIGGRAPH '87 Proceedings* ACM.

Brian Reffin Smith is an artist who has used computers in his work for
about 30 years. He studied at Brunel University and at the Royal College
of Art, where he later held a Research Fellowship and was then
appointed College Tutor in Computing. He works in his studio in Berlin,
Germany and teaches computer-based art for the French Ministry of
Culture at the Ecole Nationale des Beaux Arts de Bourges, France.His art
and performances are shown internationally, often accompanied by his
songs on CD players nailed to the wall. In 1987 he won the first-ever Prix
Ars Electronica at Linz, Austria. He has also written several books and
contributed to many journals, including *Leonardo, Art Monthly, New
Scientist,* and *Kunstforum* in Germany. He is a sporadic contributor to
radio and television. After recent one-person exhibitions in France he
was compared to Stephen Spielberg in the French newspaper Le Monde,
to the sculptor Jean Tinguely in *Art Presse* and to the author Georges
Perec in *La Depeche du Midi.* Since the radio station 'France Culture'
played a couple of his songs, his students at last think he can do
something.Undergoing pioneering angioplasty in a Paris hospital
involving the use of a Japanese Fugu or pufferfish to inflate and unblock
a coronary artery resulted in him become a Zombie, and he now
presents performances, exhibitions and so on which contain no feelings
at all. Current gallery: pepperprojects, Berlin.

Brian Reffin Smith

Post-modem art, or:
Virtual reality as Trojan donkey, or:
Horsetail tartan literature groin art.

*'Computer-based art is a new artform that is revolutionising the way we make and
think about art. This art is made using machines characterised as quantitative
information-processors, using software ranging from traditional or "natural"-media-
like tools for artists, to mind-expanding, interactive or virtual environments that give
users the freedom to explore worlds hitherto unknown, or to range far beyond the
superficialities of everyday life.'* [1]

The above statements are all errors, disinformation, lies, propaganda or (more often) merely marketing strategies, whether for artists or cyber-sellers.

The aim of this text is to try to strip bare the essential nature of computer-based art, to see what it is, where it is going (and has been) and, optimistically, to endeavour to reclaim 'computer-art', even at this late stage, for what I shall call '*Real Art*'.

But this chapter will inevitably have a somewhat schizoid quality to it. The left, 'logical' hemisphere of my brain knows that most computer-based art is unworthy nonsense; my right hemisphere feels that actually it really can be revolutionary, exciting, even emotional stuff. The corpus callosum – that 'tough body' of a communications network connecting the two hemispheres – unfortunately cannot write – and so the rest of this piece consists of despatches from the two warring sides.

It's so easy to think that computer-based art is just a more or less artistic manifestation of the latest technological possibilities. Most 'virtual art' merely tries to replicate 'reality' in shiny and convincing ways. Oh God! After all that philosophy, psychology, art, literature and years of Tory mis-rule have taught us, that's what we end up with? One is tempted to be reactionary, to be bad-tempered and thick in the face of all this stuff; to try to keep sane during discussions where the words 'New Media' are chanted like a mantra, by imagining they are referring to 'Numidia', the Roman province fuzzily co-extensive with Algeria. And indeed I shall in this chapter try to have some sport at the expense of those who creep into galleries, conferences and art or computing magazines laden under the weight not only of the verrucous paraphernalia of their virtuality but also of their own self-deception.

Yet this is too easy and is not enough, deeply pleasurable and stimulating to the immune system though it can be. Ninety-nine percent of computer-based art is complete crap. But then 99 percent of almost everything (and certainly of other art forms) is complete crap. The point is to understand why and how, and to do it (or encourage others to do it) better. To go beyond virtual reality (VR), beyond today's presentations, even beyond Internet and World Wide Web and globally participative art to a Post-Modem Art, is not reactionary but dangerously revolutionary!

Let's see what's wrong with the first paragraph above.

Computer-based arts are not new and still less do they spell death for any of the 'traditional' arts. The future of art does not lie with each new technological advance, put on a pedestal, in a frame or shown at an exhibition sponsored by manufacturers of missile guidance systems and presented 'as if' it were art. If that had really been the determining factor of the avant-garde, we should only be pursuing an art based on a reeking mixture of fractal images, holography and paintbox animation, all of which were touted (by art magazines even, as well as the usual suspects) as THE future of art. I have several issues of international art publications with the same image based on the Mandelbrot set on their covers; and a good few articles proclaiming holography as the form and content of the 'new' museum. More recently, we have seen the same publicity shot of a person with flowing hair wearing a video headset illustrating editorial matter in scores of magazines and newspapers proclaiming a new avant-garde. Where are the artworks now? If fractal images were so important a few years ago, why aren't they now? It was fashion. There was usually zero art content.

Of course there are interesting things being done in the interstices of all this and there are individuals or (often) groups beginning to produce worthwhile interactive art on compact discs and across various networks, as well as installations where computers aid genuinely innovative work, but they really are exceptions. We are seeing art defined as 'those problems that are capable of computer-aided solution using the latest system I can get a grant for'. The truth is that there used to be much better art produced using computers. How can I say 'better'? Because it approached problems of art, not just of spectacle. It was often done to make art, to ask questions, for art-like reasons, not just to jump on the six-month band-wagon of some marketing strategy.

The first piece of computer-based art was produced in 1951 by John Whitney, using bits left over from old analogue computational devices. In the succeeding years, most if not all of the present-day 'miracles' have already been explored and used in more or less sophisticated, more or less artistic ways. Whitney, again, as early as the mid-1960s, was using a graphics terminal (costing hundreds of thousands of dollars, but lent by IBM) linked to the Health Sciences facility at UCLA, Los Angeles. 'One of the biggest computers outside of the Pentagon', said John, fairly proudly, when I talked to him. 3-D goggles, network art, computer-generated choreography, bio-computer interfaces, expert systems, robot art, exotic input and output devices of all kinds were already common currency in the 1960s and 1970s. That's 20 to 30 years ago, kids. The reason you didn't read about it so much, and with less hype, was that it was often made, and not bought, by the artists using it. Thus there was nothing (except perhaps the artwork) to sell.

When artists wrote most of their own software, the results were idiosyncratic and rare. There was thus variety and a proliferation of ideas, hence the possibility for comparison, for fusion, for provocation. Now, 99 percent of artists working on flat media (including myself) use Photoshop or Painter, musicians use Cubase, makers of interactive art compact discs tend to use Macromind Director, and so on. Thus the work tends to feel the same.

How fortunate I am, then, to have four computers: a Research Machines 380Z, 56k of memory, from the late 1970s; a BBC 'model B' from a year or two later, with a sparkling 32k of RAM; a second-hand Amiga 1000 and, using more memory to tell me that a floppy disc is empty than the BBC machine possesses in its entirety, a Macintosh LCIII, deemed a really good buy when I bought it two years ago, now raising sniggers because it's so small, weak, slow and so on.

Yet I can make the 380Z (when connected to an early speech and sound synthesizer) sing; and I use it to produce all my 'false text' artworks, where what looks at a distance like pages of magazine text, on closer examination appears to be Japanese, then just random squiggles. With images incorporated into pages of this text, and with false 'headlines', one question that people ask is, 'if it did say something, what would it say?' Thus the 'spectator' of these images becomes involved in the critical discourse surrounding (literally surrounding) the work and helps to 'write' it, and hence its meaning. And if the text is 'false text', what's the picture? What's a 'false picture'? And so on. Wouldn't have thought of it without the computer.

The BBC? With its four 'hi-res' colours I make the pictures to go in the false text pieces. I have a digitiser that takes video images and puts them onto screen and into memory

once a second. I can ask the computer to analyse things about what it 'sees'. There is an analogue port in the back, where two joysticks go. In place of these I can plug in anything whose electrical resistance varies, such as a chain of people holding more-or-less sweaty hands, and get that to control images, sounds, texts, anything. Including a £50 floor turtle that can hold almost any drawing device, such as charcoal or a loaded paintbrush, and can trundle over about 100 square feet of paper, or canvas, leaving its mark or not.

It was with the BBC computer that I won the first Prix Ars Electronica in Austria, in 1987. One of the judges apparently thought the image was faked, saying that even with all his powerful equipment he couldn't get the same smooth result. In fact, for the obligatory screen-shot I had used an old monitor and thumped it repeatedly during a four-second exposure. Better call this magneto-kinetic-assisted image enhancement. Haven't you got it yet?

Also with the BBC and 380Z, a bit of artificial intelligence written in the computer language BASIC causes the machines to have a conversation with you, or with each other, about... art and computers. There is also a version, more satisfying, that gets more and more hysterically rude. These conversations are non-predictable and non-trivial, though often complete bullshit.

The Amiga 1000 has a video digitiser that takes between 5 and 20 seconds to absorb a black and white image from a video camera. This is terribly slow, of course; even for the Amiga there existed others that took an image each 25th of a second. These days, you can't buy a digitiser as slow as mine.

This is a great pity. For if the scene being digitised, or the camera, moves during the 'exposure', all this movement is captured in a single frame. All the looks and expressions from a face can be piled up in one picture; suddenly, the power shifts to the person being pictured, who can determine, by seeing his or her portrait gradually appearing on the screen, its form. The near-obscenity of film and video is that they cut 'reality' up into little-bitty lies, like the differentiation of a rainbow's curve or a thrown ball's flight, up-and-along, up-and-along, lying little approximations, and then show them so fast that you think it's the truth (pace Jean-Luc Godard, who said that video was better than film because at least it was the truth 25 times a second instead of 24). This digitiser takes up to 20 seconds of 'truth' and represents it as a picture. To be honest, it's not of course 'better' than film or quick digitisers, but it's very important to have both possibilities, that's all.

We need (I am not joking) a sort of working computer art museum, where older computers and peripherals can be seen and used to make art - examples of artworks would also be displayed. When all printers are single sheet, pictures made up of huge columns of perforated listing paper will not be possible, printed using a new ribbon for each fragile hanging column, on a grotty nine-pin dot-matrix printer. Beautiful! But how, on a laser printer? Slowly digitised portraits of someone picking their nose? No way. Floor turtle robots? Analogue ports? Pen plotters? Gone, gone, gone; or very soon.

And the Mac? What can it do? I connect it to an A0 size pen plotter and reproduce texts on very nice paper measuring about 120 by 80 cms. Because it's a pen plotter and not

some electrostatic or ink-jet nonsense producing impermanent, dull, flat images, I can make it hold tools such as pencils, graphite, charcoal, a silver point, chalk, pastel, water-colour brush (hollow plastic handle holds the colour) and so on, as well as acrylic inks in any colour under the sun. But texts? Ah!

I bought my Mac in France. Its spelling checker is thus French. If I type the word 'the' in a document, it 'corrects' (not translates) it to 'thé', thinking I must have meant to type the French for 'tea', as 'the' isn't in its dictionary. If I give it, for example, a text of the well-known art-lover Chairman Mao talking about art, the paragraph -

> 'In the world today all culture, all literature and art belong to definite classes and are geared to definite political lines. There is in fact no such thing as art for art's sake, art that stands above classes, art that is detached from or independent of politics. Proletarian literature and art are part of the whole proletarian revolutionary cause; they are, as Lenin said, cogs and wheels in the whole revolutionary machine.'

becomes, when 'corrected' -

> In thé Orly Tokay allô culture, allô littérature aine art belon té définites classes aine are gérer té définites polyptyque lunes. Taire ils in faut no sucé théine as art for arts saké, art chat stands aboie classes, art chat ils détachez froc or Inde pendent of politique. Prèle tartan littérature aine art are part of thé ho prèle tartan révolutionna cause; thé are, as venin Sand, Gogh aine ailes in thé ho révolutionna machine.

Allô culture, indeed. For when we translate (not 'correct') this back into English, it says 'In tea Orly Tokay hello culture, hello literature groin art shellfish T-square defined classes groin 100 sq. metres to administer T-square defined polyptic moons. Shut up they in must no sucked caffeine ace art custom arts saké (drink), art cat stalls at bay classes, art cat they undo frocks well India hang off (le 'off') talk politics. Horsetail tartan literature groin art 100 sq. metres share off tea ho! horsetail tartan revolutionised reason; tea 100 sq. metres, ace venom Sand, Gogh groin wings in tea ho! revolutionised machine', and I think we can all agree with at least some of that.

It is machine art. Machine because it couldn't have been done or thought of without the computer. Art because when nailed to the wall in an art gallery it makes people laugh and think about the original text and other such texts and want to try it themselves and even start talking about sub-texts and authorship (this was in France). They also look, I think, really beautiful - perfectly computer-drawn Futura letters, plotted accurate to 0.005 cm, done with, for instance, a piece of wobbly charcoal.

Back to the first, 'wrong' paragraph: the idea of 'natural media' being to do with art is bound up with the American confusion (at least in the computer field) of 'art' with 'graphic design looking a bit like art'. Art is NOT simply 'that which is done using charcoal, etc.' If 'Painter' (a very fine 'natural media' program) is 'art' software, then so is the programming language 'C', so is Claris Works. Well, maybe. But have a look at almost any serious computer magazine. They often have an 'art gallery' section. The contents, often produced using 'natural media' software, are in respect of art nearly always pitifully trivial. How dare these buggers insult us like that? The equivalent in music terms would be to present one-note versions of Christmas carols as state-of-the-art sounds, but they'd never (too sophisticated about music, not enough about art)

do that. And, the crunch question, what use are natural media on a screen (as art, not as art-like graphic design, which, when honest, is perfectly ok), when you can't get it big, on paper or something? 'Painter' lets you simulate an infinity of papers and canvases, but all you can do is simulate them, then print out the results on a laser printer (in black and white, usually) or a colour inkjet printer, where of course there is no texture, though forcing in sheets of good art paper can help, when it doesn't destroy the machine.

So paper is old hat? No; it's the only way to get big (I mean 2 x 3 metres) pictures up on a wall where everyone can see it at its proper, 'meant' scale. A video-projection would be ridiculously bitty and blurred, the only texture there coming from the pixels. This is the point at which the techno-freaks start saying that, anyway, when everything's interactive etc., etc., you would only want it on a screen. The vicious circle starts again. If you're daft enough to think that traditional media are finished, you're never going to make any decent art in any medium at all. Because, because, because, it's the ideas that are important; and if you have a really good art idea, it's new and incredible and powerful whether in oil, on canvas or distributed in the Internet. A bad idea, on the other hand, will not be saved by all the thé in China, be it ever so technologically advanced.

And changing 'the way we make and think about art'? Well, emphatically 'yes', but absolutely not in the way 'they' mean. For whilst the first 30 or so years of computer-based art probably did contribute a bit towards contemporary art, the last decade has seen a degrading and vulgar trivialisation of the genre. Art has often been replaced by spectacle, with spurious lines about democracy and participation advanced as justification. In fact most of this art is authoritarian in its stance, hierarchic in its structures, business-oriented in its paradigms. It is tragic that because of this, many 'real' artists who might produce wonders with the technology, reject it because of the awful, terrible 'art' they see being produced day to day.

And look how computer people can treat 'fine art'. The following is taken verbatim from the Compuserve publication 'I Didn't Know I Could Do That On Compuserve!' It is a description of one of the many discussion 'Forums' you can go to on the Compuserve network to chat to like-minded people. This is the Fine Art Forum:

> 'Paintings and sculpture from artists past and present can be found in the Fine Art forum. Featured are works from pre-Raphaelite (sic) artists like Rubens, contemporary (sic) artists like Van Gogh and Gunni Nilsson Price (?), and science fiction and fantasy artists. Discussions in the forum range from artists' impressions of others' work to the style of being an artist (sick).'

I think that where computers are positively changing art, in parallel to the negative effects, is in the metaphors and ideas that come spinning off. I am sure that in 30 or 50 years, we shall look back at this period as one of ideas, and those who adhere to a sort of technological determinism will be (I hope) despised or forgotten. (Because, no, art is not democratically unjudgeable; it's hard, important stuff, of which some is brilliant and some is crap. Now I might be wrong in my judgements, but showing me the priceticket on your computer won't persuade me, nor what Euro-grants you get, nor how many public relations persons your centre of new media employs.)

But here's how ideas can work. One night (the only time this ever happened) I had an 'art dream'. I dreamed of a picture, made of coloured grains of sand suspended in a thin aquarium. Gradually, the sand settled in layers on the bottom of the tank, the picture 'fell down'. Morning came. Pixels! Why not program the computer to do the same thing to pixels in an image?

Six months of intermittent programming later, I had it. The algorithms, the ways to do it, were not easy. If you just let the non-white pixels drop, they soon form one-pixel-wide columns. So there had to be a sort of 'molecular vibration'. And since each pixel does not yet have its own processor, you have to drop them in order. Which order? Or randomly? And so on. But it works - on the BBC actually. It takes about a week, day and night, to calculate and save to disc 10 stages in the sedimentation process. Then you see the image piled up on the bottom of the screen in layers of greys or colour. An archaeology becomes possible. No, desirable. What would it mean to reverse the process, start with the layers, like any archeologist would? Well, there'd be an infinity of possibilities. What would any archeologist do? Look for clues. Ok, in the reverse process, allow... what? fragments? traces of descents like a bubble chamber (hey, there's a...)? And so on.

I made a picture of three Nazi figures from a teach-yourself-German-and-be-quick-about-it book published (this is serious) in 1942 by those well-known educational publishers, the Waffen SS. The figures, over the week of processing, dropped out of their own space (I specified only their pixels to move) leaving person-shaped holes in what now suddenly looked like a sky with spectral spaces where the SS Schutz Karl Bauer and his two girlfriends (one German and healthy, the other a sick, brown-eyed Pole: 'which one should he marry?' asked the first question) had been. Their 'remains' pile up in little spikes on hills and look like Golgotha. Some say the spectral spaces look like condoms. It takes all sorts. But I do assert that it's art, and that, good or bad, it couldn't have been thought of without the computer, though now, of course, one could approximate it by hand. I'm doing oil paintings like that. I'd still call it computer-based art, not that it matters.

Another idea: absence, as I shall say later, is important. That which cannot be seen, or is intentionally not to be seen. Imagine you wrote a chapter for a book on 'art and computers', using word-processing software on a computer. You might, in the course of the piece, make thousands of changes, deletions, alterations, spelling mistakes, re-arrangments and so on. Now you can get software that stores up everything, absolutely everything, you type, and keeps it in a special file just in case the system crashes. Suppose the piece you wrote was then compared with this file and a new file created on a 'difference' basis. The new text would consist only of the alterations, the crossed out stuff. What a document that would be! There one could see what you really wrote before you decided it was libellous. And how it changed between Thursday night, when you thought you were in love, and Friday morning, when you had a hangover. How, indeed, 'Tuesday' became 'Friday', because you didn't want the reader to think you'd been drunk on a Monday night, though you certainly were. Imagine all the meaningful *non sequiturs* and, hence, oxymorons part-wistfully discarded, the references to friends' art less so.

Figure 1

Now imagine the same principle applied to a drawing or something. Only the erased bits left. Only the scrubbings out and workings over remaining, in terms of that which was scrubbed and worked over, not the new, shiny, 'proper' coat of electronic paint. I think it could be good, references to Rauschenberg's 'Erased De Kooning Drawing' and all.

More creativity can come from diverting existing techniques or ideas, used in some other computer-based field, towards art. For example, in the image-manipulation and retouching software 'Photoshop' there exists a filter known as 'Displacement'. You have your image on the screen and it's then distorted by a second image. Each pixel of the first image is compared with the equivalent point on the second image. The greyscale value of this pixel determines how the point in the first image is moved: black causes maximum positive displacement, white maximum negative displacement, and mid-grey does nothing. This is indeed amazing. An image can be distorted because of another image, or even because of itself (used as first and second image - why not?) White areas can, for example, suck the image into themselves, black areas pushing it away. You can easily control the degree of distortion.

There is absolutely no way that this process could have been invented or used without the computer. But the question, of course, is 'invention by reference to what?' Is it adequate and interesting, or is it idle manipulation? That's an art question, not a Photoshop question. Figure 1 shows a self-portrait, displaced by itself.

Figure 2

Figure 2 shows the reclining figure of Manet's Olympia, the model Victorine, in the process of being transformed by - sucked into - a representation of a molecule of Hydrogen Cyanide, HCN. (The image also uses a stereogram, containing an optical illusion. But the illusion only works if you close one eye, while the stereogram needs both eyes wide open.) A second series of images used a molecule of Ammonia. These two substances, the one the 'Zyklon B' of the Nazi death-camps, the other the stinking ingredient of stale urine, were, bizarrely, the two gasses frozen together in solution, in 1966, in an attempt to replicate the primordial conditions of the possible birth of life on earth. They indeed found molecules of Adenine, one of the four bases of DNA and hence of life.

Think now of 'in-betweening', that process of which 'morphing' is a particular example. Some thing (an image usually but it could be sounds, text, etc.) is gradually transformed into another. A square becomes more and more rounded until it is a circle. What about OUT-betweening? What could that mean? I have been working at this for a number of years but it was not until I saw a commercial software package that partly undertook this process and called it 'Caricature' that I realised that that's what it is.

The word comes from the Italian *caricare*, and has to do with 'load, burden, charge'. That's lovely. By taking the in-betweening process between A and B out, beyond B (or out beyond A, the other 'side' of the process), we achieve precisely a caricature. If a politician has a big nose, he is represented in cartoons with an even bigger nose. If A is a square and B a circle, then in a world of Bs, squares are crazily pointy, yet have pathetically un-bulging sides. A caricature of a square, in a world of circles, can be

Figure 3

imagined. But in a world of squares, what is a circle? No corners, fat, sticking out sides. The computer can construct this.

Figure 3 shows just such an in-between, a neo-Fascist transforming into a coffin; another in the same series shows a computer turning into a 'massage'-vibrator. The originals are big, and after being plotted by computer using acrylic ink, were coloured by hand, using water-colour and various body fluids and antibiotics in solution.

Now, what would the out-betweens look like? In a world of coffins, what does a neo-Fascist become (apart from redundant)? Or in a world where ashtrays are normal, what does a bicycle look like? Where the typeface 'Helvetica' is the norm, how would 'Times' be caricatured? What is the caricature of a Jackson Pollock, what 'charge or burden' does it aquire, in respect of, say, a Goya? One can go miles in imagination here, even without a computer, let alone without virtual reality.

Other teases: what about a fractal novel, and Photoshop image filters 'applied' to stories...well, think of your own ideas; these are mine and I'm doing them. But there are millions left in there, waiting to emerge in dreams or through hard thinking. Not, I think, in cyberspace. John Berger wrote, a long time ago, a very influential book on art called *Ways of Seeing* that every art student has read. It was about seeing art, and hence ourselves, in new ways. I think the computer art equivalent of that would be 'ways of imagining', about new ways of inventing art, and hence ourselves.

The computer is not just an 'information processor'; it is a general purpose representation-processor. Even a computerised bank account is a representation of

something. An interactive computer-based sculpture, or a piece of music or visual art produced by a computer, is not just 'information'. A fractal image is a visual representation of a mathematical function. A coded 'Magic Eye' style picture that lets a three-dimensional image emerge when you relax your eyes and look 'through' it, when generated on the computer, photographed, projected onto canvas and reproduced in acrylic paint on a canvas too big for the 'Magic Eye' effect to work, may well be a representation of certain problems to do with the painted surface and 'art that is not to be seen' in the post-post-modern 1990s.

The computer, just because it's digital, is not to be characterised merely as 'quantitative'. Our brains, those electro-chemical, biological 'computers' running on glucose, are, at rock bottom (quantum) levels, presumably quantitative. So what? We structure our mental models of the world (without which we could not act upon it) we perceive, process and communicate, with qualities. Did you ever cry whilst watching television? Your tears were provoked by representations that were, for at least part of their life, digital. Yet qualitative representations went in, came out and affected you.

Gregory Bateson said that 'information is a difference that makes a difference'. If it doesn't make any difference, it's not information; then we have to consider to whom, and under what circumstances this 'information' is communicated (that's why Marshall McLuhan was wrong: the medium is NOT the message because the 'message' is constructed at least as much by the person receiving it as by he or she who transmits it). We can be sure that any consideration of such processes, including art, that does not take account of mental, social and political factors is incomplete at best, and probably rubbish. That computers are qualitative, representation-processors, making them primarily art tools, is wonderful. That we emasculate and objectify them before we've even begun is sad indeed.

It seems that there are two quite common errors about today's computer-based art . The first, understandable in those who approach the field for the first time, is to assume that VR and interactive or network art are all that is happening, all that is important. An approach to the area five or six years ago would have given the idea that fractal-based art was the be-all and end-all; 20 or more years ago it would have seemed that systems-art, repetition, variations on minimalist themes were what computer art was about.

This happens to some extent in any field, but where computers are involved there are so many marketing and other opportunistic forces at work. These forces say that today's images or ways of making art are exactly where it's at, where the futures of art and computing and culture lie, whilst yesterday's stuff (on, importantly, yesterday's computers) is ridiculously old hat, even though they told us yesterday that those things were the future, etc.

This is vital to understand. When there was not so much change in, and not much (or any) domestic market for computers (let's say up to about 1976), the art that was made using them was considered more or less as art, however mysterious and marginal. But now computers have become rather like status symbols. People's memories seem to atrophy in inverse proportion to those of the computers they are constantly being urged to buy and then, about six months later, to update or discard as hopelessly passé.

Thus the attention span for onlookers or joiners-in, the 'generation' of interested people, is very short indeed, and for them, the 'state of the art' technology will produce 'state of the technology' art, and isn't that what it's about? Well, no.

As I said, this error is understandable, given the way computer-based art is presented today. The second error is less excusable and consists in opportunistic and meretricious 'art-work' that gives little or nothing to (indeed often takes away from) contemporary art but is rather about fooling people. This has to be said. In other fields of art there have, of course, been those who have arrogantly and cynically manipulated markets, lied to the public, corrupting themselves and others. But if that's not hard in the field of art in general, it becomes wonderfully easy in computer-land, where overweening and thrusting arrogance allied to technological mystification can, for a short time, get you a long way. Many of the trends are labelled with phrases beginning 'New'. It has been suggested by a French person that what ex-Yugoslavia 'needs' is not UN soldiers but rather 'new' artists and psychologists. The idea of mass airdrops of the Princess of Wales's Own, the Royal Regiment of Nouveaux-Imagistes, into the war zones does have a certain appeal, if only because they would all presumably be shot on sight.

Derrick de Kerckhove, in his book *The Skin of Culture* [2], uses the idea from cognitive psychology of the brain as filtering mechanism, reducing incoming stimuli to manageable proportions, to argue (pp. 61-62) that 'the new economy of interactive media will be based on reduction. The jobs of the future will go to gatekeepers, intelligent assistants.'

I am sure this is true and has been so since (a) temporarily knocking out my own personal gatekeepers with certain mind-altering condiments in the 1960s, and 'seeing' what that did, and (b) working in the 1970s and 80s at the Royal College of Art on aspects of computer-aided cognition of artists and designers. There we found that much artistic and design activity was to do with erasure (and hence memory), with the interstices, the gaps between things (and hence the things' interelations) and with reduction and simplification (and hence complexity and its management). (Incidentally, we used the forerunner of the Internet, the ARPAnet, frequently, and it seemed, 15 or more years ago, to be no big deal. Now to use the Internet for such research is seen as somehow glamorous. Why is this?)

De Kerckhove talks of the value of ignorance: 'You might find value in not knowing something, as the very process of discovering anything might be more useful and exciting than the content of the discovery.' Yes! And what value then an art which presents predigested objects or ideas or virtual worlds (it matters not) that one can really only consume? Who, before encountering them, would have noted the absence of and initiated a search for, the vast majority of the contents of artworks using 'New Media'?

The much-vaunted interactive nature of some of this art is trite and pointless. The mere ability to explore and interact with elements of some lousy artist's virtual world does not justify it as art. If the basic genes are missing (those of excitement, the ones that make you shiver, that make you want to rush off and do art work) then all the recombinant DNA in the world will not clone anything worth talking to (or walking through).

Let each of us have our biting Cerberus, the three-headed, canine gatekeeper to Hades, to warn away (and to confuse with mixed metaphors) those naughty and pretentious 'artists' and their apologists who would smuggle disappointingly empty Trojan donkeys through the doors of our perception on the grounds that (a) donkeys are the thing and (b) it's (virtually) a present and (c) it's virtually present and can nod its head and bray in deeply realistic ways.

It is true, however, that the concept of sharing and distributing responsibility for 'New Media' artworks is a useful one.

First of all we had private production and ownership of artworks; then, perhaps, the democratisation of the objects, or at least of their perception. The reproduction and communication of art became easier. Now, as Roy Ascott says [3],

> 'The virtual and real not only co-exist, but co-evolve in a cultural complexity...The issue is political. It concerns as much the democratisation of meaning as the democratisation of communications, a shared participation in the creation and ownership of reality...In our present understanding of the world, nothing is sufficiently stable for us to wish to give a permanent form to its representation. Nor is stability desired. We are on that evolutionary spiral which has returned us to a more Taoist desire for flux and flow.'

Well, Roy is an optimist, but you know what he means. Please note that he is not necessarily de-materialising objects (this having been well done in art since the 1960s) but rather talking about 'representations'. This is what computers process (not just information, as I have already argued) and it is what art is all about.

He touches on two very important things. The first is what I put in slightly different terms as 'sharing responsibility'. This includes sharing the responsibility not only for the production of a work's meaning but also for decisions about what is 'real' or 'virtual' about it, and indeed what is 'art' about it. I mean the artist sharing with the spectator, who now of course becomes participant - and these 'individuals' might just as well be groups, the location of the artwork might just as well be distributed in time or space as in a gallery. For the dimension 'real - virtual' is a continuum, not an either/or polarity. We should perhaps do well to try making artworks that are part 'real' and 'part' virtual, just to point this out. The decisions about the work's nature would be an important aspect of it. One has no need at all to use virtual reality, let alone a computer or network, to make art about these questions, however. You can use all kinds of art to talk about and ask questions about VR; you can't use VR adequately to discuss art - only to show or to 'explore' it.

Roy Ascott's allusion to the Tao is also central to one of my arguments against virtual reality seen as be-all and end-all in art. When in doubt, turn to Chinese philosophy! In the Tao-te Ching (also known as the Lao-Tzu, meaning 'Old Philosopher' and referring to its little known author) there is a chapter concerning 'absence' or 'nothingness': in clay pots, it's the spaces that make them useful; the hole throught the wheel's hub; the doors and windows of a room; thus what is, is made useful by what is not.

Now get VR to deal with that! This inherently superficial, gaudily painted prostitute of a medium can only deal with representations of bits of stuff, not the absence or the

difficulty or the invisibility or what 'Art and Language' have called the 'not-to-be-seen-ness' of it. Where real art is erotic, virtual-reality-art is pornographic; the former stimulates the desire to make love and needs more than one person; the latter (not really paradoxically, despite all the claims made for it) is solitary, individualistic and leads only to that which its practitioners habitually practice. It is also, unsurprisingly, authoritarian, anti-revolutionary and dull.

A revolutionary is someone who takes problems from our 'normal' level and makes them appear on a higher or meta-level, where they are apparently insoluble and (revolutionary) work has to be done to make them soluble. The reformist is one who takes problems from this meta-level and drags them down to a more suitable domain of discourse where they can be got at and apparently fixed, but nothing really changes. Computing is not the same kind of thing as art or physics or even philosophy. It is 'about' things like that; it is on a meta-level to them. In fact, to talk about 'computer-art' (or computer-anything) is wrong, because it is confusing two categories that are fundamentally on different levels. Yet from the use of computers in art can come the most revolutionary of activities. How tragic, then, that most of the self-declared apotheosis of this artform is so singularly reformist, so irredeemably meretricious, so deeply old-fashioned and so patently impotent in the face of any worthwhile problem of contemporary art. It is poor in all its aspects save this, that it is richly offensive.

A 'revolution' is literally a single turn leaving you back where you started, but you hardly recognise it because everything has changed as a result of your journey. In contrast, some are busy skipping round and round the perimeter of their fractally-modelled islands, until one day they see tracks...something to discover in their virtual world! But it is only their old footprints they are seeing; and it is not a Friday and the art world has sent no boats.

Well, why is so much of the above negative and carping? Is there nothing positive to say? Of course there is! But I'm sure that the other authors in this book will ably have demonstrated much that is good and of value in the field. I just thought it was necessary to try to tell some of the truth, as I see it, about some of the rest and the context surrounding it. An honest description of what computer-based art really is like today would have to include the fact that few people dare even attempt to criticise it. Festivals always have to appear to be one jump ahead of the other festivals by showing the 'cutting' edge; sponsors are not really interested in anything except zeitgeisty publicity; critics, museum curators and so on are often mystified by the technology; educators have to justify whatever grants, equipment and projects they can get, and may not do so according to strict art criteria.

To sum up: some of the art now claimed to be at the cutting edge is in fact determined and directed by strategies and paradigms of business and marketing. It is the most old-fashioned, restricted, earthbound, craven and inept of all the arts. Whilst claiming to be liberating and revolutionary, it is patently shackled by chains of incomprehension, delusion and gouging careerism to the most banal of 'realities'. It is reformist, not revolutionary. It is busy destroying art (which enters coma if not vigorously questioned and pushed forward by real change) whilst claiming to advance it. Already you can read about the possibility of the 'decline of visual arts'. The media and ideas, the metaphors and paradigms that could have made art one of the

most important things to be doing this decade have been hi-jacked, for nefarious reasons, by those whose 'cultural' statements betray all the sensitivity and promise of a brochure advertising plastic land-mines.

And you who read this writing now, what are you going to do? Plug-in and add-on to the ploys of the marketing men, changing worthless banalities into value-added insults to the intelligence? Or will you look around at the needs and possibilities for change and endeavour, for revolution even, and grab your computer or some idea emerging from it and make something so good, so dangerous as art that no company would sponsor it, no computing magazine patronise it, no critic mystify it and no one with half a hemisphere possibly mistake it for anything other than a real work of art done by, with, or in spite of a computer?

To those who want to change the world, get famous as artists or just do some really good stuff, can I suggest that there are probably very few objects or representations of objects that will do the trick, whether these be painted on canvas or represented in 3-D space and experienced using tactile sensors on the more sensitive of the body's extremities. We are not, artistically at least, amused by any new such thing, or not for long. What we want are new forms of relationship between these things, and new ways of experiencing and imagining these relations. These might end up produced co-operatively between artists in Shanghai, Paris and Toronto and experienced simultaneously by huge, interacting 'audiences' across the world, or as drawings on a wall.

Further, there is a hell of a lot of work to be done on discovering and re-interpretting the (big gulp here) whole gamut of cultural manifestations from at least the Renaissance on. Then re-presenting these discoveries in forms that map onto the possibility that what has been going on in art and elsewhere (but let's say art, that's where we are now) is NOT WHAT WE HAVE BEEN TOLD, but is rather (despite everything) more virtual, to do with the very sharing that computer-based arts can make more vivid, and where the ideas may start from. In other words, I'm saying that computer-based art can be revolutionary precisely because of what it can provoke or excite us to do in all art, in all media, and not because of what it looks like just in itself.

The 'what we have been told' above (I didn't want to expand it in the middle of an already-too-dense paragraph) relies on a system of authoritatively imposed, widely accepted, false assumptions about artist/artwork/audience, artist/society, perception/objects, world views in general, the tyranny of perspective, and so on.

Painting and VR and distributed systems of art-making (for instance) have much in common. That is why VR is not more avant-garde than drawing or sculpture. If it is seen as such, its potential will have been missed and have been replaced by mystification. We need REAL ART, using all the techniques at our disposal, from making marks on paper to the most sensitive uses of trans-global network art. The ideas that these artworks 'worry at' will be what is avant-garde. Otherwise future generations of art historians and others will laugh at our passing infatuations with each new technological possibility, seen as avant-garde just in itself. Potentially revolutionary art reduced to mere techno-spectacle. What a waste that would be. What a responsibility we have.

References

1 Smith, Brian (2002) in: Mealing, Stuart (ed), *Computers & Art*, p 127, Exeter & Portland: Intellect, (quotation invented for the purposes of attacking it, but people do say things like this).

2 De Kerckhove, Derrick (1995) *The Skin of Culture*, Toronto: Somerville.

3 Ascott, Roy (1995) contribution to the seminar *How can Art help Science, and vice versa?* at the Centre Culturel de l'Albigeois, Albi, France, simultaneous to the present author's exhibition 'Olympia Transformed by a Molecule of Zyklon B and Surrounded by a Stereogram containing a Coded Optical Illusion', in the gallery of the Centre Culturel.

Mike King was born in 1953 to a family of fine artists. He has a BSc in Physics and Chemistry from London, an MSc in Software Engineering from Oxford and a PhD in Computer Graphics from the Royal College of Art, London. He is currently Reader in Computer Art and Animation at London Guildhall University where he teaches on a course in Digital Moving Image. His digital print series 'Virtual Visions' is shown nationally and internationally, and he writes widely on the digital arts. He is also involved with Digital Art Museum, a project which aims to create the world's leading on-line resource for the history and practice of Computer Art.

Mike King

Artificial consciousness – artificial art

Abstract

The electronic arts derive their energy and fascination from the relationship between artist and machine. Attempts to automate art are increasingly successful as developments take place in artificial intelligence, artificial creativity and artificial life. However, it may take artificial consciousness to create a totally artificial life. This in turn requires the resolution of the question: is quantum mechanics inextricably linked with consciousness? The future of a totally artificial art may hinge on this.

Introductiion

James Gleick points out in *Chaos* [1] that the 20th century will probably be remembered for three great scientific revolutions: relativity, quantum mechanics and chaos theory. With only five years to go it is probably too late for a fourth revolution to emerge in this century but we are seeing, in embryonic stage, the first scientific revolution of the 21st century: studies in consciousness. The claims for chaos theory are that, unlike the preceding two revolutions, it relates to the more immediately tangible world of our experience. Studies in consciousness relate to an intangible but infinitely more intimate world: our being. The classical sciences of the previous centuries give us a very different world however.

The discoveries by Copernicus, Galileo, and Kepler that showed the Earth to revolve around the Sun have become a metaphor for the growing realisation that Man was not at the centre of the Universe but an insignificant creature on an insignificant planet in an insignificant solar system, of which there are millions or billions. The triumph of Western science has come at the price of an alienation from the previous natural order and a haunting sense of insignificance or *angst*, to which feeling the 20th century has given a unique flavour. One can characterise our present universe as anthropo-*eccentric*, that is a universe in which man is no longer at the centre, in contrast to the previous anthropo-*centric* universe. John Archibald Wheeler points this out in his introduction to the *Anthropic Cosmological Principal*,[2] as does Danah Zohar at much greater length in *The Quantum Self*[3] (more of these later). One can reasonably assert that both the infant and the mystic (mystic in the sense that Evelyn Underhill[4] and Aldous Huxley[5] use, for example) live in an anthropo-*centric* universe, and one may speculate that certain tribal peoples may also do so, to varying degrees. But the average Westernised person now lives in an anthropo-*eccentric* universe.

144

The reductionist, mechanist sciences of Newton and Darwin leave the educated individual in no doubt that, from the perspective of 'rational' science, he or she is an accident in an accidental universe — and in no way at its centre. The more recent discoveries of chaos theory show a less ordered universe, with room for 'emergent' properties, which allow for more poetic descriptions. Rocks, weather, organisms, society, the economy: these become non-linear systems with unpredictable developments but they are still *deterministic*. The individual is a *system* of organs and cells, the result of a gene pool *system*, embedded within social and economic systems. The individual is still alienated.

Until quantum theory

Quantum theory completes the cycle of scientific revolution and renders the universe anthropo-*centric* once more. The job of science is done.

Quantum theory is inextricably linked to the current debate on consciousness, which in turn is inextricably linked to debates on creativity. We shall look at quantum theory, consciousness, creativity, computers and the electronic arts, starting with chaos theory and quantum mechanics.

Chaos theory and quantum mechanics

The debate on consciousness involves many disciplines, and many theories from these disciplines are brought to bear. For the purposes of this paper the two most important sets of theories are those related to non-linear systems, and those related to quantum theory.

Chaos theory, or the theory of non-linear systems, involves the study of phenomena whose developments are highly sensitive to small fluctuations in starting conditions. Examples include the weather, turbulent flow and fractal computer graphic images — James Gleick gives a popular introduction in *Chaos*.[6] An example of a linear system is a bicycle: if you pedal twice as fast you cover the same distance in half the time. A one percent increase in speed gives a one percent decrease in time taken and so on. Some linear systems can become non-linear systems at a critical point; an example of this is laminar (orderly) flow in a liquid becoming turbulent flow (indeed much

research into non-linear systems arises from efforts to prevent turbulent flow in pipes, and to cause it in spoilers, for example).

As previously mentioned, non-linear systems are, in principle, *deterministic*. This means that the same starting conditions will give the same end conditions, and, if we have computers powerful enough, we can predict the outcome. In practice, because of the extreme sensitivity to the starting conditions, it may be very difficult to predict the outcome but this is merely a problem of computing power – a non-linear system is said to be computable (in principle). However, these systems are of great interest because there may be an *apparent* unpredictability and because of emergent properties.

The philosophers Deleuze and Guattari have applied the principles of non-linear systems to a wide range of phenomena, including human society. Manual De Landa gives an interesting account of this in connection with modern warfare.[7]

Non-linear systems, in terms of physics, are classical systems, that is they conform with Newtonian mechanics and Maxwellian electromagnetic theory. Hence, despite the relative richness of the universe they describe, and the fruitful consideration of emergent properties, they remain part of the anthropo-*eccentric* universe defined above.

Quantum theory represents a far more radical departure in the sciences from the ordered stream of development in the understanding of the physical universe going back to Copernicus and Galileo. To some it is merely an esoteric and specialised field of knowledge dealing with the sub-atomic level, and represents a small tributary in the growing expansion of an essentially classical vista of knowledge. To others it challenges the roots of the objective, scientific worldview.

Quantum theory grew out of a seemingly innocent debate over whether light consisted of waves or particles. It was assumed that the debate would be resolved in a straightforward way, as countless other debates over the nature of other phenomenon had been (and will be). However, in the last century it became clear that light behaved as a wave under some experimental conditions and as a particle under others. This simple fact was obstinately unresolveable and its unwanted (by classical science) implications were twofold: firstly, that the observer's behaviour could not be removed from the experiment – thus challenging traditional notions of 'objectivity' – and, secondly, that science was going to have to live with the unthinkable: paradox. The Aristotelian law of the excluded middle (something can be A or B but not both), which is the cornerstone of rational thought, would have to be abandoned, though only in some circumstances.

Quantum theory as we now know it gives a terminology for the wave/particle paradox but does not remove the paradox. In fact a quantum scientist is required 'to believe three impossible things before breakfast', in the words of the Red Queen, on a regular basis. Sub-atomic particles are to be considered as 'standing waves' with discrete energy levels (hence quantisation). The smallest amount of light energy is called a photon and can be considered a particle in the sense that one cannot have less than a photon's worth of light energy. On the other hand, it has frequency and wavelength. Photons interact with matter by being absorbed by orbiting, standing-wave electrons, which jump an energy level within the atom. Light is emitted when an electron falls to a lower energy level.

146

David Bohm lists four basic features of quantum theory[8]:

1. *Indivisibility of the Quantum of Action:* this is the basic postulate, that wave energy cannot be divided up below a certain (very small) quantity, proportional to its frequency.

2. *Wave-Particle Duality:* all waves can be considered as particles at the quantum level, but also as waves — it is up to the observer to set up the conditions for observation that give a wave or particle description of a phenomenon.

3. *Properties of Matter as Statistically Revealed Potentialities:* the 'classical' world of discrete solid objects with deterministic behaviour is a statistical description of large numbers of quantum particles; for example, the half-life of a group of millions of uranium atoms can be stated accurately but nothing can be said about an individual atom.

4. *Non-causal Correlations:* quantum theory requires sub-atomic particles to behave as if they communicated instantaneously over large distances. This is called instantaneous non-locality and was one of the aspects of quantum theory that led Einstein to search for the remainder of his life for ways to disprove quantum theory. He was unsuccessful.

A deeper understanding of these ideas requires considerable study and a grasp of mathematics. However, quantum theories can be summed up in two terms: quantum indeterminacy and quantum holism. The quantum physicist Erwin Schrödinger invented a 'thought experiment' that demonstrates both of these aspects, usually referred to as Schrödinger's Cat. Schrödinger imagined a single photon being directed through a half-silvered mirror (a mirror that allows 50 percent of light energy through and 50 percent to be reflected). The mirror is arranged in such a way that if the photon (a single quantum of light energy) passes through the mirror it triggers a photo-sensitive device which kills an unfortunate cat kept in an opaque box.

Because of *quantum indeterminacy* there is nothing in the history of any part of the experiment that will allow us to predict, even on a statistical level, whether the photon goes straight through or is deflected. Hence the only way that we can know whether the cat is alive or dead is by opening the box. No well-informed bookie would give you odds on the cat's survival, even if you repeated the experiment a million times with a million cats. Photons do not have 'form'. *Quantum wholeness* enters with the observer: the person who opens the box. In technical terms the photon is described as a wave, with a mathematical description known as a wave function; and when the photon is discovered (by the observer) to have gone one way or the other, this is known as the 'collapse of the wave function'. It has become accepted that the observer is integral to this process and recent thinking places great emphasis on this.

An alternative version of the experiment involves the decay of a small amount of radioactive substance and a Geiger counter to detect it and trigger the release of poison to kill the cat. In either case there is argument as to whether the sensor (photosensitive device or Geiger counter) which amplifies the quantum effect into the classical universe is responsible for the collapse of the wave function, or whether it is the cat, or whether it is the human who opens the box. Most researchers in consciousness accept that it is the human.

Many commentators have postulated that if we knew more about the fine structure of atoms and photons we could eliminate these paradoxical and disturbing implications of quantum theory, but so far there has been no success in this direction (this approach is sometimes termed the seeking of 'hidden variables'). Einstein was particularly unhappy about quantum indeterminacy, as shown in his famous remark that 'God does not play dice'.

Scientists and lay persons alike are entitled to take different views on the implications of quantum theory. One view, promoted by Niels Bohr, is that the precise mathematical formulations of quantum theory are successful as a model for prediction but the wider implications can be ignored. A middle ground, perhaps, was the stance now called the Copenhagen interpretation, which admits that quantum theory is a theory of observations rather than a theory of objective independent realities. The more radical position is that quantum theory places the human act of observation as essential for the existence of the universe. A more symmetrical way of expressing this is in a formulation by John Archibald Wheeler: 'The observer is as essential to the creation of the universe as the universe is to the creation of the observer.'[9]

The difficulty over the interpretation of quantum mechanics is more a problem of metaphysics than physics, as illustrated in an interesting conversation between Werner Heisenberg, Niels Bohr and Wolfgang Pauli (all great contributors to quantum theory).[10] They were reflecting on the presentation at the original conference of quantum theory to the Vienna Circle of positivist philosophers, which drew no questions from them. Wolfgang Pauli commented that the positivist stance gives an emphasis to 'facts' – if quantum mechanics described sub-atomic behaviour correctly, then that was enough for the positivists. Werner Heisenberg pointed out that the wider implications smacked of metaphysics, which was, for the positivists, a term of abuse.

If metaphysics, i.e. the posing of questions just beyond the boundaries of the discipline of physics, has been a term of abuse for some thinkers in the past, it would seem that it has become the pastime of many scientists today. This might be because Platonic metaphysics was seen as pre-scientific, or even against the scientific method. Modern metaphysics can ask seemingly more legitimate and informed questions, and if the answers look a little Platonic that is just too bad. We live in an era in which the prestigious Templeton prize for progress in religion (£650,000) has gone to the physicist Paul Davies; in which the physicist Frank J. Tipler argues soberly that his computations prove the existence of God; and in which Oxford mathematician Roger Penrose embraces Platonist views in his argument against the computability of mind (more on this later). The recent spate of speculative writings by scientists led the *Guardian* newspaper to complain recently that 'Atheists, at least, used to find comfort in the sceptical words of the boffins. But now even the most rigorous of scientists are showing signs of conversion to the idea of a deity.'[11]]This may be an overstating of the position – Peter Holland, a professor in the foundations of physics, attacks the 'new-ageist' view of physics as not just metaphysics but mysticism leading to obfuscation: 'Science still represents a noble tradition of anti-clerical subversion but society infects all its products. What a historical irony that the arch-rationalists end up bearing a new-ageist banner'.[12]

However, we are not arguing here that quantum theory gives us back a theocentric universe but an *anthropo*-centric one.

Aspect of consciousness	Average score 0 to 10	Maximum score 0 to 10	Minimum score 0 to 10
Perception	8.30	10	0
Awareness	7.89	10	1
Thought	6.74	10	0
Creativity	6.44	10	0
Will	6.15	10	0
Identity	6.07	10	0
Autonomy	5.22	10	0
Intelligence	4.81	10	0

Table 1 Aspects of consciousness

The inclusion of the observer as fundamental to the universe as a result of quantum theory should finally settle the Zen *koan* 'does a tree falling in a forest with nobody there to hear it make a sound?' The answer now is certainly not.

It is worth pointing out that quantum theory is not the only area in physics that supports a more anthropo-*centric* world view. John D. Barrow and Frank J. Tipler in their excellent book *The Anthropic Cosmological Principle* [13] give an exhaustive survey of what they call the anthropic principle, that there is life-giving at the centre of the whole machinery and design of the world. The quantum arguments are dealt with as part of a range of 'pointers', including the extraordinary properties of water and chlorophyll and the observations by many scientists that 'the possibility of our own existences seem to hinge precariously upon the concidences between the numerical values of the fundamental constants of nature'. [14] There is also a good examination of the arguments in favour of a revival of a teleological approach (explanations in terms of purpose), the importance of which has been eroded from the primacy given to it by Aristotle.

Consciousness: an overview of current theories and debates

The study of consciousness has only recently become a respectable academic pursuit, as shown by the number of recent books on the subject and the establishment of the International *Journal of Consciousness Studies*. [15] However, according to each researcher and their background, the term consciousness is used in many different ways or with different emphases. Aspects of the human experience that seem closely associated with consciousness include: awareness, will, perception, thought, memory, intelligence, creativity, identity and autonomy. A small survey was recently conducted at London Guildhall University amongst 27 participants at a seminar. Participants were asked to score eight of the above aspects of consciousness with a mark from 0 to 10, 0 being awarded to an aspect considered to have no importance, 5 to one having average importance and 10 to essential ones. Table 1 shows the results.

The small sample and the simplistic nature of the survey mean that one should not read too much into the results, but it is interesting to note that perception was rated

the highest and intelligence the least important aspect of consciousness. It is also interesting to note that at least one person in the group was willing, for every category, to rate it essential, and at least one person was willing, for every category except awareness, to rate it of no importance at all. For the purposes of this paper it is also worth commenting on the rating of creativity and autonomy as slightly above average importance.

A good introduction to the debates around consciousness is to be found in Daniel Dennett's Consciousness Explained. [16] The over-optimistic title does not detract from the book, though it does lead one to expect more than the Multiple Drafts Model for consciousness that Dennett proposes. He gives a good historical review of the problems of understanding consciousness, starting with the 'brain in a vat' analogy and Descartes' mind-body dualism (also referred to as the 'ghost in the machine'). Dennett's emphasis throughout is on perception (possibly vindicated by the survey described above), though oddly, he avoids attempting a solution of the 'qualia' problem (how are we to account for the redness of red, for example).

The problems with Descartes' view of consciousness is in the mind-body split or dualism that it is based on. The dualistic view is not consistent with classical physics because for any perception to impinge on the mind there must be a chain of energy transformations that reach from the material world to the non-material (upward causation), and another chain from the mind to the body (downward causation). Physics cannot conceive of the 'injection' of a form of energy, however small, into a physical system from a non-physical system. Upward causation, that is perception, is less problematic than downward causation, or action derived from the will. However, Descartes proposes a location in the brain where perceptions come together for the mind to view them as a whole; this is done by some kind of homunculus. This Cartesian theatre then presents us with the problems of a reasonable description of the homunculus, and the danger of infinite regress: has the homunculus got a homunculus within? (Like the lady who insisted that below the turtle that supported Atlas it was 'turtles all the way down', are we to accept that consciousness involves 'homunculi all the way in'?)

The problems of consciousness can be reduced to the two problems characterised above as upward causation and downward causation, though this barely does justice to the richness of debate both past and current. The problem of upward causation in particular has a history of debate around the problem of the holistic nature of our perceptions, often called the binding problem. This is related to the problem of the Cartesian theatre and has evolved from the time of Descartes through the thinking of Hume and Kant, to the modern psychological problem of binding. The debate around the downward causation is even more problematic because there is much less agreement about will than there is about perception.

While Dennett's emphasis on perception is to some extent reductionistic, it is the work of Francis Crick that takes this to an extreme. His recent book The Astonishing Hypothesis[17] claims that all aspects of human experience, including consciousness, are to be understood in terms of neuronal activity. This leads him to discuss the neural correlates of perception, and to postulate that one day we shall discover the neural correlate of consciousness itself. Crick tackles head-on the qualia problem that

Dennett avoids. Neither Crick nor Dennett have much time for chaos theory or for the notion that quantum-mechanical effects are involved in consciousness. As such neither are of much relevance to this paper, though I would argue that the work of such reductionists is vital to healthy scientific debate, particularly because of their insistence on rigorous laboratory experiment.

One could characterise the view of reductionists on consciousness as being epi-phenomenal, i.e. it is a side-effect. The view of chaos theorists could be described as emergent-phenomenal, i.e. consciousness arises from complex systems as a whole that is greater than the sum of its parts. An epi-phenomenon and an emergent phenomenon could be argued to be the same thing, but it is useful to see a difference of emphasis in the two terms: an epi-phenomenon is to be largely dismissed, while an emergent phenomenon is to be taken seriously as an explanation.

We have seen earlier that quantum theory presents a radically different view of the universe than classical mechanics and it is no surprise to find that many thinkers on consciousness have sought to relate consciousness to quantum theory. There is a growing sense that quantum indeterminacy may allow a window in the deterministic universe for free will (downward causation) and that quantum wholeness is directly related to the binding problem of perception (upward causation). One of the chief protagonists of a quantum mechanical view of consciousness is Roger Penrose. A mathematician, he has been interested in the extent to which computers can prove mathematical theorems. Building on the work of Gödel, a mathematician who demonstrated the unprovability of a certain class of theorem, Penrose has argued that computers are therefore unable to 'think' about a certain class of entities that the human mind can. From this Penrose extrapolates a proposition that mind is essentially non-computable, at least by our current technology.

Penrose devotes much of *Shadows of the Mind* [18] to an explanation of the quantum (i.e. sub-atomic) world and the characteristics of it that are also to be found in descriptions of mind. He then goes on to explain how *quantum coherence* comprises a series of characteristics of the quantum world translated into the classical world, for example in superconductivity. He then argues that quantum effects must translate into the 'classical' world of chemicals and neurons in the brain and that these give the window of indeterminacy required for manifestations of consciousness such as free will. At this point he admits the dualistic position of his argument (which has led to accusations of him being a 'Platonist'). He is supported in his approach by neurologists and biologists in their discovery of 'microtubules', structures within the neurons that could be the seat of quantum coherence effects. Microtubules are also said possibly to increase the connectivity within the brain, making it a far more complex mechanism than its known 10 billion neurons and their connectivity would suggest.

David Bohm was a physicist who specialised in quantum mechanics and is also known for his search for profounder meanings, leading, for example, to his conversations with the Indian spiritual teacher Krishnamurti. One of his best-known books is *Wholeness and the Implicate Order* [19] in which he stresses his two main concerns. Wholeness to Bohm is a fundamental philosophical problem, often raised by researchers in consciousness as one of its most puzzling attributes (mentioned previously as the binding problem). For Bohm, classical physics is fragmentary,

involving the interaction of discrete and separate parts. Relativity goes some way to proclaiming some kind of unity in its quest for a unified field theory while quantum mechanics shows the universe to be a totality. Bohm's implicate order is not so much a theory in physics but a way of reading quantum mechanics or science in general. It proposes an interrelatedness that can be understood by analogy with the hologram: each small part of the holographic record contains the whole picture. Every part of the universe is intersected by every other (a result of quantum theory), so in some sense every part of the universe 'knows' about every other part. Bohm develops this theme throughout *Wholeness and the Implicate Order* and then relates it to the question of consciousness.[20] He discusses in depth the Cartesian dualism of mind and matter, which he feels can be resolved by the idea that they have the implicate order in common. Bohm's thought is subtle and complicated but, oddly enough, has a passing resemblance to Dennett's Multiple Drafts model.

Bohm's work is dense and sometimes appears to be contradictory. His emphasis is on a holism but also on an *order*, and it may be his emphasis on order that leads him to revive Einstein's failed theory of hidden variables to explain quantum indeterminacy. This aspect of his work has not been accepted however.

Another researcher proposing links between quantum theory and consciousness is Robert Jahn, a specialist in aerospace engineering until one of his students requested permission to pursue a project to see if the mind could influence a circuit board. Jahn thought the results would be negative but gave the go-ahead anyway because of the pedagogical value of building the circuit itself, which was a random-event generator. To Jahn's surprise, the experiment gave a small, though positive result. The experiment was well-enough defined and carried out to cause Jahn to investigate further, resulting in a stream of positive indications: an electronic circuit designed to give random fluctuations about a mean can be influenced by the mind to record results above or below the mean in quantities that were outside any statistical variation, though by only small amounts. That Jahn pursued these studies eventually led to his demotion, and the scepticism of the academic community, including journals like Nature which refused to publish his results. (Jahn comments wryly that *Nature's* refusal was only partial: they would accept his article if he could transmit it telepathically.)

Jahn attempts to explain the interaction of minds and circuit boards through quantum mechanics and elucidates his theories in *Margins of Reality: The Role of Consciousness in the Physical World* (co-authored with Brenda Dunne). Jahn's work is largely ignored by other theorists, who favour a quantum explanation of consciousness, which is a shame, as he puts forward many interesting and complementary ideas. For example his evidence that minds can reach out beyond the bodies that carry them, both in upward causation (perception at a distance) and downward causation (manifestations of the will at a distance), is linked in his work to the wave/particle duality. Minds exhibit wave properties when interacting at a distance and particle properties when 'enclosed' within their bodies.

Dana Zohar's books The Quantum Self[21] and The Quantum Society[22] explore quantum theory firstly as a range of metaphors but also as evidence for the holistic nature of the universe and the self. Her views derive partly from quantum theory itself and partly from interpretations leaning to the mystical such as that of Bohm, Fritjof

Capra[23] and Gary Zukav [24]. However, her interpretations are more accessible than Bohm's, less populist and mystical than Capra's and Zukav's, and less radically paranormal than Jahn's, which gives her work an appropriate stature to complement Penrose's mathematical approach. Her approach to consciousness starts with the metaphors of quantum theory, allowing for the discovery of more evidence of its involvement with consciousness as it arises. She is not in favour of an interpretation that revives the Cartesian dualism of mind/body and leans towards the realist approach. Penrose, less wary of dualism, is pursuing more directly the evidence, including mathematical, biological and physical.

Creativity: the link with consciousness

Religions like Christianity and Buddhism are often criticised for an emphasis on ethics and morality, in contrast to forms of religion that emphasise celebration of the creative aspect of the universe. The three religions of the Book show a view of the Creator as having finished his work in six days, a description often compared to the Big Bang of modern physics: the universe is 'wound up' and then proceeds to evolve according to its inherent laws and tendencies. Pagan religions, and perhaps Hinduism, find a continuing role for the creative principle, often allocating a particular god, or aspect of the divine, to that role.

Western philosophers such as Descartes, Hume and Kant have however placed considerable emphasis on the concept of imagination as central not only to creativity but to our understanding of the world. The philosopher Mary Warnock has had a life-long interest in the imagination, stating that its cultivation should be the chief goal of education.[25] For Warnock, imagination is the key to perception and all our values, as well as the driving principle behind creativity. In *Imagination*[26] she charts the developments of our understanding of this faculty, from Descartes through Kant and Hume and Schelling to Sartre and Wittgenstein. For Hume, imagination is linked to the everyday ability to receive an interrupted and chaotic sequence of sensory impressions and derive from this a belief in the continuous existence of objects. Using my terminology, this is an anthropo-*centric* view, as distinguished from a view that there is an existence of objects independent of us (the realist view, taken by Einstein, and, oddly enough, Zohar). Hume postulates that from this belief follows the independence and distinctness of objects. Kant calls this faculty the transcendental imagination (because it is universal and possibly related to Plato's essences) to distinguish it from an empirical imagination, the fiction-making power which varies from person to person. Warnock's work has been to seek out the common ground in the different forms of imagination, in particular the creative sense and the world-ordering sense.

Margaret Boden is another philosopher with an interest in imagination, but in the narrower sense of creativity. Her work, based in computational psychology, involves an investigation of creativity via attempts to simulate it with computers. Her book *The Creative Mind*[27] covers many aspects of research into creativity, especially those debates around Artificial Intelligence. Her interest is not primarily with consciousness, however, or the kind of world-ordering imagination of Warnock, but rather in the emergent property arena, i.e. in chaos theory. She is editor of a more recent volume called *Dimensions of Creativity*, [28] which is a compilation of different

types of analysis of creativity, including papers by Simon Schaffer and Gerd Gigerenzer which both stress that creativity cannot be separated from justification and authorisation. Their point is that neither scientific discovery nor artistic creativity can be regarded as significant without a system of evaluation to give them status.

In chapter 13 of *The Quantum Self* Danah Zohar turns to the link between creativity and quantum theory. For her, the main question in the creative act is the selection of one outcome from all the possible outcomes, a process that she associates with the collapse of the wave function: this is the function of consciousness. One could see this as a special case of a quantum interpretation of the creative world-ordering imagination of Kant and Hume.

From both the Hume/Kant tradition expounded by Warnock and the emerging quantum consciousness position of Zohar et al. we can assert that consciousness is at the heart of creativity. There are, however, two competing claims to an explanation of creativity: chaos theory and quantum consciousness. As outlined earlier, chaos theory describes both consciousness and creativity in terms of emergent properties. The battle between the two systems of thought will be fought out in an area of relevance to the electronic arts: artificial life.

Automated electronic art

Since the 1950s artists and scientists have been experimenting with electronic devices in the production of imagery and more generally in the arts. Herbert Franke and Ben Laposky used oscilloscopes to produce images and were soon amongst a number of computer art pioneers who began to use the digital computer and its display screen or plotter.

These developments are well documented in books such as Franke's *Computer Graphics - Computer Art*,[29] and Cynthia Goodman's *Digital Visions*.[30] The author looks at the use of programming for artists and animators in a recent article in *Leonardo*,[31] and the reader is also recommended the many articles by Professor John Lansdown on algorithmic art from 1970 on. His own experiments with algorithms for theatrical performances (including custard-pie fights) are documented in an ACM paper,[32] while a good overview is to be found in a recent paper "Artificial Creativity: An Algorithmic Approach to Art".[33]

Evolutionary electronic art is a branch of algorithmic art that uses the concepts of Darwinian evolution to generate family trees of images or forms that are then selected by the artist for further breeding. Karl Simms [34] and William Latham [35] (See Figure 1) are two computer artists who have been working in this field and who have been extensively commented on by Margaret Boden.

The difficulties with the work of both Simms and Latham lie in them having to make the selections themselves: they have not been able to automate the aesthetic survival function as a parallel to the natural survival function. This problem has been avoided in the work of Harold Cohen, originally a successful modern painter, who set out to incorporate his own rules of composition into an artificial intelligence program called AARON (described further in Chapter 7).

If we recall the distinction made by Schaffer and Gigerenzer regarding the creative act and its authorisation by society, then we can see that the issue of design criteria or

Figure 1 Work by William Latham

computable aesthetics becomes very important. Latham's and Simms's work fails to include this aspect (not that this detracts from their work: it merely means that there is an opportunity for further research and development of their ideas). In evolutionary art the selection mechanism becomes paramount. For other forms of automated art, such as Cohen's, there must be algorithms at the outset that control design, composition and aesthetics. The field of algorithmic aesthetics has its origins outside of the electronic arts. Franke[36] gives a good introduction to the German thinkers in this area, including Wilhelm Fuchs and Max Bense. Franke also relates the story of how analysis of Mondrian's compositional rules by Michael Noll led to a series of computer images that were found by a (selected!) audience in a blind selection to be more attractive than the original.[37]

Stiny and Gips suggest a computer-based aesthetic giving, as part of the justification, a quote from Knuth:

> It has often been said that a person doesn't really understand something until he teaches it to someone else. Actually a person doesn't really understand something until he can teach it to a computer, i.e. as an algorithm.[38]

Stiny and Gips quote this in the context of aesthetics but we can see from the range of topics covered in this paper that are influenced by computing that Knuth's insight is far-reaching. The simulation of creativity helps us understand creativity and the simulation of consciousness should help us understand consciousness.

We are now approaching the point where we can ask 'what would be a totally artificial art?' Clearly it would involve computers and the simulation of both a creative and a critical function. Cohen's work is based on his ability to formalise his own compositional rules (though he looks beyond his own aesthetics in the formulation of these rules): what is lacking is the spontaneous generation of work beyond his own formulations. In the evolutionary art of Latham and Simms we have the potential for an infinite creativity, as images and forms mutate from generation to generation but we lack the automated aesthetics to select from them.

Artificial consciousness and the electronic arts

Artificial Life or a-life for short, while not originating as an art-form, has been explored as such by computer artists such as Steve Bell [39] and Clifford Pickover. [40] A-life originated in the biological sciences as computing power became available to them to simulate evolutionary algorithms, biological behaviour and eco-systems. By abstracting from the physical world simple rules and constraints governing entities that live, breed, consume energy, fight for resources and die, biologists have programmed a-life systems that have given them valuable insights into living systems. Steven Levy [41] gives a good overview of the emergence of a-life, including its applications and philosophical implications. A-life theory, as shown in Levy's book, is firmly located in the debates around chaos and non-linear systems: the attributes we normally associate with 'life' are seen as emergent phenomenon. There has also been little attempt to endow a-life entities with artificial creativity, perhaps because of an intuition that the parallels between evolution and creativity are rather weak, as discussed in some depth by David N. Perkins in Boden's *Dimensions of Creativity*. [42]

To date there seems to be only one serious attempt to create an artificially conscious entity. This is the goal of Igor Aleksander at Imperial College, where he has created an artificial neural net (ANN) called Magnus, designed to be conscious in the sense of being able to tell us what it is like to be Magnus. [43] Again, there has been no initial intention to make Magnus creative or to locate the work in the electronic arts. However, two computer animators, Nadia Magnenat-Thalmann and Daniel Thalmann, in their quest for synthetic actors, have picked up on the work of Aleksander in the hope that it will provide a missing element in their simulations: autonomy. In the Thalmanns' book *Artificial Life and Virtual Reality* [44] Aleksander contributes an article called 'Artificial Consciousness?' [45] in which he sets out his emergent-phenomenon position on consciousness, and, in contradiction to Penrose's non-computability stance, give the mathematical background of his attempts to create an ANN in which consciousness, in effect, grows out of complexity. Magnus has only 16,000 neurons compared to the brain's 10 billion, so any failure of Aleksander's venture can be explained in chaos theory terms as due to a lack of complexity of the right order.

As we saw in Table 1, autonomy may not be the most obvious attribute of consciousness and other researchers have taken a different approach in simulating autonomy.

Figure 2 From Programmed == Damned series

Distributed computing, that is a model of computing where the single processor is replaced by many, possibly arranged in an artificial neural network, has required new approaches to writing software. The development of autonomous programs is one solution, described in another article in *Artificial Life and Virtual Reality*.[46] A further article in the same book gives an account of how algorithms for autonomy are developing from work in artificial intelligence. [47]

The Thalmanns are the first to consider the use of artificial consciousness in the electronic arts. For computer simulations to generate truly artificial art, they will undoubtedly have to incorporate some aspects of consciousness: creativity, intelligence, will and autonomy. It may be that other aspects such as identity, perception and awareness will also be essential if the artificial art is to have any status against human art, leading us to the position that we require not just artificial life but artificial beings at least as complex as humans. This plunges us into the chaos versus quantum debate: is mere complexity sufficient for artificial art to come forth as an emergent property, or is a quantum dimension required? As yet there are no attempts to deliberately introduce quantum indeterminacy and holism into computer simulations, yet ironically the hardware that our deterministic software runs on is based on quantum-mechanical effects in the transistors of the digital microchips. Penrose seeks quantum-mechanical effects in the microtubules in the brain; Jahn finds conscious interplay between mind and electronic circuit-boards. Perhaps Aleksander is right: just build the thing and consciousness will emerge.

Figure 3 From Programmed == Damned series

Programmed == Damned

Programmed == Damned is a series of images by the author based around the concept of an artificial being questioning its own autonomy. (See Figures 2 – 4) The work is not artificial art in any strong sense of the term but takes its inspiration from many of the themes debated in this article.

The imagery is created using a system called RaySculpt, a Windows program derived from an earlier modelling system called Sculptor[48] and a ray-tracer written by Richard Wright. The system is partly a test-bed for user interface design[49] (including methods for navigating parameter space[50]), and partly a means for personal artistic expression. The series of images are loosely based on the journey of an artificial being from a state of mild disturbance through a partial recovery to a state of catatonic schizophrenia – total shut down. The artificial being, called Maxine, is imagined to be a descendent of Aleksander's Magnus.

Conclusions

The attempt to hand over part of the creative act to machinery has a long tradition going back to musical compositions based on the throwing of nails.[51] Algorithmic art on digital computers represents a substantial move in this direction, while progress in AI, a-life and artificial autonomy brings together more of the components of a truly artificial art. In the context of chaos theory, no radically new developments are required to reach this goal: only a certain level of complexity. However, in the context of quantum theory and proponents of quantum consciousness as the ultimate

Figure 3 From Programmed == Damned series

creative principle in the universe, artificial consciousness is, at present, the missing ingredient. Some of the best thinkers of our time believe that this is non-computable, but if it were (perhaps with technology not yet dreamed of) quantum mechanics would not just have restored to us an anthropo-centric universe, but also a cyber-centric one.

References

1 Gleick, J. (1994) *Chaos: Making a New Science*. London: Abacus, p6.

2 Barrow, John D. and Tipler, Frank J. (1986)*The Anthropic Cosmological Principle*. Oxford: Clarendon Press.

3 Zohar, Danah (1991) *The Quantum Self*, London: Flamingo.

4 Underhill, E. (1993) *Mysticism –The Nature and Development of Spiritual Consciousness*. Oxford: Oneworld Publications.

5 Huxley, A. (1950) *The Perennial Philosophy*, London: Chatto and Windus.

6 See ref. 1.

7 De Landa, M. (1991) *War in the Age of Intelligent Machines*. New York: Swerve Editions.

8 Bohm, D. (1980) *Wholeness and the Implicate Order*. London: Ark Paperbacks (Routledge).

9 Wheeler, J.A. (1995) *At Home in the Universe*. The American Institute of Physics.

10 Wilber, Ken (1985)*Quantum Questions – Mystical Writings of the World's Great Physicists*. Boston & London: Shambhala, pp. 33 -38.

11 Peter Lennon (1995) 'Science's New God Sqad'. *The Guardian*, 3 May.

12 Peter Holland (1995) 'Conjurors of Conjecture'. *The Times Higher*, 12 May.

13 See ref. 1.

14 ibid p. xi (paraphrased).

15 *Journal of Consciousness Studies – controversies in the sciences and humanities.* Thorverton UK: Imprint Academic.

16 Dennet, Daniel C. (1991) *Consciousness Explained.* Allen Lane: The Penguin Press.

17 Crick, Francis (1994) *The Astonishing Hypothesis –The Scientific Search for the Soul.*. London: Simon and Schuster.

18 Penrose, Roger. *Shadows of the Mind – A Search for the Missing Science of Consciousness.* Oxford University Press.

19 Bohm, D. (1994) *Wholeness and the Implicate Order.* London: Ark Paperbacks (Routledge).

20 ibid, p. 196 onwards.

21 See ref. 2.

22 Zohar, Danah and Ian Marshall (1993) *The Quantum Society.* London: Bloomsbury.

23 Capra, Fritjof (1992) *The Tao of Physics.* London: Flamingo. (3rd edition).

24 Zukav, Gary (1979) *The Dancing Wu Li Masters,* London: Fontana.

25 Warnock, Mary (1980) *Imagination..* London: Faber, p. 9.

26 ibid.

27 Boden, Margaret (1990) *The Creative Mind.* London: Abacus.

28 Boden, Margaret (1994) *Dimensions of Creativity.* Cambridge, Mass., London: MIT Press.

29 Franke, H. W. (1971) *Computer Graphics — Computer Art.* London: Phaidon.

30 Goodman, C. *Digital Visions.* New York: Abrams, 1988.

31 King, M.R. (1995) 'Programmed Graphics in Computer Art and Animation', in *Leonardo,* 28, No. 2, pp. 113 - 121.

32 Lansdown, John. 'Computer art for theatrical performance', in *Proceedings ACM International Computing Symposium,* ACM, Bonn, pp. 718-735.

33 Lansdown, John (1995) 'Artificial creativity: An algorithmic approach to art', in Beardon, Colin (ed.) *Digital Creativity.* University of Brighton, pp. 31-35.

34 Sims, Karl (1991) 'Artificial Evolution for Computer Graphics' in *Computer Graphics,* Vol 25, No 4, Association for Computing Machinery, New York, pp. 319 - 328.

35 Todd, S. and Latham, W. (1992) *Evolutionary Art and Computers.* Academic Press.

36 See ref. 26 pp. 106 - 118.

37 ibid p. 113.

38 Stiny and Gips (1978) *Algorithmic Aesthetics – Computer Models for Criticism and Design in the Arts.* Berkely, Los Angeles, London: University of California Press, p. 6.

39 Bell, Stephen (1995) 'Creative Participatory Behaviour in a Programmed World', in *Leonardo,* Vol. 28, No. 3. pp 171-176.

40 Pickover, C.A. (1990) *Computers, Pattern, Chaos and Beauty.* Stroud: Sutton.

41 Levy, S. (1992) *Artificial Life — The Quest for a New Creation,* London: Jonathon Cape.

42 Perkins, David N. (1994) 'Creativity: Beyond the Darwinian Paradigm' in Boden, M. (ed.) *Dimensions of Creativity,* Cambridge, Mass., London: MIT Press.

43 Patel, Kam (1994) 'Matter over mind for mighty Magnus'. *Times Higher Education Supplement,* 6 March.

44 Magnenat Thalmann, Nadia and Thalmann, Daniel (1994) *Artificial Life and Virtual Reality.* John Wiley and Sons.

45 ibid, pp. 73 - 81.

46 ibid, pp. 84 - 95.

47 ibid, pp. 97 - 114.

48 King, M.R. (1991) 'Sculptor: A Three-Dimensional Computer Sculpting System', in *Leonardo,* 24, no. 4 (383-387).

49 King, M.R. (1995) 'Syntax Channelling and Other Issues affecting Innovation in the Graphical User Interface' in *Computer Graphics Forum,* Eurographics.

50 King, M.R. (1995) 'Manipulating Parameters for Algorithmic Image Generation' in Beardon, Colin (ed.) *Digital Creativity,* University of Brighton.

51 See ref 33, p.31